The Building as Screen

MediaMatters is an international book series published by Amsterdam University Press on current debates about media technology and its extended practices (cultural, social, political, spatial, aesthetic, artistic). The series focuses on critical analysis and theory, exploring the entanglements of materiality and performativity in 'old' and 'new' media and seeks contributions that engage with today's (digital) media culture.

For more information about the series see: www.aup.nl

The Building as Screen

A History, Theory, and Practice of Massive Media

Dave Colangelo

Amsterdam University Press

Cover illustration: The Empire State Building with Philips Color Kinetics System. Photo: Anthony Quintano, licensed under the Creative Commons Attribution 2.0 Generic license. Layout: Sander Crius Group, Hulshout

ISBN	978 94 6298 949 8
e-ISBN	978 90 4854 205 5
DOI	10.5117/9789462989498
NUR	670

Printed and bound by CPI Group (UK) Ltd, Croydon, CR0 4YY

For Monica and Nico

Table of Contents

Acknowledgements

If I had to identify a starting point for this book it would be the moment the organisers of Nuit Blanche in Toronto accepted my proposal to transform the LED façade of the CN Tower into a collective beacon for the city's 'energy'. My nascent interest in the communicative capacity of the combination of media and architecture may have quickly faded had they not placed their faith in me. It was around that same time that I met Patricio Dávila. Over the past decade, with our various collaborators at what has now become Public Visualization Studio, we have created a number of projects that have engaged buildings, public spaces, and screens, testing and refining theories and techniques along the way. Nothing has been more productive to my thinking on this subject than the work we have done together and the conversations we have had.

Early on in the process of conceiving of, researching, and writing this book I connected with Janine Marchessault. She is the kind of academic I continue to aspire to be: actively engaged in fostering and contributing to a community of critical thinkers and doers, locally and globally, through her writing, creating, curating, and teaching. I am grateful to her for the doors and windows she has opened for me into these ecstatic worlds. The support of Paul Moore has been invaluable in this process as well. He has imparted a spirit of intellectual and interdisciplinary rigour that has shaped the way I approach my work and has been exemplary in his generosity towards his colleagues and students.

I am grateful to my instructors, colleagues, and students in the various programs and departments I have been a part of as a student and as a faculty member over the course of my life in the arts and academia including the Arts and Science Program at McMaster University, the MA in Cultural Studies and Interactive Media at Goldsmiths College, the joint PhD Program in Communication and Culture at Ryerson and York Universities, the Digital Futures MA/Mdes/MFA Program and the Faculty of Liberal Arts and Sciences at OCAD University, the School of Film at Portland State University, and the School of Design at George Brown College. Thank you for giving me the opportunity to engage in critical conversations about media, design, cinema, architecture, history, and culture.

I am also grateful to the community of scholars and practitioners involved in the work of the Media Architecture Institute. Thank you for establishing an ever-evolving space for the investigation of our ever-evolving combinations of media and architecture. It has been a pleasure to be a part of this

group and to help create events, projects, and publications that provide focus and direction for these vital conversations.

Colleagues and friends that deserve special mention for their advice, inspiration, and contributions to all of the thoughts, words, and deeds that went into this book are Tanya Toft Ag, Martin Tomitsch, M. Hank Haeusler, Gernot Tscherteu, Chang Zhigang, Martijn de Waal, Shanti Chang, Ava Fatah gen. Schieck, Susa Pop, Nina Colosi, Immony Men, Jay Irizawa, Maggie Chan, Jessica Tjeng, Preethi Jagadeesh, Robert Tu, David Schnitman, Alexis Mavrogiannis, Patricia Pasten, Alen Sadeh, Berkeley Poole, Tim Macleod, Claire LaRocca, Emma Allister, Jessica Tjeng, and the rest of our many collaborators at Public Visualization Studio, Jennifer Fisher and Jim Drobnick at the Journal of Curatorial Studies, Zach Melzer, Annie Dell'Aria, Michael Longford, Sennah Yee, Bruce Piercey, Michael Forbes and the RyeLights team at Ryerson University, Monique Tschofen, Keith Bresnahan, Sarah Diamond, Tom Barker, Will Straw, Matthew Fuller, Janet Harbord, Ilana Altman, Layne Hinton and Rui Pimenta at ArtSpin in Toronto, Sarah Turner and William Rihel at Open Signal and RACC in Portland, Mark Berrettini, Amy Borden, Jungmin Kwon, Tomas Cotik, So-Min Kang, Cathy Crowe, Arun R.L. Verma, Ana Rita Morais, Luigi Ferrara, and Maryse Elliott and the editorial team at Amsterdam University Press. Last but certainly not least, I am deeply indebted to Scott McQuire whose scholarship is the foundation upon which this book is built.

Finally, to my family: my grandparents, who were selfless in their sacrifices; my parents, Luigi and Antonietta Colangelo, whose care is apparent each and every day; my brothers Steven and Adam Colangelo and my lifelong friends Massimo Di Ciano, Michael Moretti, and Jamie Webster, who have been there with me in my battles with big, flashy buildings, and other things too; and, to my wife Monica Nunes and our son Nico, to whom I dedicate this book. Home is wherever you are and it is where I always want to be. Thank you for your kindness, support, patience, and love. I could not have done this without all of you and would not have wanted to anyway.

1. Introducing Massive Media

Abstract
This chapter introduces the concept of massive media, a term used to describe the emergence of large-scale public projections, urban screens, and LED façades such as the illuminated tip of the Empire State Building. These technologies and the social and technical processes of image circulation and engagement that surround them essentially transform buildings into screens. This chapter also introduces theoretical concepts surrounding space, media, cinema, monumentality, and architecture in order to provide a framework for the analysis of the emergence of the building as screen. These concepts are key axes upon which the ongoing transformations of the public sphere revolve. Subsequent chapters are introduced in which massive media is probed, in case studies and creation-as-research projects, for its ability to enable new critical and creative practices of expanded cinema, public data visualisation, and installation art and curation that blend the logics of urban space, monumentality, and the public sphere with the aesthetics and affordances of digital information and the moving image.

Keywords: urban screens, LED façades, architecture, public sphere, monumentality

From the Top

Toronto's CN Tower was built in 1976 as a telecommunications tower. The iconic building rises 553 metres above the city as an omnipresent reference point for anyone within a 20km radius. It dominates photos taken of the city and reflects the status and character of the city as relatively young and steeped in the architectural modernism of the era in which so much of it was built, simultaneously gesturing towards technologies and techniques as well as the past, present, and future visions of the city.

Colangelo, D., *The Building as Screen: A History, Theory, and Practice of Massive Media*. Amsterdam: Amsterdam University Press, 2020
DOI 10.5117/9789462989498_CH01

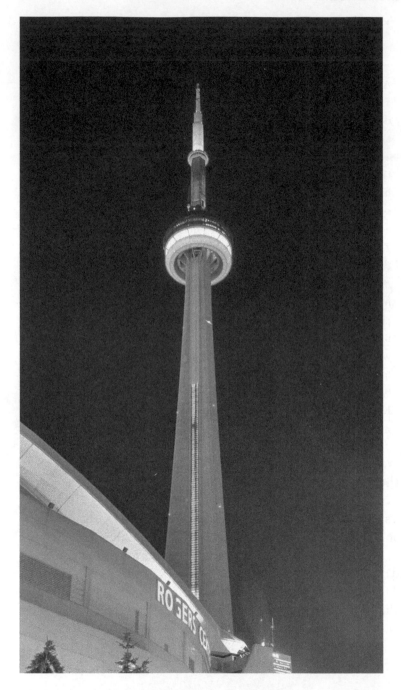

Figure 1-1: The CN Tower, Toronto. Photo: Taxiarchos228, used under the Creative
Commons Attribution-Share Alike 3.0 Unported license. Desaturated from original.

While the tower has always been prominently lit, it was not until 2007 that the building was fitted with programmable light-emitting diodes (LEDs). Its seemingly endless elevator shafts, cylindrical observation deck, and sharp antenna became illuminated and animated by a range of changing colours. Certain holidays, events, and causes were celebrated on the building by way of programming the patterns and colours of the lights. Deep runs into the playoffs by local sports teams were represented in team colours, the rare championship celebrated in gold tones, the deaths of fallen Canadian soldiers commemorated in patriotic reds and whites, and breast cancer awareness turned the tower bright pink once a year. The CN Tower website provided a calendar of lighting events to help the public decode this information, but one might also hear about it on the radio, see it on television, read about it in a newspaper, or come across a social media post depending on who decided to use lights as part of their publicity campaign. Eventually, the CN Tower began distributing images of the changing illuminations of the tower on Facebook, Twitter, and Instagram so that people could witness and participate in discussing, liking, and otherwise identifying with the associated images and messages on their own self-fashioned channels of communication.

The expressive lighting of the CN Tower and its related media and cultural practices, along with many other architectural landmarks around the world including the Eiffel Tower (which has its own Twitter account in which it speaks in the first-person) and Shanghai's Oriental Pearl Tower, to name but a few, represents a significant shift in the role of buildings with a monumental presence in urban space. As these buildings have become more screen-like, with their animations and colour changes, and as they have become more entwined with other media and screens through their representations on social media, their role as monumental and iconic architectural expressions, as a dense transfer points for civic and individual identity formation, have merged with the role of screens in our culture creating an entirely new cultural entity in the process. In the case of the CN Tower, the stoic tower became open to the ephemerality of the digital trace and became more available, attractive, and open to various causes, concerns, media channels, and conversations. It reflected its place, time, and audience in a new way, responding in a more sensitive, diverse, and timely way to the city allowing people to interact with and through its image. It became an object that could seemingly listen and speak for the city and its inhabitants. It became a building to have a conversation with.

Similarly, the Empire State Building also adorned its tip with a programmable low-resolution LED façade, promoting it through social media channels

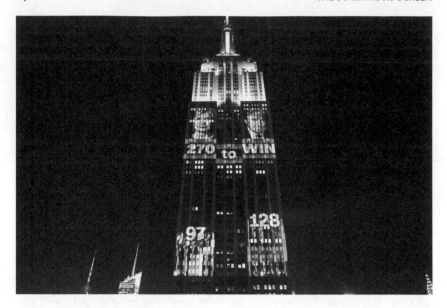

Figure 1-2: Empire State Building, Election Night 2016. Photo: © Jonathan Reyes, courtesy of Jonathan Reyes.

and presenting light shows coordinated with internet radio stations, effectively updating the *son et lumière* tradition for the digital age. The Empire State Building and the people that live in its vicinity routinely upload videos of these shows to YouTube, extending the viewing area and public inscribed by the tower. In another example, during the 2008 presidential election, the Empire State Building became a massive real-time display for election results, pitting incremental blue and red columns of light against one another on its spire until finally being bathed in blue to signify Barack Obama's victory, all of which was broadcast on CNN. More recently, digital projection was added to the election spectacle, the increased resolution allowing for the display of real-time vote counts and images of the candidates on the façade (see Figure 1-2).

This massive public visualisation of data and digital imagery tapped into the status of the building as an icon and as a monument that is augmented with programmable lights to create a spectacular embodiment of data that becomes the focal point of a worldwide news event. While buildings have been the substrate for delivering news about elections via magic lanterns since the early twentieth century (see Figure 1-3) (Huhtamo 2013), this current incarnation as a digital, networked screen means that buildings can now perform historical realities in real-time, inserting themselves into public discourse in the process both *as* and *on* architectural surfaces.

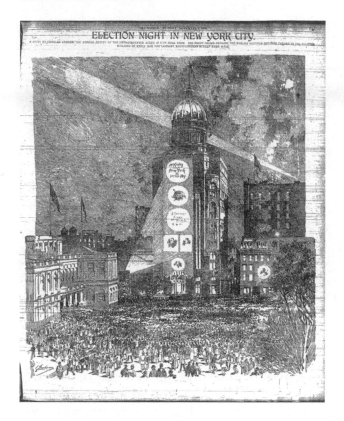

Figure 1-3: Charles Graham, 'Election Night in New York City', *The World's Sunday Magazine,* November 8, 1896. Photo: courtesy of the Library of Congress, newspaper microfilm 1363.

In addition to the ongoing screen-reliant transformation of iconic and monumental buildings in cities, critical and creative uses of what is often referred to as media architecture (Media Architecture Institute 2015) — buildings with dynamic, expressive, often-digital, elements — have also changed the nature of what we look up to and interact with in public space. Artists such as Krzysztof Wodiczko and Jenny Holzer have spearheaded and developed much of this work, using the power of the monumental building or the pulpit of the public, commercial screen to insert messages of anti-consumerism and criticisms of government policies, exposing the complexities of capital, geopolitics, and identity in powerful, highly visible ways that only massive images in monumental public spaces can provide. Famously, Holzer's expansive *Truisms* project found a temporary home on Times Square's Spectacolour electronic billboard, displaying messages such as 'PROTECT ME FROM WHAT I WANT' and 'MONEY CREATES TASTE' in

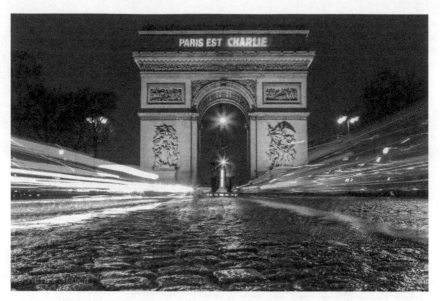

Figure 1-4: *Paris Est Charlie* is projected onto the *Arc de Triomphe* in Paris. Photo: © Patrick Mayon, courtesy of Patrick Mayon.

what might be the spiritual centre of American capitalism and consumerism. Newer works by Rafael Lozano-Hemmer, such as his *Vectorial Elevation* series and *Body Movies*, extend the possibilities of light and architecture to include the direct participation of people at various sites, as well as incorporating telepresent participation to expand the possibilities for identification and meaning at and between these sites through buildings that have in effect become screens.

Along with buildings that have LEDs directly embedded into their façades, merging physical mass with ephemeral animation, high-resolution large-scale digital projection mappings are now common in cities around the world. Synchronised displays across cities, such as Hong Kong's *A Symphony of Lights*, which incorporates over 40 buildings in the skyline, have become popular for touristic as well as political purposes. Light festivals such as Vivid Sydney and the *Fêtes des Lumières* in Lyon transform entire sectors of cities into digital cinemas and outdoor galleries for public art and spectacle. Coordinated monumental lighting displays have also been incorporated into city-wide protests and demonstrations. In the weeks following the terrorist attacks on the offices of satirical newspaper, *Charlie Hebdo*, the words '*PARIS EST CHARLIE*' (see Figure 1-4) were projected across the *Arc De Triomphe* and the trademark light show of the Eiffel Tower was dimmed to pay respect to those who had died in the attacks (Keromnes 2015). Both

intensified a sense of solidarity through light, architecture, and public space with those gathering and demonstrating in the city.

While artistic and political uses of large-scale projections, screens, and media façades multiply in cities, it should come as no surprise that advertisements take up the most space and time on buildings that have become screens. In this sense, it is more often the case that cities and buildings are not becoming screens so much as they are becoming ad-based media channels. Buildings such as the Empire State Building regularly rent their luminous tip to corporations (such as Facebook and Microsoft) or even Broadway shows to display their colours and use the resulting 'content' for promotional purposes. For example, a recent promotion for Verizon saw the building display the results of an online poll that asked fans who they thought would win the 2014 Super Bowl in the week leading up to the event, eventually displaying the results of the daily tally in the colours of the more popular team on the building. Likewise, projection-mapping projects and urban screens around the world regularly promote anything from cars, to clothes, to mobile phones on prominent civic buildings.

Overall, the expansion of critical, creative, and commercial uses of expressive architectural surfaces is a growing cultural force that is changing our relationship to iconic, monumental structures. As buildings become more like screens through the application of interactive, networked, large-scale outdoor projection, architectural façades, and urban screens, we must explore their creative and critical potential, opening up spaces through curation and programming for new expressions of place and identity in the face of advertising and city branding initiatives.

Why Massive Media?

The building as screen and its related practices of conversation, contestation, and commerce in public culture have two key characteristics. Firstly, they are big — they are, in fact, *massive*. As a result of their scale they are highly visible and thus loaded with cultural and economic value and significance. They *take* space, that is, they take up a significant amount of prime real estate and demand to be considered as public and communal, thus referencing a history and future of *mass* culture as well. Secondly, they are communicative and technical — they are *media*. They use their scale, visibility, ephemerality, centrality, and communicative capacities, from data visualisations enabled by programmable LED façades, interaction through sensors and mobile ubiquitous media, moving images, sound, and networked

communication, to broadcast their messages and engage on- and offline publics. In this way, they are *mass media*. They make space and produce it through interactions both proximal and distal: they mediate. All together, they are *massive media*. They are buildings that reflect a larger shift in our society towards the foregrounding of interactivity and experience. They are structures that can talk and listen, buildings that we can click on, swipe, share, capture, and converse with and about. Massive media are buildings that tell us something about the place they are in, about ourselves and others as we engage with them, and that connect us to other people and times, both near and far.

This book addresses this emerging phenomenon. And it does so because there is a lot at stake in these seemingly playful, benign situations. Architecture and media shape our understandings of who we are, individually and collectively, and change how we read and interpret the world around us. Questions of identity (of the self and other) are bound up in our cultural expressions, particularly ones that appear to be public and representative, as works that appropriate the scale and visibility of a building tend to be. These spaces are also particularly fraught with competing commercial interests, be they those of advertisers who seek to capture larger markets in increasingly spectacular ways, by technology and telecom companies whose aim is to convince us that more technology in cities is an inherently good thing in itself ignoring the power imbalances and biasses this creates, or cities that are angling to compete for global talent and tourism. Many projects in this field present themselves as playful, participatory, or revolutionary but amount to little more than city branding or passive entertainment, and are often elitist and exclusionary. The critical and creative potential of these spaces remain despite these tendencies. The relative novelty of the form presents us with unique opportunities to shape emerging practices and to carve out new spaces for new media art and expanded cinema that can strengthen our ability to connect with our past, present, and future, locally and translocally, at a time when these connections are under threat by politics of division, economics of disparity, and technologies of distraction and segregation.

The exploration of creative, historical, and critical understandings of massive media is necessary considering the proliferation of screen-based and screen-reliant buildings and environments and their potential impact on the development of public culture and architecture. How do these new assemblages of media, architecture, and space fit within a history of iconic architecture and monumentality? How do they reflect and challenge our notions of public culture and how we have expressed collectivity and progress? How does massive media change and challenge our notions of space,

monumentality, and the public sphere through the application of various primarily screen-based media? And finally, and perhaps most crucially: How can the combination of media in the form of moving images, data, networks, and animations make large-scale public displays and urban media environments more inclusive and sensitive to their social and historical contexts?

In exploring these questions, this book will outline useful, practical and theoretical tactics that should be of interest to students, practitioners, and researchers of architecture, new media art, interaction and user experience design, cinema, and the humanities, providing a test for theoretical claims made about the transformative properties of digital technology in cities and for monuments, and a reliable guide and predictor of future outcomes, directions, and critical practice in this field. It aims to establish critical perspectives, theories, and methods for the practice of public visual culture through massive media amidst technological, social, epistemological, ontological, and economic change.

A Brief History of the Public Sphere, Monumentality, and Media

The Most Advanced Site of Struggle: The Public Sphere

Looking at and conversing about the same thing at the same time. It is a simple idea but it is a critical element of intersubjective cultural discourse. When millions of us watch the same television show, listen to the same song, or read the same book, we become part of a discursive community that, through various channels of feedback, both immediately and at various mediated distances, shapes how we collectively think and feel about these things. These scenarios outline the conditions of what we might call a public sphere: a place where autonomous individuals can come together to form a group that can mediate and manage feedback related to their collective thoughts and desires.

The public sphere can be seen to have undergone a trajectory of transformation and fragmentation alongside technological advancement. Jürgen Habermas defines a healthy public sphere as the places and protocols (both technical and social) by which private people come together to form a public that is as accessible, autonomous, non-hierarchical, and participatory as possible. Habermas' understanding of the contribution that various media and spaces have on this coming together is crucial to the resulting qualities of the discourse generated by a public sphere. He notes that the public sphere, due to its size, is a dispersed commonality of strangers, which 'requires specific

means for transmitting information and influencing those who receive it'
(1974, 49). For the bourgeois public sphere, emerging in the early eighteenth
century from a previous courtly conception of 'representative publicness'
(Habermas 1989, 5), this meant a combination of media and public space
that included the growth of the press, literary societies, the salon, and the
coffee house. Habermas argues that the health of the bourgeois public sphere
flagged in the twentieth century due to a re-feudalisation and fragmentation
via mass media that concentrated power in large multi-national corporations
and isolated individuals in private dwellings where the media platforms of
television and radio had taken hold.

More recent theories of the public sphere tend to focus on the role of
media in the public sphere. Following from Habermas, German filmmaker
and theorist Alexander Kluge and his colleague Oskar Negt take on the
challenges posed by mass media to the health of the public sphere such as
fragmentation, isolation, and distraction. Negt and Kluge were particularly
interested in electronic media and satellite links that created the conditions
for the existence of global news outlets such as CNN in the 1980s. Somewhat
more pessimistic about the global proliferation of electronic media than
McLuhan, Negt and Kluge saw 'the media of industrial commercial public-
ity, in their most negative implications, as an inescapable horizon, and
as the most advanced site of struggle over the organisation of everyday
experience which contextualises all other sites' (Hansen 1993, 211). Thus,
the public sphere became for them a struggle for the contextualisation
of sites of debate and memory through media. As a result, their approach
shifted the conditions for the health of the public sphere to those of 'open-
ness, inclusiveness, multiplicity, heterogeneity, unpredictability, conflict,
contradiction, and difference' (ibid., 189) that can be enacted in and through
the use and appropriation of media which changes the who, what, and how
of participatory politics. As Miriam Hansen notes in an essay that revisits
Negt and Kluge's work:

> The new types of publicity that have been proliferating over the past
> decade or two, especially with the electronic media, not only urge us to
> rethink, once again, the function, scope, and mode of intellectual activity;
> they also force us to redefine the spatial, territorial, and geopolitical
> parameters of the public sphere (ibid., 183).

The proliferation of media in public space via monumental projections and
displays, as well as networked, location, and context aware technologies,
as evidenced by buildings like the Empire State Building, can be seen to

introduce a new dimension to the ongoing struggle for spaces and forums for
reasoned argument and debate. Here, specifically, Claire Bishop is critical
of the quality and meaning of the modes of public participation afforded by
certain assemblages of expressive displays, digital sensors, and networked
devices as public spheres. In her discussion of relational aesthetics and
the idea of activated spectatorship in installation art, Bishop argues that
good participation should open up channels for discussion and debate.
Bishop notes 'the public sphere remains democratic insofar as its naturalised
exclusions are taken into account and made open to contestation' (2004,
65). In the context of public space, these 'naturalised exclusions' include
the exclusions of sociability enforced by the prioritising of flow through
spaces as well as the prohibitions related to the rights of the citizen to alter
their surroundings or see themselves reflected back in it. For Bishop, what
is central to authentic participation is 'activated spectatorship' (2006, 50),
or a scenario that values equality over quality, collective authorship over
singular control, and the 'on-going struggle to find artistic equivalents of
political positions' (2012, 3). The degree to which various examples of massive
media achieve this kind of 'activated spectatorship' will be discussed in
case studies and examples in the chapters that follow.

Michael Warner (2005) adds that the contemporary public sphere, as
much as it is about rational argument and discourse, can also be apolitical
and agnostic, emotional and playful. It can be merely about getting involved
intimately, viscerally, and deeply with strangers. This could be something
as simple as cheering at a sporting event, collectively facing (or de-facing)
a monument, retweeting a hashtag *en masse*, or clicking a 'like' button online.
Warner's perspective can be linked to the earlier work of Hannah Arendt who
prefers the term 'public realm' to describe what emerges from the simple act
of being able to act together, and to share 'words and deeds' (1958, 198). For
Arendt, the public realm need not be tied exclusively to physical locations,
but rather bound to the ways in which we might create and control, to various
degrees, a 'space of appearance' (ibid., 198) for ourselves. These spaces, of
course, are threatened by censorship, power, and control in its many forms.
And, while Arendt focusses primarily on forces of tyranny and fascism
affecting society in her time, in many ways these forms of control have
become embedded and encoded in technologies and our interfaces with it.
All of this points to a technics and politics of visibility, a 'distribution of the
sensible' (Rancière 2000) and appearance that is supported and challenged
by various extensions and tools such as the expressive surfaces of structures
and media linked in and through them via media interfaces. In this way,
massive media can be seen to emerge as a kind of 'common', a public sphere

that serves to shape dominant economic and social uses of public space. As such, massive media is in part constitutive of a larger coordination of technology, politics, and economics, shaping contemporary public spheres and a commons that is, to various degrees, 'oriented towards the production of social relations and forms of life' (Hardt 2009, 26).

Looking Up Together: Monumentality

Like the public sphere, monumentality is a concept that has been tied up in the politics of memorialisation, debate, and representation, and thus factors in to an understanding of massive media. What we think of as 'monumental' has been influenced and inflected by various technologies of production and communication, including media architecture, urban screens, and public projection technologies, thus challenging and changing notions of space, public space, and the public sphere.

Monuments are dense transfer points that collectivise individuals and condense memory and ideological meanings. Through the monument, these meanings are transferred back to the collective through the performance of rites and rituals associated with them. Analysing this in greater detail, Henri Lefebvre argues that monuments in general enact two major things: '(1) displacement, implying metonymy, the shift from part to whole, and contiguity; and (2) condensation, involving substitution, metaphor and similarity' (1997, 136). For example, with respect to displacement, the Statue of Liberty can be a stand-in for the whole of the United States. As another example, The Empire State Building can represent New York as a whole, and to come in contact with it or its image is to come in contact with the entire city in one place or image. Conversely, with respect to condensation, New Yorkers, or even Americans as a whole, can congregate around these objects (or image-objects) — they condense attention, values (life, liberty, and the pursuit of happiness), and longing for connection into a dense point of semiotic transfer. In massive media, the addition of social media to these sites extends the possibilities for trans-local displacement and condensation through telepresence.

Monuments can be any combination of material, symbolic, and functional characteristics. Pierre Nora uses the more general term *lieux de mémoire*, or sites of memory, and includes anything from a state archive to commemorative statues and plinths and even shared moments of silence which we might observe on Remembrance Day as possible sites of memory. He says these are necessary because we no longer have *milieux de mémoire*, that is, 'real environments of memory' (1989, 7), a category of collective memory lost in the post-industrial decline of peasant societies in which

memory was contained in 'gestures and habits, in skills passed down by
unspoken traditions, in the body's inherent self-knowledge, in unstudied
reflexes and ingrained memories' (ibid., 12). That said, Diana Taylor argues
that the distinction is not as clear as Nora contends. Taylor places a greater
emphasis not on temporal shifts, but in changes in forms of transmission,
which may be embodied or archival and may occur among different kinds
of publics and communities (2007, 22), thus modulating the qualities of
cultural survival and affect in memory.

The *Arc de Triomphe*, as a site of memory for example, honours those who
fought and died for France in the French Revolution and Napoleonic Wars,
or, with the recent projected application of the text '*PARIS EST CHARLIE*',
also honours those who died in the terrorist attacks on the Charlie Hebdo
office (Keromnes 2015), indicating the collective importance of this issue to
Parisians, the French public, and via its remediation, the rest of the world.
While the *Arc de Triomphe* is a site of memory, in Nora's words, it is also a
more nuanced form of cultural transmission in that it combines forms of
transmission through the application of projection (the physical monument
and the projected image) while also reaching communities locally and glob-
ally in its remediation through electronic and print media — another form
of transmission. In the *Arc de Triomphe*, like all sites of memory, the material,
symbolic, and functional coalesce as collective memory that, in Nora's words,
'crystalises and secretes itself' (1989, 7), and does so today through multiple,
composite, and simultaneous forms of transmission arguably activated and
centred upon, in this case, what we might call massive media.

While Nora emphasises the variations in possible sites of memory, and
Taylor refines this by emphasising the role of media, it is the specificity of
large, public displays — the plinth, the arch, the statue, or the clock tower,
illuminated, animated, or not — that represent a unique trope of monu-
mentality that are particularly germane to the development of a concept of
massive media. It is both the scale of the display and its urban situation in
these examples, often one that is both visible and central, that lends them
particular powers and influence. Monuments and urban space effectively
act cooperatively as power brokers that exchange authority and importance
through metonymy (literally and figuratively: what and who they stand
for) and condensation (who and what they call out to congregate around
them). Michael Rowlands and Christopher Tilley, quoting Herbert Bayer,
note that these 'civic compositions [...] assume that the urban landscape
is the emblematic embodiment of power and memory' (2006, 500). Iconic
buildings and monuments represent this power and memory in relation to
their setting, and do so in concentrated form. They are concise statements

of memory and power within the urban landscape as a whole. In this way, monuments and landscapes give power and significance to one another, one existing on the stage of the other, made particularly visible to their audience in their scale and position: they produce and share what Walter Benjamin (1999) might call the auratic.

The Empire State Building in New York City provides one such example of auratic monumentality. Situated as it is in central Manhattan, the backdrop of the city with its layers of power and memory coalesce with the monument due to its scale and juxtaposition with that backdrop. The images of the building, promotional and personal, reproduce this idea as a testament to the aura produced by it (as opposed to diluting it). The various reproductions of the building's images are inspired by and contribute to its unique geographical situation. Monuments exist prominently within urban and public space so that both the monument and the space around it can benefit from the metonymy described by Lefebvre (1997), allowing for a transfer and amplification of power.

It should be noted that not only do monuments transfer meaning, they also transfer power through meaning for those that control and direct their construction and use. As Lefebvre notes:

> [...] each monumental space becomes the metaphorical and quasi-metaphysical underpinning of a society, this by virtue of a play of substitutions in which the religious and political realms symbolically (and ceremonially) exchange attributes — the attributes of power; in this way the authority of the sacred and the sacred aspect of authority are transferred back and forth, mutually reinforcing one another in the process (1997, 136).

The authority to facilitate the construction of the monument is seen as sacred, and this reverence is recursively transferred with the 'religious' (or ideological) content of the monument which has its own symbolic power in society. Thus, power is consolidated and shared by form and content. The dispositif — to borrow a term from cinema studies — of the monument in the city (its visibility, scale, and permanence) represents an attractive and useful site for discourses of power because of the metaphorical and metaphysical connection it creates between power, authority, and society. For example, Big Ben, a unique source of identification for the City of London, and perhaps an example of proto-massive media, symbolises the orderliness of parliament and reinforces the power and centrality — geographically, politically, and symbolically — of the institution, which then, recursively, becomes a source of pride. The authority of order, and the orderliness of authority are broadcast,

transferred, and mutually reinforced. Monuments have metaphorical and metaphysical power to which societal values, civic and national identities, and political ideologies are attached, exchanged, and entrenched.

In addition to a transfer of power, monuments and iconic structures also act as dense transfer points for memory and connection when coupled with rites and rituals that animate the space around and on them. As Rowlands and Tilley point out, monuments 'provide stability and a degree of permanence through the collective remembering of an event, person or sacrifice around which public rites can be organised' (2006, 500). Monuments, such as war memorials or iconic, city-defining structures such as the Eiffel Tower produce a set of associated social practices such as annual Remembrance Day rituals or marriage proposals. As Lefebvre notes, 'Such a space is determined by what may take place there, and consequently by what may not take place there (prescribed/proscribed, scene/obscene)' (1997, 135). This includes mediated practices such as the use of recording devices, the socially accepted volume of speech, the calendar of rites and rituals associated with the site, the laying of wreathes on certain days, and so on. Essentially, Lefebvre's point is that monumental space is produced through proscribed performance. Take, for example, the many war memorials in the form of statues or more abstract concrete, metal, or marble forms, in front of which wreathes are placed at specific times of the year. This practice of monumentality need not be visual either. We might also include the example of the ancient 'call to prayer' that rings out across the rooftops of cities in the Islamic world, or the ringing of church bells in the West, both performed from purpose-built structures that rise above the space around it, creating, essentially, a broadcast.

Sites of memory are completed and maintained through public performance. To this, we can add the performance of the monument itself, or the performances of various kinds of participation it exhibits, when it is animated by computer-controlled pixels in the form of an LED façade or digital projection. This book will apply the idea that new performances and repetitions of rites and rituals arise with the proliferation of massive media, helping to produce new identities for spaces and for people, making them feel connected through the changing symbolic value of the digital monument.

A Modern Monument for the Modern Masses

While deities on hills, church spires, and other conspicuous religious symbols formed the majority of the ritualistic monumental landscape in cities prior to the advent of modernity, the last two hundred years of monumentality have

tended towards more secular structures, many of which incorporate some form or expression of technology and/or media that reflects discourses and practices of modernity; namely industrialisation, urbanisation, mechanisation, electrification, increased travel and migration, and the acceleration of capital (Berman 1982). An example, albeit never built, is Vladimir Tatlin's Monument for the IIIrd International, planned for Petrograd (now St. Petersburg) in 1919-1920. Seeking societal reform through art, Tatlin proposed a many-tiered, spiralling tower of glass and steel reaching skyward at a dynamic angle. The work sought to be 'an active transformational force in the mass revolution' (Rowell 1978, 100) of communism in the USSR and throughout the world. Notably, the stacked, cylindrical sections of the building each had a different function and were meant to revolve at a different speed. The bottom-most cylinder housing the legislative body would revolve once a year, and the two upper-most, an information bureau and broadcast centre equipped with radio antennae and film projectors 'to emit propaganda to the street' (ibid., 104) would revolve daily and hourly, respectively. Tatlin's Tower was, according to critics at the time, a dynamic, mechanical monument to 'something alive and still developing' (Shklovsky quoted in Lynton 2009, 102), as opposed to 'torsos and heads of heroes and gods' (Punin quoted in Lynton 2009, 99) of the past, and thus could better 'share in the life of the city' (ibid., 99) and its time by expressing, shaping, and contributing to the collective emotional life of the masses.

Other monuments of modernity include the Eiffel Tower, a monument to industrialisation, the clock tower such as Big Ben, a massive timepiece for the mechanisation of industry and standardisation of social practice, the great gateways of travel such as the Golden Gate Bridge or the Statue of Liberty, welcoming weary immigrants to a new nation, or the sky scraper such as the Empire State Building with its electric lights lit by the energy of capital made to circulate at ever increasing speeds by the occupants that light its windows. These were monuments to capital, to standardisation, to consolidated power, to functionalism, but not necessarily to any specific population, individual, group, or historical event. Like modernity, they were impersonal, efficient symbols of hope, dynamism, power, and progress. While modernity realised itself through mechanisation, the circulation of capital, and even cinema, as Hansen (1995) points out, it was also realised through monumental expressions of mechanical, sculptural, and electric media.

According to certain modernists, these monuments, while emblematic of their time, still left much to be desired in terms of the role that monumentality should play. For example, Sigfried Giedion theorised that monuments should be sites for 'collective emotional events, where the people play as

important a role as the spectacle itself, and where a unity of the architectural background, the people and the symbols conveyed by the spectacles will arise' (1944, 568). Except for Tatlin's proposal, this was not the case with the kinds of monuments modernity had typically produced. Giedion called his views the 'new monumentality' (Mumford 2000, 151), essentially arguing that monuments should not be stoic and stuffy, but should allow collectives to participate in and through them in some way. While acknowledging the return to grandeur at large scales in public spaces which characterised modernist monumentality, in *Nine Points on Monumentality*, members of the *Congrès International d'Architecture Moderne* (CIAM) which included Giedion and the French artist Fernand Léger, advocated instead for something more responsive and variable in monuments. Tellingly, their suggestions included the provision of 'vast surfaces' for projection:

> Mobile elements can constantly vary the aspect of the buildings. These mobile elements, changing positions and casting different shadows when acted upon by wind or machinery, can be the source of new architectural effects [...] During night hours, colour and forms can be projected on vast surfaces for purposes of publicity or propaganda. These buildings would have large plane surfaces planned for this purpose, surfaces which are non-existent today (Giedion et al. 1943, 50).

Giedion et. al saw the provision of colour, light, and variability as a progression in monumentality: a redefinition of grandeur, identification, and monumentality through surface contingency. Along with László Moholy-Nagy, whose experiments with his Light-Space Modulator at the time mirrored the aesthetic goals of CIAM, and were even extended by him (theoretically) to the realm of architecture, these modernists, critiquing modernism, suggested that there was potential in architectural dynamism for 'publicity and propaganda' through the application of moving light. How this would create greater emotional connections between people and space was not clear at the time, but the potential had been identified: buildings needed to become more like screens to break from inadequate modern and pre-modern precedents.

Space and Media

A deep understanding of theories of space and media is necessary for the study and use of the emerging building as screen — of massive media. As was shown in a number of the examples above, space and monumentality are

not static or fixed but produced in complex social and technical processes. This idea comes to us primarily through the work of Henri Lefebvre. In his book *The Production of Space*, he argues that we have moved past a strictly Euclidian, mathematical understanding of space that sees it as measurable, continuous, and discrete, to an understanding of space as a collection of fragmented, subjective spaces produced through practices, protocols, social relations, and technical supports. As such, spaces need not be purely physical. They can include mental spaces, commercial spaces, global spaces; essentially there are multitudes of spaces (1991, 236) that are produced and also, importantly, consumed in time through our actions. While in a public square, for example, we simultaneously consume and produce space by photographing it, appropriating it in various ways, or transposing it to other spaces and contexts through media. A public square is a commercial space in that various exchanges and transformations of capital are present in the form of advertisements, street vendors, and even street photography. It is also a global space in the way these photographs might circulate in print or online, or the way in which the materials and goods on display are made and marketed elsewhere. Finally, it can be a mental space in the personal cartographies created by individuals, something that Kevin Lynch (1960) describes in his *Image of the City*, or in the way Nora (1989) describes sites of memory. Space, instead of being fixed, is co-produced in the complex interplay of social and technical actors, groups and individuals, matter and memory. Thinking of how this relates to massive media, take the specific example of being in a crowd in Times Square: the bright lights and grand vistas of the space contribute to its production, as well as tourists snapping photographs (which contribute to mental images for those near and far), the nearby hotels cashing in on the spectacle, and the advertisers reaping the attention lavished upon the flashy billboards by the eyeballs that take them in.

Technologised spaces of massive media such as Times Square manifest themselves in the many relations that are opened up when space is not seen as authentically achieved, static, or absolute. In his book *The Media City*, Scott McQuire uses the term 'relational space' (2008, 28) to define this shift as it relates specifically to theories of contemporary public spaces. By way of television, cinema, and photography, and now accelerated and augmented by media including digital mobile devices and urban screens, public space has increasingly become something that, according to McQuire, 'cannot be defined by essential attributes or inherent and stable qualities' (ibid., 22). He argues that these media factors have introduced greater *ambivalence* and *contingency* to our conception and use of space. McQuire explains that changes in urban form and the embodied experience of space beginning

with the modernisation of cities, the development of rapid transport, and the electrification of cities in the early twentieth century diminished the coherence of traditional means for the representation and construction of social space and identity. David Henkin provides an even earlier example of this co-evolution of media and space in the city. Focussing on late-nineteenth century New York City, Henkin describes how a burgeoning population in the city gave rise to an 'increasingly heterogenous and unwieldy urban community' (1998, 38). This condition of estrangement led to what Henkin calls 'city reading' in the form of more public signage for the purposes of advertising goods, spreading political ideas, and sharing information, as the 'city of strangers' (1998, 7) could no longer rely on trusted intersubjective interactions or a shared culture. Public space, once solidly 'anthropological' (Lefebvre 1991, 229), based on tradition and familiarity, has, over time, tended towards increasingly unfamiliarity, mirroring the emergence of mass society, defined instead by the flow of people, capital, and information.

Changes in how space is produced have shifted how space is perceived and how people reorient themselves amidst these jarring changes. As McQuire notes, 'in a world remade by machine technology, artificial light and rapid movement, embodied perception was increasingly susceptible to sudden switches and abrupt shifts' (2008, 62). Consequently, changes in urban form 'levied increased demands on technological images to 'map' the city, and thereby make it available to perception, cognition and action' (ibid., ix). Thus, the city and media have existed in a dialectic between rupture and recuperation, between distraction and enhanced attention. For example, serialised photographs taken of the Haussmannisation of Paris, a process that introduced a great deal more artificial light and rapid movement to the city, were used to both demonstrate the transformation of spaces as well as to make it comprehensible. Similarly, the radical montage of early city symphony films such as Dziga Vertov's *Man With a Movie Camera* (1929) had the effect, as Benjamin observed, of unlocking the 'prison-world' of the modern metropolis (quoted in McQuire 2008, 65) that had become incomprehensible in its complexity and the speed with which it was to be traversed by car, tram, or subway.

Furthermore, McQuire demonstrates how distinctions between private and public, local and global, are blurred to create new spaces, and the ways that communicational and spatial bonds are transformed as a result. Expanding on the quality of *ambivalence* of contemporary relational spaces, McQuire notes that 'Relational space names the ambivalent spatial configuration which emerges as the taken-for-granted nature of social space is withdrawn in favour of the active constitution of heterogeneous spatial connections linking

the intimate to the global' (ibid., ix). The role of mobile ubiquitous media in public is a clear example of this shifting spatial characteristic. Smartphones can, for example, aid in the escape from a taken-for-granted context such as public transit by providing refuge through an intimate (yet potentially globally connected) space. The enclosures that once defined private and public, local and global, recede and hybridise in such instances. As a consequence, McQuire argues, space today more frequently assumes significance through heterogeneous, variable, and impermanent interconnections (ibid., 22) as opposed to unidirectional, homogeneous, fixed connections (as envisioned in early practices related to television consumption, for example). As McQuire concludes, 'communicational bonds exhibit different durations and velocities to older forms of social bonds embedded in spatial proximity' (ibid., 22) and thus, relational space contains an ambivalence that comes with the speed associated with the rapid switching of tele-communication, and forms the basis for the mixture of contexts, of spaces of places (Lefebvre 1991) and spaces of flows (Castells 2001, 2002).

In a concept similar to McQuire's relational space, Adriana De Souza e Silva focuses on the role of mobile interfaces in creating what she calls 'hybrid space' (2006, 261). This also serves to describe the space in which massive media emerges as both a disruption and a filter. 'Produced and embedded by social practices, in which the support infrastructure is composed of networks of mobile technology' (ibid., 271), hybrid spaces blur the boundaries of physical and digital space, augmenting both in the process. Data is extracted from these spaces through practices such as surveillance, personal photography, or social media, while also augmenting these spaces via computer displays and public screens. As De Souza e Silva notes, 'the flows of information that previously occurred mainly in cyberspace can now be perceived as flowing into and out of physical space' (ibid., 265). Like McQuire, De Souza e Silva considers our 'always-on' (ibid., 262) connection to virtual spaces in physical spaces as the means by which remote contexts, both in space and time, become enfolded inside the present context, creating an ontological bridge of sorts. McQuire adds a critical dimension to the idea of enfolded, hybrid, and ambivalent space noting that these spaces create mostly hidden meshworks of surveillance evoking what Deleuze (1992) presciently described as an emerging 'control space'. At the same time, these hybrid spaces also contribute to pockets of network-driven activity such as flash mobs and protests, and furnish access to building-scale effects on urban screens and reactive architecture via interactive installations. As McQuire notes, this can lead to a perpetual state of responsiveness and anticipation for devices, individuals, and buildings — akin to computer interfaces themselves — that

act either as distractions or a points of grounding reference. Here, we see how the building and the city have become screens, and begin to understand what the consequences, effects, and affordances of this might be.

Continuing along this line of inquiry, McQuire names *contingency* as a second major characteristic of the emergence of relational spaces — the kinds of spaces that massive media are an integral progenitor of. He notes that both public screens and mobile devices contribute to a fluidity of social space and subjectivity that can be considered radically contingent particularly with the relative speed at which images are produced and consumed within these contexts. The contingencies brought about by the mixture of spaces and contexts have, for McQuire, allowed for the emergence of new spatial ensembles that better reflect the ways we interact in and through the image today. For example, the current apex of the heterogeneity and contingency of spatial regimes can be seen to be embodied in practices such as augmented reality and mixed reality (2008, 21) in applications such as Google Glass and Microsoft's HoloLens. In the promotional discourse attached to such devices, and in McQuire's theories, there remains an optimism about a new frontier of hybrid space in terms of the freedoms it affords for the layering of contextually relevant information, for telepresent yet embodied encounters, but also for dissenting voices and interpretations.

In addition, contingency, as a characteristic of contemporary relational space, can be seen as central to the affective register and thus, much like cinema before it, a powerful attraction for representational (and commercial) applications and perceptual training through spectatorship and participation. The moving and networked image in public space plays a significant role in the accelerated contingency of surface effects — the multiplication of images in, on, and around buildings as a result of public and private displays — and the attraction/distraction that this creates. Siegfried Kracauer (1965), an early observer of the effects of contingency introduced into space by the moving image, argues in his *Theory of Film* that cinema works through the distraction and mystification caused by the moving image. This is precisely a distraction from the surrounding environment and context of the observer. Kracauer observes that film results in an increased demand on the spectators sensorium resulting in a distracted attention, innate curiosity, and an openness to sense impressions. The moving image creates an effect that captivates an audience and acts as a unique and powerful physiological stimulus. He likens film to an object of prey, tapping into our animalistic tendencies to notice and fixate on moving objects. Janet Harbord (2007) extends this analysis to public spaces. She argues that contingency is central to the affective register and notes that

whereas films projected in cinemas can be described as contingent insofar
as the moving cameras that captured them present changing views within a
cinematic frame, current configurations of expanded cinema via projections
and screens in public space can achieve contingency and the subsequent
effects of distraction, attention, and mystification through indeterminate
viewing conditions and digital manipulation that open the digital moving
image to recombination, relationality, and reactivity. Public screens up the
ante in terms of the distraction/attention dialectic of media, a dialectic that
will be explored in more detail throughout the book.

Following from this, cinematic concepts and considerations such as scale
(Doane 2009), superimposition, montage, and apparatus/dispositif (Baudry
1975) are important factors in exploring the implications for the combination
of media and monumentality. Tom Gunning speaks about the role that
superimposition plays in cinema and beyond in his article, 'To Scan A Ghost:
The Ontology of Mediated Vision'. He notes that 'incongruous juxtaposition'
of a superimposition on film 'yields an eerie image of the encounter of two
ontologically separate worlds' (2007, 6). Although, in Gunning's case, he is
describing the appearance of superimpositions upon and within the space
of the screen, when this diegetic space is the life world, so to speak, then
the superimposition becomes the projection itself and the thing being
imposed upon is the city, opening up new ontological complications and
possibilities. Furthermore, public projection can be seen to extend the
concept of montage, the juxtaposition of images to create new meanings, to
a spatial montage with the city around it again, affording new possibilities
for the moving image and space.

Both of these concepts can be encapsulated within an understanding of
the apparatus/dispositif, the ideological and technical interface of cinema, as
expanded (Youngblood 1970) and extended by massive media. For example,
Mary Ann Doane (2009), writing on the role that scale plays in cinema,
describes the way that cinematic scale reflects a desire to lose oneself in
the image — an essential quality for ideological transmission through any
media form achieved to a degree by the dispositif. These concepts of film and
cinematic media take on new dimensions and qualities when transposed
onto the city in the large-scale projections and animated displays of massive
media explored in this book.

Accelerated Rituals

One potentially negative side of the stimulus of increased contingency,
often by way of the application of media in public space, emerges in the

belief that it can erase history, mystifying and fragmenting a public for the purposes of capturing an audience within the crosshairs of ideology. Jonathan Crary argues that the 'accelerated ritual' (Crary 1999, 370) of the moving image can efface the history of a space and divorces repetition from its association with tradition building. For example, think of the repetition we might associate with seeing the same structure every day, for example, and the traditions that might follow from this. Now think of what happens when that structure is covered in screens that display ephemeral content.

As Crary argues, it was electrification that first transformed the surfaces of the city into mutable, oneiric, 'formless fields of attraction' (468) that often had an effect of distraction and dehistoricisation for the purposes of pleasure and persuasion. That is not to say that tradition, community, and debate cannot be fostered through the moving image in public space. In spaces dominated by moving images, tradition may be found simply in the repetition of the spectatorship of the moving image, or it may be created in repeated exposure to the same images or sets of images, or perhaps in their appropriation and circulation amongst viewers. McQuire characterises such practices as moving us from 'object-oriented perception' (2008, 41) to a mode of perception that foregrounds the relations between objects and operations on them — essentially, to a mode of perception based on ideas of superimposition and montage that emerge from the creation and reception of cinema. Thus, in relational space tradition, connection, and meaning is not completely obliterated, it simply takes on a different velocity: it is more ambivalent and contingent, but no less meaningful. Extending this thinking to mobile screens, McQuire also notes that in contingent, relational space, 'the pre-given nature of social space and the taken-for-granted contours of subjectivity are increasingly withdrawn in favour of the ambivalence of mobile spatial configurations and ephemeral individual choices' (ibid., 22) engaged by such devices. As such, contingency is seen to be suspended in relational space, albeit briefly, through the 'interconnections established between different nodes and sectors' (ibid., 22) and thus tradition and con-nection may be re-established, albeit primarily according to this modified logic of the digital and networked screen. Rituals, publics, and tradition are not necessarily obliterated by screens — they are made temporary and provisional, site and device specific.

Thus, screen technologies in public spaces might be seen as existing along a continuum with crude distractions on one end and sensitive filters on the other, making space both more and less sensible and legible. Picking up on the way mobile technology modifies the legibility and flows of public space and changes power dynamics, De Souza e Silva and Frith (2012) focus

on the filtering possibilities that personal media afford us, noting the ways they provide a mast to affix ourselves to amidst increased contingencies of media maelstroms that now permeate public spaces. Similarly, media artist David Rokeby has stated that 'we are desperate for filters' (1995, 154) in the sense that we need ways to manage the contingency of media messages and channels that we actively and passively encounter. While technologies such as mobile phones and urban screens can be seen as contributing to contingencies, they are also the filters by which these contingencies can be navigated and managed for the purposes of legibility. Similar to Simmel's (1950) concerns decades earlier, De Souza e Silva and Frith cite the omnipresent threat of overstimulation by the city and its associated media through interfaces both individual (such as the smartphone) and shared (such as public space) as ultimately desensitising. De Souza e Silva and Frith see personal, mobile interfaces as connecting, influencing, and providing some means of control over flows and spaces of information. These interfaces, and the growing importance of the concept of interface in culture, address a growing desire to selectively interact with public spaces as a way to fend off the onrush of a blasé attitude that might result via the bombardment of the senses. As such, mobile media, alongside the massive media they accompany directly or indirectly, are capable of making public space both more and less legible and sensible.

Predating McQuire, others such as Moholy-Nagy have taken a positive stance on the subject of increased stimulus in the city and its relationship to perceptual acuity. As he states in *Painting Photography Film*, his investigation into perception and various media, 'The vast development both of technique and of the big cities have increased the capacity of our perceptual organs for simultaneous acoustical and optical activity' (1969, 43). He cites Berliners crossing the Potsdamer Platz who simultaneously perceive 'the horns of the motor-cars, the bells of the trams, the tooting of the omnibuses, the halloos of the coachmen, the roar of the underground railway, the shouts of the newspaper sellers, the sounds of a loudspeaker' (ibid., 43). To close the loop, he insists that far from being a mechanism for disorientation, this shift in stimulus can prove generative for the media arts where 'modern optics and acoustics, employed as means of artistic creation, can be accepted by and can enrich only those who are receptive to the times in which they live' (ibid., 43).

Krzysztof Wodiczko is similarly interested in the role that certain urban stimuli, particularly of the massive media kind (although he does not name it as such), can play in the rupture and recuperation of meaning. For Wodiczko, the city and its structures, such as its monuments and government buildings,

are imbued with the misdeeds of the past, such as colonialism, and the present, such as racism and xenophobia. Through media interventions such as large-scale projections of disadvantaged people (e.g. immigrants, people experiencing homelessness, inmates) on contextually relevant buildings (e.g. courthouses, monumental plinths) he sees his role as helping to 'heal the city's wounded psychosocial relations and its catastrophic reality' (1999, 4). In doing so, he hopes to 'arrest the somnambulistic movement' (1999, 47) of passive consumption (and production) of space, which serves to reproduce hegemonic myths of power, and foster a collective and communal form of therapy with the city.

Arguably, what this groundwork of media studies shows is how media and processes of mediation make the modernising city both manageable *and* unmanageable, and how the human sensorium and cultural consciousness is co-evolutionary with its media-rich environment, something that is echoed in the writings of Benjamin and McLuhan. This points us towards posing important questions about the role that massive media play in this dialectic of perceptual rupture and recuperation, questions that I tackle in the following chapters.

Reverie Amidst the Real

Others, such as Brougher in *The Cinema Effect*, further argue that the illuminated night of the modernised city, with its moving images and the growing cultural obsession with the moving image, triggered an ontological shift in city life beyond mere perception. As Brougher notes, 'film has spilled out of the great movie palace cathedrals and has spread into the city itself and into the way we live our lives' (2008, 19). He notes that since the advent of outdoor projection, amusement parks, and other such illuminated spectacles, we no longer encounter the cinema's technology of spectatorship, its apparatus and dispositif, in the cinema alone. As he says, 'dark chambers separated from the world at large are no longer a necessity for the cinema effect' (ibid., 35). These alternative cinema-like scenarios can furnish the possibility of alternative worlds and spaces of reverie amidst the very real, material spaces of everyday public life, thus engendering the possibilities for abject negation of one's surroundings and/or increased relationality, hybridity, and legibility.

Increasingly, the gap both perceptually and ontologically between cinema and the city, between mediation and the built environment, has narrowed due to the proliferation of cinema and the city's increasing uptake of the functional characteristics of cinema, namely the use of electric light in darkened spaces filled with people. McQuire and others (cf. Gunning 1990)

actually situate a mobility of vision and an embodied, collective spectatorship in proto-cinematic environments such as the World's Fairs and Expositions of the late nineteenth century. As McQuire notes, 'The World's Fairs showcased the potential for electric lighting to establish a new rhetoric of urban space, opening the way for the city to be transformed into a performative space in which fixity of appearances would give way to increasing flux' (2008, 119). Similarly, Gunning states that 'The World Expositions were not only founded on the regimes of the wandering eye, but they also proved to be expert tutors in the delights (and possible perils) of this new mobile vision' (1990, 15). Perhaps one of the most well-known cinematic cityscapes that embodies this vision is that of Times Square in New York City, perhaps the very icon of what might be termed massive media. Critical theorist Marshall Berman, in his article 'Metamorphoses of Times Square', observes of the space that 'you have to tie yourself to some sort of inner mast in order not to be overwhelmed' (2001, 42). Whereas the traditional cinematic experience provides a mast in the form of a comfortable, standardised environment of spectatorship, the media city affords no such reliable reassurances or restraints. The exaggerated electronic forms of Times Square turn the city into the cinema, complete with lights, camera, and plenty of action. As Berman notes, 'Under the lights a whole new world could be born [...] the street itself is a form of living theatre; ordinary people on the street are performers as well as spectators' (ibid., 54). It is within this frenetic, frameless context that massive media experiences can be seen to operate, and in which their possibilities for the construction of new registers of space and identity are played out.

To aid in an understanding of such affective, fragmented, relational, and mediatised spaces, the concepts of the 'composite dispositif' (Verhoeff 2012), 'non-representational space' (Thrift 2008), the 'peripatetic' audience (Bennett 2009), and 'transversal' identity (Murphie 2004) will prove useful. First, composite dispositif describes a state of mediation in which standardised environments of spectatorship, such as the cinema, the city, or the interface of a smartphone, overlap and co-constitute a relational experience. This concept helps to provide a more nuanced and complex understanding of media as being semi-coordinated, filter-like, and personally constructed, based on access to various technical and visual interfaces (such as the city and mobile devices). Here, Verhoeff draws from both Michel Foucault (1980) and Jean-Louis Baudry (1975) in constructing her sense of what dispositif means. For Foucault, dispositif is used to describe a historically specific mixture of material and discursive practices that combine to contribute to some form of social control (i.e., a prison), while Baudry, following from Louis Althusser, uses the term to describe the conceptual arrangement that

interpellates the viewer into a certain subjectivity or point of view as a result of a coordinated technical apparatus. In cinema, this coordinated technical apparatus is the equipment, such as cameras, film, the theatre space, and other cinematic hardware required to produce various effects, namely the capturing and maintenance of the viewer's attention on the diegesis. For massive media, this technical apparatus might include elements of cinema, architecture, urban space, mobile technologies, and telecommunication. As such, the effects of massive media can be considered as composite, relational, and contingent mixtures of many technical assemblages and associated dispositif. For example, the coordinated effect of a heavily screened environment that includes elements of the media city such as urban screens and mobile devices that cater to an ambulatory spectator that is variously attracted and distracted by media (Verhoeff 2012, 104) might be described as a composite dispositif. Simply put, the composite dispositif describes a situation in which we are both captured and comforted, distracted and attracted, by the overlapping media layers that define relational space. This is an important concept when considered alongside Susan Bennett's concept of the 'peripatetic' audience of performance in public space which, she suggests, must be captured by embracing and supporting multiple, incomplete combinations of media forms (2009, 12).

Massive media also alludes to the possibility of expressing another concept of contemporary spaces known as 'non-representational' space (Thrift 2008). Nigel Thrift suggests that metaphors of cyberspace and information superhighways have challenged the ideation of what constitutes environments for experiences and action in contemporary life — of space. Thrift also focuses on *flow* as opposed to what he calls 'authentically achieved space' (2006, 141) existing outside of the of-the-moment flows of people and things in and through it. In this, he shares an affinity with Lefebvre in that he foregrounds action, performance, and flux in the production of space. Thrift's work also has parallels with Manuel Castells's notion of space as being the result of tensions between the 'space of flows' of the electronic age and more originary spaces — what he calls the 'space of places' (2001, 2002, 576). The inclusion (and incursion) of this 'space of flows', the electronic, computerised networks of telecommunications, into the 'space of places', the physical nodes of public squares, skylines, roads, neighbourhoods, and buildings — the lines, nodes, landmarks, and zones that Lynch (1960) describes in his *Image of the City* — is an important shift in how we conceptualise space. Spaces of places have become globalised through technological incursions, and spaces of flows are localised when substantiated through technology (such as screens, personal and public) in spaces of places.

Such a techno-social situation can be seen to produce what Andrew Murphie (2004) designates as 'transversal' subjectivities existing in many localities, or trans-locally. To understand the identity of a peripatetic entity as transversal within a composite dispositif in non-relational space is to understand it not as transcendent or fragmented, but as deeply enmeshed with other identities and locations via technologies of mediation. One phenomenon that demonstrates the way identity is expressed and performed transversally today is seen in the way different profiles may be acted upon on multiple websites for various purposes. Trans-local, transversal identity may also be produced through urban screens that are networked or participatory, once again, merging spaces of flows and spaces of places, generating complex hybrid spaces and publics.

Entering Supermodernism

Taken together, this transformation in what space is and how it is constructed points to a shifting architectonics of space, that is, the expression through architecture of the history, setting, and specificity of a site (Frampton 1983), one that continues to be shaped primarily by various visual media and the flows they engage and carry. To put a name to these changes, theorists have invoked terms such as super- (Ibelings 2002) or hyper- (Augé 1995) modernity. Supermodernism describes a design perspective focused on and inflected by the acceleration of technology in the design, creation, and reception of architecture, space, and the monumental. While these spaces might include the non-descript spaces of automated flow in the service of capital, such as airports and parking garages (according to Marc Augé), they also include architecture, such as the programmable tip of the Empire State Building, that enacts and embodies an information aesthetic (Manovich 2008) through specific and precise computer visualisations and animations.

As with attention and legibility, the digital can be both a blow and a boon to architectonics, depending on who you ask. Paul Virilio, writing somewhat exasperatingly yet presciently in the late 1980s, a time when the challenges and possibilities of the digital were just beginning to be felt, argues that the digital can sever our connection to the material and corporeal. Virilio sees the dawn of supermodernity as a distinct shock to the very principle of architectonics, and thus also to the ability 'to assert, describe, and inscribe reality' (1986, 18). He notes:

In fact, if architectonics used to measure itself against the scale of geology, against the tectonics of natural reliefs with pyramids, towers and other

neogothic structures, today it no longer measures itself against anything
except state-of-art technologies, whose dizzying prowess exiles all of us
from the terrestrial horizon (1986, 30).

One example might be the critique of architectural works such as Frank
Gehry's Bilbao Guggenheim Museum, criticised for semiotic and technical
overreliance on the algorithmic instead of purely architectonic considera-
tions. McQuire argues that 'Gehry's project utilised the computer not as a
tool for communication but as a technique of architectural mastery' (2008,
98), thus creating a structure that has a greater connection to the tools of
its conception than to site or audience specificity. What Virilio warns us of,
and what is demonstrated in Gehry, is the danger of a kind of technological
determinism in architecture and monumentality that ignores the discursive
potential of these new technologies for citizens.

Hal Foster argues that to make architecture more 'actual, grounded and
pragmatic' (2010, 136) we cannot ignore technology. Instead we need to find
ways to have it express the 'social real' (ibid., 136), which includes the traces
of culture, memory, and presence of the site and the people that populate
it. In many ways, this echoes the sentiments of the CIAM in their advocacy
for a greater connection to the emotions of people and the space(s) they
inhabit, as well as the critical, creative, and commercial thrust behind
massive media. For Foster, expressing the social real includes coming to
terms with what he calls our 'complicity in the culture of the image', meaning
that our buildings must work both as powerful images and as generators of
bodily affect, thus reflecting a shift in our thinking regarding the relation-
ship between architecture, mediation (technology, or image), and affect
(embodied experience). The opposition between the terrestrial plane upon
which buildings and bodies are measured, the plane of appearances (images
and buildings themselves), and the non-representational (information), is
continually collapsing and should be expressed and developed materially
in architecture and public space. One way to do this is to create 'urban
visualisations' with expressive architecture that are considerate of the
environment (surrounding buildings, local culture, atmosphere), content
(the information displayed and any interpretations that may be generated
by it), and carrier (the building, square, façade, or any other element that
supports the broadcast medium) (Vande Moere and Hill 2012; Vande Moere
and Wouters 2012). The proliferation of massive media might be evaluated
based on how well it is situated in a real-world environment (both borrowing
and contributing to it), how informative it is (whether it allows onlookers
to create meaningful insights or provide feedback), and if it provides a

useful civic function (is aesthetically pleasing while calling for some kind of reflection, change, or action).

Finally, as Hito Steyerl argues, our complicity in the culture of the image in general, but specifically through our changing hybrid surroundings, also calls to mind the importance of 'post-production' (quoted in Shental 2013) or the documentation, dissemination, and archiving that occurs officially and unofficially alongside the production of culture which can be seen to contribute to a supermodernism in architecture and culture. As Steyerl notes, 'We are embedded within a post-cinema that has been completely transformed, mutated into whole environments, permeating reality to the point that we can now understand it with media thought and alter it via post-production'. As an element of this supermodern condition of architecture, massive media may be seen as a conduit or catalyst for the circulation of images in that it contributes to a reality understood through remediation and the social recombination and distribution of images and media traces.

How this Book Works

Chapters Two, Three, and Four of this book focus on one of three related yet distinct subsets of massive media: moving images in large-scale public projection, data-responsive low-resolution façades or media architecture, and the curation and programming of massive media. Each chapter includes a number of case studies (Yin 2012) that are used as probes into particular contemporary instances of massive media. The case studies, which include site visits, participant observation, interviews with artists, designers, and cultural producers, close and distant readings of social media associated with various buildings-as-screens and their related events, and archival and historical research, where applicable, flesh out some inflections and possible trajectories of massive media, all in relation to a rich and varied history of media, space, and architecture. These chapters also include examples of creation-as-research (Chapman and Sawchuck 2012). Creation-as-research is a form of research-creation, the more general term for the integration of a creative process, experimental aesthetic components, or artistic work as part of a research work (ibid., 5). Actually making works of massive media has allowed me to struggle with the logistical, theoretical, and creative questions that surround this area of architecture, design, and culture, and to better articulate and critique it. In doing so, I have been inspired by the work of Matthew Fuller, who, commenting on the challenges of observing and understanding the imbrication of media and spatial assemblages, or

media ecologies, notes: 'to see how the world operates necessitates a more complex and involved participation in it' (2005, 106). In partly researching this book through creative works, I have designed, proposed, situated, and experienced the technics (Thain 2008), politics, and practices associated with massive media, using these experiences to augment analysis, critique, and theory. In this way, creation-as-research follows from Heidegger's thinking about 'praxical knowledge' (Smith and Dean 2009, 7) where ideas and theory are ultimately the result of practice. The five creation-as-research projects I present throughout the book include a number of large-scale public projections and public data visualisation installations, as well as a plan for curating massive media that I have put into practice and continues to evolve. These works provide a point of comparison against the case studies presented in the chapters, as well as a specific perspective on the artistic and curatorial use of massive media.

In Chapter Two, I investigate the narrative and associative potential of massive media with respect to moving images and monumentality, focussing primarily on Robert Lepage's *Le Moulin à Images* (or *The Image Mill*) (2008-2012), *McLarena* (2014) at the *Quartier des spectacles*, and two creation-as-research projects: *30 moons many hands* (2013) and *The Line* (2013). *The Image Mill*, presented in the lower town of Quebec City every night in the summer from 2008 to 2012, remains the world's largest outdoor projection to date. This nightly occurrence celebrated the 400th anniversary of Quebec City by presenting a mixture of archival footage, motion graphics, light, and sound on a 300m wide wall of grain silos in the lower harbour of the city. With purposefully dimmed street lights, the 'stadium' seating provided by the city's ramparts, and a radio signal that carried audio to viewers in hotel rooms surrounding the site, this presentation actively transformed not just one building, but an entire city into a cinema through a composite dispostif (Verhoeff 2012) centred upon its massive display (see Figure 1-5).

In addition to *The Image Mill*, I also consider *McLarena*, an interactive outdoor projection at the *Quartier des spectacles* in Montreal that incorporated the direct participation of its audience, as a comparative case study. Through conversations with the lead production designer of *The Image Mill*, a close reading of documentation (video and catalogue), producers' reflections about the project, and site visits to investigate both examples, I compare and contrast the approaches and outcomes of these large-scale outdoor projection-based installations and read them through the theoretical lenses of the public sphere, spectatorship, monumentality, and space as inflected by media. I argue that the expanded cinema of monumental projection places the moving image in a direct relationship

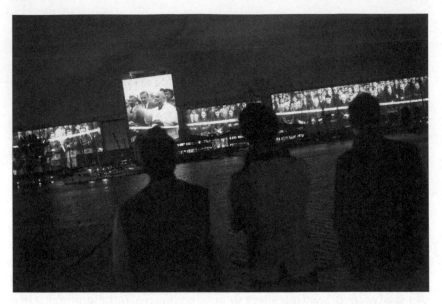

Figure 1-5: Robert Lepage / Ex Machina, *The Image Mill* (2008), Quebec City. Photo: Nicola-Frank Vachon (nicolafrankvachon.com), courtesy of Ex Machina.

with its surroundings, thus invoking an extra-diegetic, spatial montage with the city, multiplying contingency and ambivalence and thus extending the boundaries and characteristics of architecture and monumentality. I also argue that cinematic superimposition persists in large-scale public projection and is extended through the urban and architectural specificity of the substrate and situation in which it is presented. The architecture and affordances of massive media spectatorship mediate between space, people, and image, recentring audiences towards a confluence of bodies, the city, and discourses of memory. Taken together, the special effects of cinema taken outdoors transform the conditions of space, monumentality, and the public sphere, furnishing possibilities that range from 'dehistoricisation' (Crary 1999) to 'activated spectatorship' (Bishop 2004) in public spaces. In short, as buildings become screens, they become exhibition spaces for the relocation of cinema (Casetti 2015), a powerful technology/idea in itself that must be adapted and managed within public space to better engage site, audience, and architecture.

Building upon these principles, Chapter Three focuses primarily on low-resolution LED façades, highlighting their unique potential as public data visualisations and the implications of this more durable and architecturally integrated form of massive media. Specifically, I examine the narrative and associative potential of The Empire State Building. A structure that has a

long history of architectural lighting, the Empire State Building upgraded its lighting to a programmable LED façade in 2012 providing animation capabilities and greatly accelerating the rate at which the lights and the causes they represent are changed. As a case study, the building elucidates the connection between data-responsive low-resolution screens/buildings, monumentality, and space. The addition of programmable lighting extends its existing function as symbol and monument of the city by integrating it into a daily program that sees it oscillate from highly corporate advertising programs to the commemoration of a much more diverse set of functions, causes, affiliations, and events. These include displaying political campaign information in real-time, engaging in global campaigns of solidarity for causes such as climate change and anti-terrorism, celebrating sports teams, and presenting dynamic animations set to live music broadcast over the radio for the purposes of entertainment, all disseminated and circulated through various channels such as television and social media. A closer look at this particular assemblage, its history (and that of related structures such as weather beacons), the discourses associated with it, and the role that data visualisation plays on large, low-resolution façades, demonstrates the way such structures couple with concepts of supermodernity (Ibelings 2002), hybrid (De Souza e Silva 2006) and relational space (McQuire 2008), and 'new monumentality' (Mumford 2000, 151). Two research-creation projects, *In The Air, Tonight* (2014-), a project created for the LED façade of the Ryerson Image Centre and Ryerson School of Image Arts (RIC/IMA) in Toronto, and *E-TOWER* (2010), a project created for Toronto's CN Tower, further demonstrate that media architecture and public data visualisations, in their massive embodiment of data of shared consequence and the subsequent intensity of embodiment experienced by spectators and participants against the scale and significance of urban space, better reflect the development of a supermodernism (Ibelings 2002) in architecture characterised by the irruption and imbrication of the 'infoscape' and the cityscape. Data-rich public spaces of identity, congregation, and contestation seek and find appropriate and consistent outlets in highly visible, contingent, and ambivalent (McQuire 2008) spatial assemblages of architecture and media. I also argue that low-resolution media façades must be situated, informative, and functional while considering their carrier, content, and environment (Vande Moere and Wouters 2012; Vande Moere and Hill 2012) which should be expanded to consider on- and off-line spaces if they are to truly compliment 'smart city' initiatives. This means that they must not only cater to the whims of their hosts and the tech companies that furnish them with these systems, but begin with a consideration of their unique historical and social situation.

Finally, it is important to consider the role that curatorial support plays in guiding, developing, and fostering artistic experimentation and equitable opportunities for representation with massive media. Thus, Chapter Four looks at the roles and responsibilities of artists and curators in signalling the way forward in art and public culture through massive media. Here, I focus on two particular efforts to develop spaces, sites, and practices of massive media. The first is the EU funded group Connecting Cities, which aims to build up a worldwide connected infrastructure of media façades, urban screens, and projection sites to circulate artistic and social content. The second case concerns the New York-based Streaming Museum, an organisation that forms temporary partnerships with cultural and commercial centres to produce contemporary-themed art exhibitions on screens (including its website) and public spaces on seven continents. Through conversations with Susa Pop and Nina Colosi, key curators and producers from Connecting Cities and Streaming Museum respectively, and an examination of their curatorial methods and goals, I describe the careful selection and coordination of on- and offline sites and networks of production and presentation and the provision of experimental relational practices in diverse urban contexts that they employ. Exhibitions such as Streaming Museum's *Nordic Outbreak* which included works that circulated online and on seven continents, including a month-long multi-screen presentation of Björk's *Mutual Core* in Times Square, and Connecting Cities' *Binoculars to... Binoculars from...*, an extended voyeuristic feedback loop between multiple European public screen scenarios, provide examples of the curatorial challenges and opportunities of massive media with respect to access, audience, participation, spectacle, and scale. I augment this analysis by presenting an on-going research-creation project called RyeLights that seeks to open up the Ryerson Image Centre and Ryerson School of Image Arts (RIC/IMA) LED façade to greater artistic experimentation and community engagement through institutional change and the provision of technical protocols and support. Taken together, these studies indicate a broader shift in curatorial attention from autonomous artworks to curatorial networks, hybrid infrastructure, transfer protocols, technical specifications, and software packages that are particularly relevant to massive media. They also demonstrate that negotiations with corporate and civic entities are crucial in order to find solutions for artistic practices of massive media that are sustainable and suitably autonomous and representative.

The final chapter provides some concluding remarks and extends my analysis to suggest various tactics for artists, filmmakers, designers, architects, city planners, and arts administrators to support the critical and creative development of massive media. These include learning from the

affordances and risks associated with other media forms such as cinema, remaining persistent in creating sustainable and open technological, political, and social spaces for critical and creative uses of massive media, and using practice itself as a way to disseminate and spread these ideas and concepts. I also suggest that massive media be considered as an important infrastructural element within smart city and digital placemaking initiatives. Ultimately, the emergence of massive media — of buildings that are fast becoming extensions and focal points of screen networks, and thus, of social activity — necessitates a responsibility for harnessing complex technologies and the complexities of networked space for aesthetic critique, empathetic social connection, and societal change.

References

Arendt, Hannah. 1958. *The human condition*. Chicago: University of Chicago Press.

Augé, Marc. 1995. *Non-places: Introduction to an anthropology of supermodernity*. London: Verso.

Baudry, Jean-Louis. 1975. The apparatus: Metapsychological approaches to the impression of reality in the cinema. In *Narrative, apparatus, ideology: A film theory reader*, ed. Philip Rosen, 299-318. New York: Columbia University Press.

Benjamin, Walter. 1999. *Illuminations*. Trans. Harry Zorn. London: Pimlico.

Bennett, Susan. 2009. The peripatetic audience. *Canadian Theatre Review* 140(Fall): 8-13.

Berman, Marshall. 2001. Metamorphoses of Times Square. In *Impossible presence: Surface and screen in the photogenic era*, ed. Terry Smith, 39-69. Chicago: University of Chicago Press.

———. 1982. *All that is solid melts into air: The experience of modernity*. New York: Simon and Schuster.

Bishop, Claire. 2012. *Artificial hells: Participatory art and the politics of spectatorship*. London: Verso Books.

———. (ed.). 2006. *Participation*. London: Whitechapel.

———. 2004. Antagonism and relational aesthetics. *October*. 110: 51-79.

Brougher, Kerry. 2008. The cinema effect. In *The cinema effect: Illusion, reality, and the moving image*. London: Giles.

Casetti, Francesco. 2015. *The Lumière galaxy: seven key words for the cinema to come*. New York: Columbia University Press.

Castells, Manuel. 2001, 2002. Space of flows, space of places: Materials for a theory of urbanism in the information age. In *The city reader*, 3rd edition, ed. Richard T. LeGates and Frederic Stout, 572-582. London: New York. 2003.

Chapman, Owen, and Kim Sawchuk. 2012. Research-Creation: Intervention, analysis, and 'family resemblances'. *Canadian Journal of Communication* 37: 5-26.

Crary, Jonathan. 1999. *Suspensions of perception: Attention, spectacle and modern culture*. Cambridge, MA: MIT Press.

Deleuze, Gilles. 1992. Postscript on the societies of control. *October* 59: 3-7.

De Souza e Silva, Adriana. 2006. From cyber to hybrid. *Space and culture* 9(3): 261-278.

De Souza e Silva, Adriana and Jordan Frith. 2012. *Mobile Interfaces in Public Spaces*. New York, NY: Routledge.

Doane, Mary Ann. 2009. The location of the image: Cinematic projection and scale in modernity. In *The art of projection*, eds. Stan Douglas and Christopher Eamon, 151-166. Stuttgart: Hatje Cantz.

Foster, Hal. 2010. New monumentality: Architecture and public space. In *The real perspecta 42*, eds. M. Roman and T. Schori. Cambridge, MA: MIT Press.

Foucault, Michel. 1980. *Power/Knowledge: Selected interviews and other writings, 1972-1977*. New York: Pantheon.

Frampton, Kenneth. 1983. *Towards a critical regionalism: Six points for an architecture of resistance*. In *Postmodern culture,* ed. Hal Foster, 16-30. London: Pluto Press.

Fuller, Matthew. 2005. How this becomes that. In *Media ecologies: Materialist energies in art and technoculture*, 85-107. Cambridge, MA: MIT Press.

Giedion, Sigfried. 1944. The need for a new monumentality. In *New architecture and city planning*, ed. Paul Zucker, 549-568. New York: F. Hubner & Co.

Giedion, Sigfried, Leger, Fernand, and Sert, Jose Luis. 1958. Nine points on monumentality. In *Architecture, you and me, the diary of a development*, ed. Sigfried Giedion, 48-51. Cambridge: Harvard UP.

Gunning, Tom. 2007. To scan a ghost: The ontology of mediated vision. *Grey Room* 26(Winter): 94–127.

———. 1990. The cinema of attractions: Early film, its spectator and the avant-garde. In *Early cinema: Space, frame, narrative*, ed. Thomas Elsaesser with Adam Barker. London: British Film Institute.

Habermas, Jurgen. 1989. *The structural transformation of the public sphere: An inquiry into a category of bourgeois society*. Cambridge, MA: MIT Press.

———. 1974. The public sphere: An encyclopaedia article (1964). *New German Critique* 3: 49-55.

Hansen, Miriam Bratu. 1993. Unstable mixtures dilated spheres: Negt and Kluge's the public sphere and experience, twenty years later. *Public Culture* 5: 179-212.

———. 1995. America, Paris, the Alps: Kracauer (and Benjamin) on cinema and modernity. In *Cinema and the invention of modern life*, eds. L. Charney and V.R. Schwartz, 362-402. Berkeley, CA: University of California Press.

Harbord, Janet. 2007. *The evolution of film: Rethinking film studies*. Cambridge: Polity.

Hardt, Michael. 2009. Production and distribution of the common: A few questions for the artist. *Open* 16. Accessed April 7, 2018. https://onlineopen.org/download.php?id=46.

Henkin, David M. 1998. *City reading: written words and public spaces in antebellum New York*. New York: Columbia University Press.

Huhtamo, Erkki. 2003. *Illusions in motion: Media archaeology of the moving panorama and related spectacles*. Cambridge, MA: MIT Press.

Ibelings, Hans. 2002. *Supermodernism: Architecture in the age of globalization*. London: NAi Publishers.

Keromnes, Chloe. January 9, 2015. L'Arc de Triomphe s'illumine des mots 'Paris est Charlie' – RTL. *RTL*. Accessed April 7, 2018. http://www.rtl.fr/actu/societe-faits-divers/l-arc-de-triomphe-s-illumine-des-mots-paris-est-charlie-7776159636.

Kracauer, Siegfried. 1965. *Theory of film; the redemption of physical reality*. London: Oxford University Press.

Lefebvre, Henri. 1997. The monument. In *Rethinking architecture: A reader in cultural theory*, 133-137. London: Routledge.

———. 1991. *The production of space*. Oxford, UK: Blackwell.

Lynch, Kevin. 1960. *The image of the city*. Cambridge, MA: MIT Press.

Lynton, Norbert. 2009. *Tatlin's Tower: monument to revolution*. New Haven, CT: Yale University Press.

Manovich, Lev. 2008. Introduction to info-aesthetics. Accessed April 7, 2018. http://manovich.net/content/04-projects/060-introduction-to-info-aesthetics/57-article-2008.pdf.

McQuire, Scott. 2008. *The media city: Media, architecture, and urban space*. London: Sage.

Media Architecture Institute. 2015. About. *Media Architecture Institute*. Accessed April 7, 2018. http://www.mediaarchitecture.org/about/.

Moholy-Nagy, Laszlo. 1969. *Painting, photography, film*. London: Lund Humphries.

Mumford, Eric Paul. 2000. *The CIAM discourse on urbanism, 1928-1960*. Cambridge, MA: MIT Press.

Murphie, Andrew. 2004. The world as clock: The network society and experimental ecologies. *Topia: Canadian Journal of Cultural Studies* 11: 117-138.

Nora, Pierre. 1989. Between memory and history: Les lieux de mémoire. *Representations* 26(Spring): 7-24.

Rancière, Jacques. 2000. *The politics of aesthetics*. Trans. Gabriel Rockhill. London: Continuum.

Rokeby, David. 1995. Transforming mirrors: Subjectivity and control in interactive media. In *Critical issues in electronic media*, ed. Simon Penny, 133-158. Albany, NY: SUNY Press.

Rowell, Margit. 1978. Vladamir Tatlin: Form/Faktura. *October*, 7: 83-108.

Rowlands, Michael, and Christopher Tilley. 2006. Monuments and memorials. In *Handbook of material culture*, ed. Christopher Tilley, Webb Keane, Susanne Küchler, Michael Rowlands and Patricia Spyer, 500-516. London: SAGE Publications Ltd.

Shental, Andrey. 2013. In the junkyard of wrecked fictions. *Mute*. 14 May. Accessed July 4, 2014. http://www.metamute.org/editorial/articles/junkyard-wrecked-fictions.

Simmel, Georg. 1950. The metropolis and mental life. In *The Sociology of Georg Simmel*, trans. Kurt Wolff, 409-424. New York: Free Press.

Smith, Hazel and R. T. Dean. 2009. *Practice-led research, research-led practice in the creative arts*. Edinburgh: Edinburgh University Press.

Taylor, Diana. 2007. *The archive and the repertoire: Performing cultural memory in the Americas*. Durham, NC: Duke University Press.

Thain, Alanna. 2008. Affective commotion: Minding the gap in research-creation. *INFLeXions* 1: 1-12.

Thrift, Nigel. 2008. *Non-representational theory: Space/politics/affect*. New York: Routledge.

Vande Moere, Andrew, and Hill, Dan. 2012. Designing for the situated and public visualization of urban data. *Journal of Urban Technology* 19(2): 25-46.

Vande Moere, Andrew, and Wouters, Niels. 2012. The role of context in media architecture. ACM *Symposium on Pervasive Displays* (PerDis'12), ACM. Article 12.

Verhoeff, Nanna. 2012. *Mobile screens: The visual regime of navigation*. Amsterdam: Amsterdam University Press.

Virilio, Paul. 1986. The overexposed city. *L'espace critique* (Paris: Christian Bourgeois, 1984); translated in Zone 1-2 (New York: Urzone, 1986), trans. Astrid Hustvedt: 14-31.

Warner, Michael. 2005. *Publics and counterpublics*. New York: Zone Books.

Wodiczko, Krzysztof. 1999. *Critical vehicles: writings, projects, interviews*. Cambridge, Mass: MIT Press.

Yin, Robert K. 2012. *Applications of case study research*. Thousand Oaks, CA: SAGE.

Youngblood, Gene. 1970. *Expanded cinema*. New York: Dutton.

2. Large-scale Projection and the (New) New Monumentality

Abstract

The use of the moving image in public space extends the techniques of cinema — namely superimposition, montage, and apparatus/dispositif — threatening, on one end of the spectrum, to dehistoricise and distract, and promising to provide new narrative and associative possibilities on the other. These techniques also serve as helpful tools for analysis and practice drawn from cinema studies that can be applied to examples of the moving image in public space. Case studies and creative works are presented in order to examine and illustrate the ways that public projections extend the effect of superimposition through the rehistoricisation of space, expand the diegetic boundaries of the moving image through spatial montage, and enact new possibilities for the cinematic apparatus and dispositif through scale and interaction in order to reframe and democratise historical narratives and scripts of urban behaviour.

Keywords: architecture, dispositif, montage, superimposition, digital projection

Moving Images

In the summer of 2008, Quebec City became the site of the world's largest architectural projection: a 45-min long projection-mapped spectacle covering 400 years of settlement, development, and culture dating back to when the city was first founded as a French colony. For approximately 60 nights every summer, from 2008 until 2012, street lights were dimmed and people would gather on the docks, along the ramparts, or in hotel rooms around the city to witness an iconic building, the massive BUNGE grain silos in Quebec City's harbour, tell the story of this UNESCO world heritage site (UNESCO 2014). With each screening attracting about 10,000 spectators, *Le Moulin*

Colangelo, D., *The Building as Screen: A History, Theory, and Practice of Massive Media*. Amsterdam: Amsterdam University Press, 2020

DOI 10.5117/9789462989498_CH02

Figure 2-1: Robert Lepage / Ex Machina, *The Image Mill* (2008), Quebec City. Photo: Nicola-Frank Vachon (nicolafrankvachon.com), courtesy of Ex Machina.

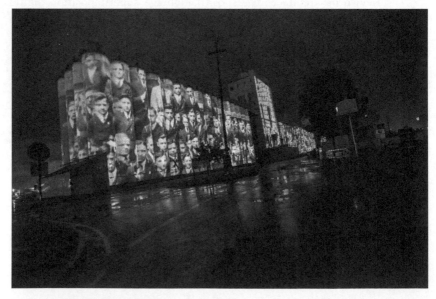

Figure 2-2: Robert Lepage / Ex Machina, *The Image Mill* (2008), Quebec City. Photo: Nicola-Frank Vachon (nicolafrankvachon.com), courtesy of Ex Machina.

à Images (The Image Mill) by director Robert Lepage and his team at Ex Machina (see Figure 2-1 and Figure 2-2) was seen by about half a million people every year (Dubé 2012, 187).

The *Quartier des spectacles* in Montreal represents another approach to the presentation of historical material in public space through large-scale projection. One particular installation, *McLarena* (2014) (see Figure 2-3), an interactive public projection commissioned by the National Film Board of Canada, invited participants to mimic the choreography of the dancer that appears in renowned Canadian filmmaker Norman McLaren's *Canon* (1964) in a mobile recording unit located in front of the projection. These images were presented in the style of McLaren's film on the façade of a building outside the Saint-Laurent metro station.

In this chapter I use historical research, site visits, participant observation, and close readings of documentation, press clippings, and literature related to both *The Image Mill* and *McLarena* in order to build a case for the critical and creative use of large-scale applications of the moving image. I argue that public projections can change and challenge concepts of space, monumentality, and the public sphere, instituting a more participatory, moving image-centred public culture in which we identify and engage with collective presence, memory, and action through information, architecture, and the moving image. I demonstrate the ways that an expanded cinema, one that merges both the logic of the monument and the logic of media and the spaces of flows and spaces of places that Castells spoke about, unlocks narrative and associative potentials for the moving image and public space. Two research-creation projects — *30 moons many hands* (2013) and *The Line* (2013) — help to operationalise these theories while describing the ways that massive media can enable urban activism and debate, and new telematic rituals that straddle the critical, affective, and commercial. I also describe how institutional ideologies limit artistic autonomy as well as the development of audiences, sites, and access — the development of spectatorship, historical discourse, and a public sphere based on the communal, large-scale moving image. Finally, I argue for the importance of repetition and semi-permanence that allows for greater syncretism to site and memory of situated, historical information presented through massive media that can help to develop a new 'new monumentality'.

In this chapter, I argue that the transformation of buildings into screens contributes to the production of hybrid (De Souza e Silva 2006) and relational (McQuire 2008) spaces by focussing on three key elements of moving image culture and production: superimposition, montage, and dispositif/apparatus. These concepts are mined for their affective efficacy in massive media

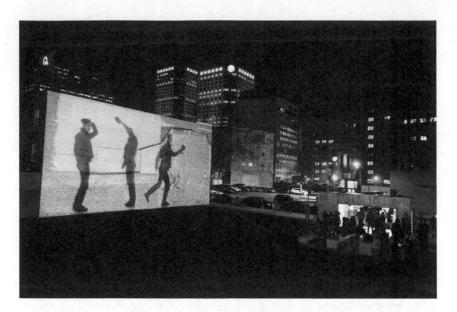

Figure 2-3: Daily tous les jours, *McLarena* (2014), presented during the event McLaren
Wall-to-Wall, *Quartier des spectacles,* Montreal. Photo: Martine Doyon, courtesy
Quartier des spectacles Partnership and the National Film Board of Canada (NFB).

instances while also stretched and transformed in their unique application
in public space. The expanded cinema of monumental projection places the
moving image in a direct relationship with its surroundings, thus invoking
an extra-diegetic, spatial montage with the city, multiplying contingency
and ambivalence, and thus extending the boundaries and characteristics
of architecture and monumentality. Spatial montage considers the moving
image with the contingent spaces around it — with the city — and creates
new contingent semiotic reference points in a what equates to a massively
expanded building and city-scale cinema. I argue that superimposition, an
effect of cinema that serves to complicate ontological conditions, layering
worlds and meanings on top of one another, persists in large-scale public
projection and is extended through the urban and architectural specificity
of the substrate and situation in which it is presented. Finally, and perhaps
most importantly, the key considerations of apparatus and dispositif form an
enduring touchstone for the experience and effect of technical assemblages
in the service of certain affects and ideological discourses which range from
the democratic to the commercial. The new architectures and affordances
of massive media spectatorship mediate between space, people, and image,
recentring audiences towards a confluence of bodies, the city, and discourses

of memory. Taken together, these special effects of cinema taken outdoors create a composite dispositif (Verhoeff 2012) that helps to transform the conditions of space, monumentality, and the public sphere, furnishing possibilities that range from 'dehistoricisation' (Crary 1999) to 'activated spectatorship' (Bishop 2004) in public spaces. Massive media can produce public spheres characterised by an oscillation between fragmentation, cohesion, conflict, and commercialisation, and new registers of monumentality (Mumford 2000) that are intended to better reflect contemporary social and community life and more effectively capture and transfer power, memory, and connection. The application of media to architecture in the form of large-scale, (sometimes) interactive moving images reflects a shift towards a more participatory, moving image-centred public culture in which we identify with collective presence and memory through the moving image.

A Short History of the Moving Image in Public Space

The application of the ephemeral moving image in public space has always left an impression. In a particularly telling example, in a letter home to his family, Sigmund Freud describes his visit to Rome's *Piazza Colonna* (see Figure 2-4) in 1907, a site that had been transformed for him due to an early foray into outdoor projection. In the centuries-old square, Freud witnesses 'lantern slides', 'short cinematographic performances', and advertisements projected on a screen at the end of the piazza (Crary 1999, 363). In a letter, written in his room later that evening, Freud is unable to recall if the piazza contained a fountain, nor does he mention the significance of the monumental column for which the space is named. Freud is, in his own words, 'spellbound' (ibid., 370) in front of the cinematograph and unable to recall additional information about the space. Crary argues that Freud's amnesia suggests public projection is a harbinger of 'a dehistoricised perpetual present' (ibid., 369), dulling the ability to recall or engage with anything beyond the moving image as it subsumes its audience.

This effacement by way of moving images in public space was seen to continue throughout the twentieth century. Electrification throughout the twentieth century transformed the surfaces of the city into mutable, oneiric, 'formless fields of attraction' (Crary 1999, 468) that often had an effect of distraction and dehistoricisation for the purposes of pleasure and persuasion. Hubs of public moving image culture, such as New York's Times Square and London's Piccadilly Circus, became sites of performance, spectacle, pleasure, and disorientation (Berman 2001). They were scenarios

Figure 2-4: Illustration of the *Piazza Colonna*, Rome.

for directing attention that merged the cinematic with the architectural in monumental proportions to produce novel effects that complimented manipulative rituals related to the consumption of objects, images, and spaces.

The effect that Freud experiences and Crary describes is consistent with, and perhaps predicated upon, the general effect of cinema observed by early theorists of cinematic reception. Cinema, no matter where it is located, is built to create powerful, affective responses. Siegfried Kracauer (1965), in *Theory of Film*, argues that film's ability to record 'reality' reveals hidden aspects of reality or aspects located in other places. Rendering this reality once again in motion is precisely what captivates an audience and acts as a unique and powerful physiological stimulus. In this way, film is like an object of prey and we are its predators, releasing our animalistic tendencies in noticing and fixating on moving objects. Film increases the demand on the spectator's sensorium as a result and produces distracted attention, innate curiosity, and an openness to sense impressions.

In a more contemporary example, an openness to sense impressions by way of cinema was exploited on the banks of the Thames in London in November of 2011. Looking for a way to direct people's attention to their new Lumia 800 smartphone, telecommunications giant Nokia used 16 outdoor

projectors to illuminate the Millbank Tower, creating a 120 metre high projection-mapped spectacle synchronised to a live DJ set by electronic music artist deadmau5. Thousands came out to the event while documentation circulated on the Internet through social media and blogs in the weeks following.[1] The content of the presentation consisted of geometrical shapes and patterns pulsating to the music and graphic visualisations on the building that referenced a virtual, electronic world, paying little attention to the site and surroundings and thus lending some credence to Virilio's (1986) fears that technology might tend to estrange us from our terrestrial surroundings. The attention generated by the visceral moving images and sound created a collective unity amongst those present at the event yet engaged in a monumentality through the moving image channelled not towards a historical consciousness but towards the valorisation of a new consumer product. This was not a site of memory where collective memory 'catalyses and secretes itself' (Nora 1989, 7), per se, but a site of syncretic co-optation by capital. It was, like the *Piazza Colonna*, a 'formless field of attraction' that 'dehistoricised' the space (Crary 1999) by tapping into the affective response generated by the moving image.

Yet, an openness to sense impressions by way of the application of the moving image to architecture need not be deterministic nor distracting from real historical conditions of a place or people. Sometimes, distraction is necessary, as Debord (2009) famously argues, to unsettle and unmask capitalist spectacle. Furthermore, dehistoricisation and distraction are not necessarily detrimental to historical consciousness nor are they the only outcome of the layering of flickering images and architecture. The ambivalence and contingency created by the moving image, as McQuire (2008) notes, can create a relational space pregnant with rhetorical possibilities. The work of Jenny Holzer, whose *Truisms* (such as 'MONEY CREATES TASTE') have among other formats been presented as large, high-contrast architectural projections (see Figure 2-5), and the participatory digital graffiti of Graffiti Research Lab that allowed people to 'tag' a public façade through a combination of lasers and digital projection, are two examples that demonstrate public projection as a powerful tactic for dissent and dissensus, and for contesting a politics of representation and any access issues inherent in public space through the affect and attention they generate by way of the moving image. By destabilising and semiotically scrambling a sedimented mode of address — in this case, advertising and/or architecture — these

1 Almost 6 million people have viewed the official Nokia YouTube video of the event to date. www.youtube.com/watch?v=SX2Gd-kqV5s.

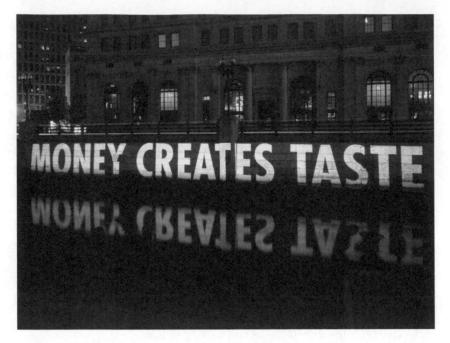

Figure 2-5: Jenny Holzer, *Money Creates Taste* (2006), Providence, RI. Photo: Erik Gould, courtesy Jenny Holzer / Art Resource, NY.

artists attempt to counter the foreclosure of space and place by bureaucratic and capitalistic powers. Both works respond to the perceived loss of the public sphere: one by shouting louder, shining brighter, and doing so in more unexpected places than advertisements, the other by temporarily enabling participation, play, and protest at an architectural scale.

Another example, Krzysztof Wodiczko's *The Tijuana Projection* (2001), involved the projection of video feeds of the faces of abused and exploited women from the local *maquiladora* industries on the façade of Tijuana's largest art gallery (see Figure 2-6). Employing public projection to draw attention to traumas that affect entire cities, Wodiczko confronts viewers in order to spark important ongoing processes of social justice which, according to the artist, must be a collective and compassionate endeavour. The collective that forms around a public building, in a public space, becomes a public enunciation in itself: it is part and parcel of the work of public projection. Wodiczko calls this the 'outer public', noting that 'fearless speaking' requires 'fearless listening': 'public truth-telling (testimony) and public truth-seeking (witnessing) are interdependent' (2015). To stop, watch, and participate in such events implies complicity with the disruptive image and support of its alternative message. It creates the potential for what Arendt calls a 'space of

Figure 2-6: Krzysztof Wodiczko, *The Tijuana Projection* (2001), Public projection: Centro Cultural de Tijuana, Mexico. Photo: courtesy Galerie Lelong & Co., New York © Krzysztof Wodiczko.

appearance' where speech acts are fostered and displayed in a 'public realm' (1958, 198) created by and for such acts. In other words, these projections are rehistoricising; a reinvigoration of a public sphere that challenges what can be said, by whom, and at what scale and level of authority. It engages a politics of aesthetics through a new 'distribution of the sensible' (Rancière 2000) made more diverse through the transformation of space and building into screen.

While the lack of durability of these images may be seen to take away from their power, Wodiczko argues that ephemerality does not necessarily diminish the impact of these works. As Wodiczko notes (Phillips 2003), a projection, when witnessed by a public, becomes a stain, a mark, a trace upon the memory associated with the building, its surroundings, and the various groups it incorporates and addresses. Furthermore, these works, including documentation of the crowds that surround them, are often captured and disseminated in books, online, and increasingly in social media, thus legitimising the gravity of the struggles (or products) highlighted by these events and bolstering their perceived impact. With the Nokia example, documentation was carefully choreographed and created as part of the event, zooming into the crowd taking their own video of the event on their Nokia phones, then to the DJ, and back out across the river to show the giant mobile phone-shaped building 'dancing' along with

the crowd and the music. This footage was posted on various websites and on YouTube, extending the life, reach, and legitimacy of the event, exemplifying what Hito Steyerl refers to as a culture of 'post-production' (quoted in Shental 2013) where images (and architecture as image) are valued in their ability to circulate and be acted upon. In this instance, the tactics of the commercial world and the art world are indecipherable: they share the same spaces both on- and offline to generate and disseminate their messages. The stain that Wodiczko refers to spreads and mutates with new technologies of image circulation, regardless of the content. The recursion between the stain in memory, the story and image of documentation, and post-production modification is a large part of what legitimises the massive efforts required to produce ephemeral commercial and counter-monumental displays.

A succession of images that implies motion can captivate and confound us, catching us in our tracks, compelling us to appropriate it or buy into its message. In a large outdoor projection, the image that sticks to a place in space *and* a space in memory (individual, collective, and virtual), can create new dimensions of the public sphere in which plurality, collectivity, and memory are contested. While space can be rehistoricised in this context, it can also become dehistoricised, commodified, aestheticised, and commercialised, including the image or brand of the city itself. Massive media in the form of public projection represents a new battleground where the power of the 'deposit of a memory trace' (Lynch 1960, 119) via architecture is called into question and redefined in hybrid urban environments, making cities more (or less) public.

Architecture, Expanded Cinema, and the New Monumentality

The experiments and effects of the juxtaposition of architecture and the moving image can also be traced through a lineage that includes the panorama, expanded cinema, installation art, and display culture. As an early precedent, moving panoramas of the late 18th and early 19th centuries shaped an emerging mediated and embodied visuality by presenting historical events, landscapes, or city vistas via circular paintings (Schwartz 1995) that unfurled before spectators. These works were aimed at making viewers feel as though they were physically present in a particular scene. Vanessa Schwartz notes that 'The panorama's realism hinged on the notion that, to capture life, a display had to reproduce it as bodily, and not merely as visual, experience' (1995, 311). Further developments in embodied visuality

Figure 2-7: Charles and Ray Eames, *Glimpses of the USA* (1959), installation view, Moscow. Photo: © Eames Office, LLC (eamesoffice.com).

can be seen in the multi-screen experiments and expanded cinema of Charles and Ray Eames. Their work showed how the moving image might be integrated and integral to architectural and spatial experience for expository purposes. With *Glimpses Of The USA* (see Figure 2-7), the Eameses created a multi-screen expanse within the American pavilion at the American National Exhibition in Moscow in 1959 (Colomina 2009). Situated within a Buckminster Fuller designed geodesic dome and presenting images of highways, bridges, homes, and subdivisions across seven screens spanning approximately four football fields, along with narration and music, the Eames's 'screen field' gained much of its monumental impact from its immensity and the interrelationship of multiple images within a space, reinforcing claims of mastery over nature, progress, good design, and culture. It showed the breadth of the technical prowess of the nation within a wider frame of an equally impressive architectural space.

The Eameses demonstrated the importance of the relationality between and outside image surfaces that an architectural juxtaposition of moving images affords. Gene Youngblood (1970) refers to this as expanded cinema, a term that he helped to popularise, where that which lies beyond the frame is included within a multisensory experience that potentially liberates new degrees of creative freedom. In the case of the Eames's work, as well as Wodiczko's projections, the elements outside the picture plane include

architectural and civic infrastructure, the presence of the crowd, as well as the location itself and its historical content. Much like the monument, which exchanges power and meaning with its surroundings (Lefebvre 1997), architectural expanded cinema allows for an exchange between moving images and relatively static but no less meaningful surroundings, while also explicitly acknowledging and incorporating the presence of the spectator: it makes cinema more public.

While *Glimpses* illustrated an idealistic expansion of the possibilities for creativity and an expansion of the human sensorium, there was a sense that the expansion of cinema into multi-screen environments was more than just a creative expansion: it was also potentially democratic. Following from Bishop (2012), it could be seen as an artistic equivalent of a political position. For example, Bauhaus pioneer Herbert Bayer's exhibition design for Edward Steichen's *Family of Man* (1955) at the Museum of Modern Art in New York City employed multiple panels, sizes, and angles of text and imagery in the hopes of developing an 'extended field of vision technique' (Turner 2012, 83) that would train viewers to adjust their consumption of images and space providing a so called 'democratic' means for the viewer to recombine and digest information. The format of the exhibition was such that viewers were to be exposed to a spatial breadth and depth of sensory material and create associative meanings of their own across spatial arrangements, essentially creating their own non-deterministic montage from the expanded apparatus of exhibition. This echoed Moholy-Nagy's (1969) arguments about the importance of multi-sensory stimulation for the development of perceptual capacity that the expanding metropolis of the early twentieth century was also providing (and requiring) of its inhabitants. Instead of combatting the purported overstimulation, disconnection, and distraction observed by Simmel (1950) and Crary (1999), Bayer, like Moholy-Nagy, embraced contingency and ambivalence in spatial design in the hopes of creating a new political position for spectators — a new register for a public sphere — that was more open, heterogeneous, unpredictable, and potentially contradictory (Hansen 1993) so that a more nuanced and personal way of knowing the world might be achieved.

The democratic forms suggested by Bayer and the Eameses begin to gesture towards a greater integration of an activated spectatorship with media for democratic and emancipatory purposes. This trajectory, particularly with respect to monumentality, can be seen to have its roots in the writing of Bauhaus architectural pioneers including Sigfried Giedion. Writing in 1944, he asserted that architecture, and in particular monumentalism, had

stagnated, or even worse, was failing to respond to the 'popular needs and aspirations' (Mumford 2000, 151) of its time. Collective identity, he argued, was not being served by existing sites of memory. The 'static immortality' of a world of statue-topped plinths, gothic cathedrals, and the like, did little to reflect contemporary life and the dynamism better embodied in architectural and artistic movements of the day such as cubism, modernism, and futurism. Giedion wondered how monumentality, which by defini-tion was a marker of the condensation and transfer of power and memory (Lefebvre 1997) and which could 'seldom be used and then only for the highest purpose' (Giedion 1944, 500), might be better directed towards 'the life of the community' (ibid., 550). While his suggestions lack specifics, they remain prescient nonetheless. For Giedion, monuments 'should be the site for collective emotional events, where the people play as important a role as the spectacle itself, and where a unity of the architectural background, the people and the symbols conveyed by the spectacles will arise' (568). Out of this, he called for a 'new monumentality' (Mumford 2000, 151) that would restore the connection between citizens and their surroundings that had been lost in the decidedly un-dynamic legacy of monuments, a kind of total media environment of memory — a democratic surround (Turner 2013) in public space. The continued expansion of the application of moving images in public space at architectural scales and monumental settings can be seen as an inspired extension of Giedion's enduring questions and worthy of consideration against his lofty claims. The parallels between the potential and perils of mixing moving images, space, and monumentality described above provide a historical lens and lineage through which to understand current experiments in massive media such as *The Image Mill* and *McLarena* at the *Quartier des spectacles*.

The Image Mill

Alternatively described by its creators and spectators as akin to fireworks, an art book, outdoor cinema, or even a 'kinetic mural' (Dubé 2012, 177), *The Image Mill* (2008-2013) remains the largest 'monumental projection show' (Mario Brien, February 9, 2014, phone call with the author) ever made, beating out the previous record set by a 300m wide projection on the Egyptian pyramids (Blatchford 2008). The technical specifications are impressive: 600m wide, 50m high, 40,000,000 pixels (EX MACHINA 2015), 30 video projectors, 30 video servers, 250 lighting devices, 24 fog machines, 50 switches and programmable controllers to dim the street lamps around

the site, 350 speakers, 50 subwoofers installed beneath the docks, and 20km of fibre optics for video, lighting, and sound (Lepage 2011). Spanning the equivalent of 25 IMAX screens (The Canadian Press 2008), *The Image Mill* was a massive media spectacle that incorporated light, sound, and architecture to tell the story of Quebec City on its 400th birthday, effectively turning a building into a screen and a city into a cinema.

The content of *The Image Mill* covered various stages of the city's development with the silos transforming into the maps of early explorer Samuel de Champlain, impressionistic scenes of important battles and rapid technological growth, and various cultural touchstones such as a catholic church and the Quebec Bridge. The show begins with images and sounds that make the silos appear as if they are rotating, churning together the images that will cover its surface for the 45 minutes that follow. The sounds of machinery, steam, and whistles recorded from inside the silo can be heard, as Robert Lepage (2011) says, 'to give it its own sound, as if it is the building telling its own story'. The gears turning also take the viewer back in time, until there is a pervasive darkness except for the twinkling night sky covering the entire surface, as if to make Ezra Pound's claim that with the modern, illuminated city 'we have pulled down the stars to our will' (Quoted in Kenner 1975, 5) as literal as possible. The silence and stillness are broken by a Pink Floyd-esque soundtrack that propels us through images of previous projections — geographic and cartographic — that allowed travellers such as Samuel de Champlain to reach these once foreign shores. Wooden fences rise up across the surface, referencing the wooden palisades and Jesuit forts built just a few hundred metres from the projection site. On the larger tower block that interrupts the long string of silos, we see central figures such as Louis XIV who reigned over both France and New France, establishing a royal government and a settlement policy. The story moves through impressionistic accounts of the St. Lawrence River cracking open in the spring, the importation of the first horse and the acceleration of cultural and technological change, and the rituals and beliefs of the catholic church. The building becomes a tableau of votive candles — luminescence mimicking luminescence once again, except this time making a small thing very large — with the sound of church bells ringing in the distance, signifying a new rhythm to daily life. As the diegesis takes us forward through history, we witness early battles between the British and French, the presence of First Nations, the mixing of cultures, and the development of fine art and architecture that reshaped the city. We see fences, arches, and bridges, such as the Quebec Bridge which counted Gustave Eiffel as one of its contributing consultants,

itself a marker of increased circulation, movement, and commerce. A plane flies across the building and it transforms into a ruled line of illuminated numbers: the building becomes a massive radio. According to Lepage (2011), we hear 'opinions, ideas, expressing the idea that Quebec is becoming a modern city'. The exposition uses a great deal of repetition and pattern, mostly because it is impossible to take in the entire screen at once unless one is up on the ramparts of the city or in a hotel room quite some distance away. There is no privileged viewing position: if one is up close one might experience the bass of the subwoofers under the dock but will not be able to see the entire panorama. If one is far away, one will have to contend with a less impressive radio broadcast of the audio but be able to see the entire projection situated amongst the rest of the city. What unites the viewers in the end is the city below their feet and the massive image that recentres their bodies and eyes.

The images speed up, mimicking revolutions in technology and culture: a library shelf is filled, x-rays are performed, and 'tiller girls' (Kracauer 1995) grace the cabarets. The silos become a huge piano, with a total of eight hands dancing across the keys, playing a single harmonious tune. A public demonstration takes over the building, which morphs into a hockey fight, becomes a large highway traffic sign, then a stock ticker, and finally a heart rate monitor indicating the beating heart of the city disrupted by a traumatic event, the shooting that took place at the Quebec National Assembly in 1984. The city is united in a symbolic death and rebirth. It then becomes a huge screen for a video game, a nod to the strength of the special effects and tech industry in Quebec, then graffiti. As the story winds down, we see images referencing the new airport and cruise ship terminal in the city, part of a further opening up and circulation of people and culture in the city. A searchlight turns on atop the projection and real smoke emerges from the building while the image of a cruise ship floats below. Fireworks are projected, a nod to the kind of light shows that usually commemorate such civic anniversaries. Next, a cheering crowd appears like one would expect at a theatre or outdoor concert, reflecting the city in that very moment back on itself. This image recedes, a vault is closed, and the building fades not to black but back to itself, lit modestly and appearing once again like a sleeping giant in the harbour.

The Image Mill transforms a building into a screen. As such, as I will expand upon and argue in the sections that follow, it represents the way that massive media constructs ambivalent and contingent spaces and suggests a 'new monumentality' through three specific characteristics of cinematic media: superimposition, montage, and dispositif/apparatus.

Superimposition and Massive Media: Super Imposing

The pure art of cinema exists almost exclusively in the use of superimposition
(Youngblood 1970, 87).

According to Tom Gunning, superimposition is the 'incongruous juxtaposition' of images in film that 'yields an eerie image of the encounter of two ontologically separate worlds' (2007, 6). In Hitchcock's work, as with when a skeleton is superimposed with Norman's face in final shots of *Psycho* (1960), this might serve the purpose of revealing some internal state, an aspect of memory, or connect the action to another space or time. Of course, these superimpositions occur within the physical and conceptual limits of the frame, the diegetic space in the cinema. The superimpositions in *The*

Figure 2-8: *The Image Mill* (2008) and adjacent 'amplified area'. Google Earth screenshot. Google and the Google logo are registered trademarks of Google LLC, used with permission.

Image Mill, and in architectural projections in general, enact these same possibilities while extending the potential for ontological hybridity and narrative and creative expansion beyond these limits.

The Image Mill used visual, tactile, and sonic superimpositions to open up new narrative and associative potentials that serve to rehistoricise its location and create affective responses from its urban audience. Sounds emanating from speakers in a dedicated 'amplified area' (see Figure 2-8) between the Old Port Market, Dalhousie Street, and Quay St-André Street across from the silos linked a certain quality of sound to a place (the sounds from within the silos, the nostalgic songs that were once played on the radio), and 'The Mill Frequency 97.5' accommodated radio listeners within the viewing radius created by the projection and the stadium-like setting of the city. The producers of *The Image Mill* added another dimension, tactility, in the form of the subwoofer vibrations that shook the dock across from the silos where many spectators congregated for the show. As horses raced across the projection surface, then trains, and later automobiles, viewers could feel the change of pace in culture created by the vibrations of the viewing area and imagine a time when these vibrations were real instead of virtual. Coordinated visual, tactile, and spatial superimpositions in *The Image Mill* like this were specifically designed to create a bridge between history, space, and memory. The ships projected onto the massive grain silos also matched the scale of the actual ships in the harbour, creating moments of misrecognition that tied two times to one place. Towards the end of the show, a searchlight emanated from the top of the projection and real smoke emerged from the building while the image of a cruise ship floated below, again, inching asymptotically closer to a unity of space and image. Finally, at the close of the presentation, a cheering crowd appeared like one would expect at a theatre or outdoor concert creating a mirror effect, reflecting the city and the importance of the presence of the audience in that very moment back to themselves.

With this expanded sense of superimposition, the public monumental projection of *The Image Mill* created an encounter between 'ontologically separate worlds' (Gunning 2007, 2), that of the expansive moving image space, the cinema, and the city, thus mixing the times, spaces, characteristics, and inhabitants of all three. As Gunning points out, 'The ontological argument claims that photography not only portrays things but participates in, shares, or appropriates the very ontology of the things it portrays'. While for Gunning this ontological bridge might mean that the phantasms that grace a screen in fact infect it in some way with their spirit, with *The Image Mill* the converse may be true: the building can be seen to be filled with 'spirits' that infect

Figure 2-9: Robert Lepage / Ex Machina, *The Image Mill* (2008), Quebec City. Photo:
Nicola-Frank Vachon (nicolafrankvachon.com), courtesy of Ex Machina.

what is portrayed on screen. In this way, the building as screen enters into a
relationship with the images, sharing and extending this hybrid existence.

The superimpositions of *The Image Mill* created an ontological bridge
that united people, space, and image in a collective performance of memory.
As noted on the official website for the project, the building was meant
to be 'in a constant state of transformation, giving viewers the surreal
impression that it is alive and talking to them' (EX MACHINA 2014), an
effect that was partially achieved through superimposition. Likewise,
Philippe Dubé, co-developer of the original scenario for *The Image Mill*,
points out, 'Each evening the mass of reinforced concrete would turn into
the segmented body of a giant beast to act out the story it had witnessed'
(2012, 182). Superimposition was harnessed and extended into public space
in *The Image Mill*, making the space more relational and furnishing new
experiences of monumentality.

With *The Image Mill*, a building becomes a screen and a city becomes
cinema — that is, it becomes theatrical. The 'cinema' expands to become
enmeshed in the urban fabric (Brougher 2008). As McQuire (2008) notes,
the relational space that the moving image in public space creates narrows
the perceptual and ontological gap between cinema and the city, between
mediation and the built environment. *The Image Mill* uses superimposition
to create moments of media-induced misrecognition where, as Gunning

notes, 'the criterion that separates real objects from their equally life-like apparitions' (2007, 21) is diminished. When the grain silos become a gigantic radio from the 50s they, and the city, become possessed with a 'liveness' and performativity: they share the same frequency and wavelength — they occupy a contemporary and historical resonance. The contingency of the moving image presented in this way, superimposed as it is on a wide expanse of urban space, expands the possibilities for a 'new monumentality', just as Giedion and others predicted, creating temporary conditions for the condensation of meaning and collectivity where 'a unity of the architectural background, the people and the symbols conveyed by the spectacles' (Giedion 1944, 568) arise.

Spatial Montage: Extra Diegetic

Montage also plays an important role in extending cinematic space in the *The Image Mill* and provides a means for greater associative and narrative possibilities. Typically, montage in film is achieved in editing by juxtaposing different shots with one another, cutting and recombining film in order to create relationships between images from different times and/or spaces. The practice of montage has expanded over time to include the additional use of composite montage within frames, itself a variant of superimposition, that has accelerated greatly with digital editing techniques. Still, through cutting and recombining film or altering layers within the digital frame, montage remains primarily diegetic. Rarely, if ever, does the montage explicitly reference or interact with its frame and that which lies beyond it, where the frame is anything from the disappearing border of the theatre screen or, more commonly now, the edges of a screen or mobile device.

The nature of montage changes when the moving image leaves standardised formats of presentation, abandoning their present-day interoperability and remediation — the any place, any time, any where-ness of contemporary media (Gaudreault 2015) — for a singular specificity precisely located on a unique surface within the shared frame of an architectural or urban space: a massive media event. When montage occurs in public space, the logic of the monument and the logic of the cinema are combined to expand the dimensions of a site thus fostering greater narrative and associative flexibility between moving images, architecture, and people.

Spatial montage in massive media juxtaposes the moving image of the spectacle with other moving images around it, with the city, and with other fragmented media forms (such as radio frequencies, subwoofer vibrations, or social media). *The Image Mill* was developed specifically to engage in a

spatial montage with its setting, its multiple media elements, and through its use of scale. For one, the diegetic montage cycled through a set of scales, from magnifying the microscopic to the scale of the building, to compressing the cosmos onto its surface, or by displaying scenes of buildings or cathedrals mapped onto the building at roughly the same scale as they might actually appear. While cinema traditionally does this in the space of the theatre designed to be isolated and sheltered from the conventional world outside it, *The Image Mill* engages directly with 'the world', imparting a dreamlike quality to it through a montage that directly references and interacts with said world. Viewers could see the ramparts appear on screen before them and turn around to see the very same structures at roughly the same scale surrounding them. Spatial montage infects space to prompt meaningful and instructive comparisons with it — it sutures space and cinema.

Spatial montage also extends what Kuleshov calls 'creative geography' (Kracauer 1965, 48) to public space, thus contributing to the production of a space made relational by way of media. Creative geography primarily refers to the illusion of spatial continuity created when material phenomena captured in different places are juxtaposed in cinematic montage: actors exit a house on set and emerge in an 'on location' street scene; an aerial shot depicts a certain mountain village and we cut to a scene in a different place altogether while believing it to be in that village. *The Image Mill* engages in 'creative geography' throughout its entire presentation by virtue of its situatedness in the urban environment: as the viewer looks to the screened images, then to their surroundings, and back again, the urban space is continually compared to the images designed to reference it, appealing to an extra-diegetic congruity. Every image it displays is implicitly related to its surroundings and asks to be either merged with it or to resonate within it. This is particularly apparent when the silos transform into various architectural elements that can be found in the city, or could have been found in the city, throughout history: ramparts, stained glass windows, office blocks, and the log fences of early settlements. These represent, in their congruous architectural scale and extension, a merging of cinematic and geographic urban space. When the building becomes a giant scoreboard for a hockey game or the LED signage used to direct highway traffic, a spatial montage is created through the inflated scale afforded by the massive projection that creatively transforms the entire city into an arena or a highway. Thus, *The Image Mill* uses images that refer to and employ the space around it to engage in a creative geography that Kuleshov could not have considered at the time, creating illusions of both spatial and temporal continuity and reinforcing ontological bridges created through superimposition.

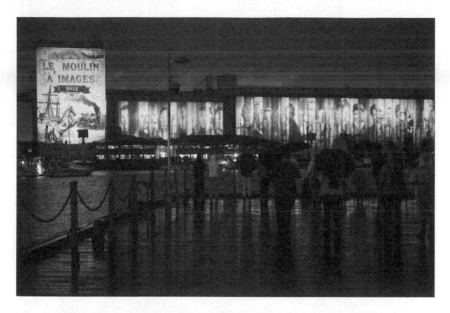

Figure 2-10: Robert Lepage / Ex Machina, *The Image Mill* (2008), Quebec City. Photo: Nicola-Frank Vachon (nicolafrankvachon.com), courtesy of Ex Machina.

Spatial montage and superimposition contribute to the framelessness and spatial ambivalence of the massive media experience, expanding the field of representation and the possibilities for narrative and association between the city, people, and the moving image.

Dispositif and Apparatus: Staging the City

Apart from superimposition and montage, the transformation of buildings into screens via elements of massive media also exhibits expanded and experimental elements of the cinematic concepts of dispositif and apparatus.

When buildings become screens and cities become cinemas, the apparatus, which includes elements of the city and the application of various media, is less clearly defined than the cinema yet together they form the basis for the arrangement of demands, desires, fantasies, and speculations for citizens and the city alike. As a result, *The Image Mill* can be seen as a *composite* dispositif (Verhoeff 2012) of an open-air theatre, the cinema, and a broadcast model like radio, that is, a media-spatio experience in which standardised environments of spectatorship, their affordances and attendant ideologies, overlap and co-constitute a relational experience. *The Image Mill* extended and combined the efficacy of these elements of transmission borrowed from

Figure 2-11: Old map of Quebec City approximating viewing area for *The Image Mill* (2008).

previous forms by design but also at times out of necessity. For example, *The Image Mill* did not create a darkened cinematic space to focus attention on the diegesis so much as it had to wait, patiently, every night, for the sun to disappear on the horizon so that an image might appear on the silos. In this way, an incomplete dampening of sensory stimuli from the surrounding space was predicated on a celestially controlled shift from the diurnal to the nocturnal, thus ceding to this natural rhythm. As much as the creators hoped to 'turn the city into an auditorium' (Lepage 2011), they could only do so by first deferring to predictable but unchangeable forces of nature. The show began at 10:15pm in June and July, and at 9:45 in August and September. Commenting on this natural phenomenon, production designer Mario Brien (February 9, 2014, phone call with the author) noted that 'It was dark of course, but not dark enough to be satisfying at times — some nights if the moon is full, the clouds are low, and city light reflects on the clouds, light spills on to the screen'. To compensate for this, some control over lighting was exercised by the production team as they were granted access to the street lighting infrastructure along Quai St-André across from the silos (see Figure 2-10). Although their efforts did not necessarily make for a brighter image on the

screen, it did create a cinema-like pocket of collective darkness for spectators, thus borrowing this device from cinematic technique and transferring its effects. It also showed the dispositif of massive media to necessarily be one that was a composite of natural and imposed conditions, an expansion of cinema that here included the rotation of the earth within the solar system.

The audience of *The Image Mill* was recentred and delivered to the diegesis through extra-diegetic, composite dispositif elements that engaged sound and touch as well. 'The Mill Frequency', a radio signal that carried audio for 'those who want[ed] to experience the mega-projection from afar' (EX MACHINA 2014) reinforced the communal aspect of the presentation and contributed to a democratic surround where pieces of information related to the presentation were made accessible to variable recombination by a wide audience. The provision of a radio soundtrack effectively extended the audio/visual apparatus of the presentation so that it was limited only by sightlines which, aided by the natural elevation to the south of the projection surface, extended approximately one kilometre away (see Figure 2-11). Mario Brien (February 9, 2014, phone call with the author) described the upper town area as 'a balcony, the same as a theatre' and noted that the scale and quality of the show meant that 'The relationship between the public and the stage was almost the same as in the theatre' despite the usual urban distractors (traffic, pedestrians, sounds). Similarly, as Amélie Demers notes, the 'monumental building also allows you to watch the work from several different points, using the spaces of the city as bleachers' (2010, 48), downplaying the idea of a privileged viewing position emphasised by the dispositif of the cinema. By mimicking the conventions of spectatorship from theatre, film, and even sporting events, as well as providing non-localised and localised sound, *The Image Mill* created a multi-modal net of capture to recentre a distributed, mobile, and diverse audience.

Finally, an essential ingredient of the effect of dispositif carried forward and amplified in monumental projection of *The Image Mill* is the role that scale plays in determining relations of power, meaning, and attention in scenarios of spectatorship. Doane (2009) argues that expanded cinema resuscitates the body as a measure of scale and distance in physical space that has been lost to a degree in the practice of cinematic spectatorship, a practice that seeks to erase the spectators sense of their own body and deliver them to some aspect of the diegesis, whether that be an identification with a subject in a film or with the camera. If monuments, for example, transfer power with their surroundings, massive media allows for this transfer to occur in a number of directions: between monument, body, image, and environment. Scale in massive media serves to help unify the presentation with its surroundings, recentre an audience, and create experiences that can

heighten the embodied experience of the spectators and their ability to see themselves as the centre of the experience. In the case of *The Image Mill*, scale puts the spectators body in a direct spatial relationship to historical images amidst historical objects: it merges the archival and memorial qualities of space and media creating an embodied experience of history and transforming the viewer into a vector of inclusion and potentiality. The expanded proscenium of the monumental projection demands that the screen be considered in relation to its surroundings within which the spectator is treated as a roving focal point.

McLarena: Recentring the Audience

In addition to scale and site-specific interventions that cater to a mobile audience, the elements of direct participation and interaction add yet another recentring tool to the dispositif of massive media. These elements, afforded by tangible interfaces at the site or mobile ubiquitous media, present additional aspects of a composite dispositif of media and monumentality that help to capture and deliver audiences to new experiences and rituals of collective memory when buildings become screens.

Perhaps the most consistent site for this kind of experimentation in the last decade has been the *Quartier des spectacles* in Montreal. Since 2003, the *Quartier des spectacles*, a coordinated area of public spaces, lighting, and permanent architectural projection sites, has been at the forefront of developing interactive cinematic experiences in public space at an architectural scale. A recent example, *McLarena* (2014), at the Saint-Laurent Metro Station site within the *Quartier*, demonstrates new ways in which the city, the moving image, and architecture can be combined along with interactive digital capture techniques that place the body in direct relation with historical material and other spectators in public space (see Figure 2-12). While building upon traditional means for capturing attention and generating affect and meaning in the cinema (superimposition, montage, and dispositif), *McLarena* adds to the composite dispositif of public projection by including a powerful suturing device of direct involvement through interactivity.

The creators of the work, Montreal-based design studio Daily tous les jours, describe *McLarena* (2014) as:

> [...] a playful participatory work that invites passers-by to imitate the choreography of the character in McLaren's film *Canon* (1964), which

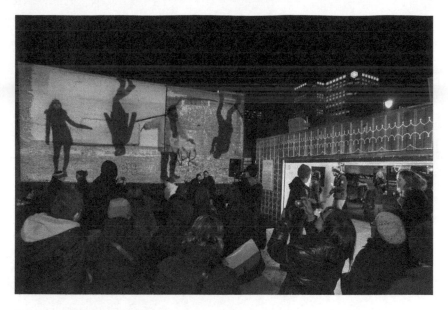

Figure 2-12: Daily tous les jours, *McLarena* (2014), presented during the event McLaren Wall-to-Wall, *Quartier des spectacles,* Montreal. Photo: Martine Doyon, courtesy *Quartier des spectacles* Partnership and the National Film Board of Canada (NFB).

depicts the musical genre of the canon in animated images. For *McLarena*, a video booth has been set up in a shipping container outside the Saint-Laurent metro station. Each participant goes into the booth and is filmed on video while attempting to perform dance steps based on the preceding participant's video. The results — errors, transformations, and an evolution of the movements — are all captured in an endless video created by the participants and projected on the façade of an adjacent building (Quartier des spectacles 2014).

McLarena asks viewers to watch and mimic parts of Canadian film pioneer Norman McLaren's original film *Canon* (1964) while their image is captured and automatically processed and presented on the architectural façade situated outside of the Saint-Laurent metro station. *McLarena* also includes a tiered seating space next to the mobile video production booth so that people can watch the performance of the participants as they attempt to mimic McLaren's work as well as the projection that displays the results of their efforts.

Canon depicts a single dancer occupying only a small portion of the frame. The dancer proceeds from left to right, twirling, tipping his hat, kicking the air, snickering and stumbling to the side, ducking, then proceeding off

Figure 2-13: Daily tous les jours, *McLarena* (2014), presented during the event McLaren Wall-to-Wall, *Quartier des spectacles,* Montreal. Photo: Geoffrey Boulange, courtesy *Quartier des spectacles* Partnership and the National Film Board of Canada (NFB).

screen. The single dancer enters again, but this time is followed shortly by his double, and then a double of that, and so on, until we begin to see not a *pas de deux*, but a *pas de trois*, then *quatres*, as dancers are recycled on the left of the screen just as they exit on the right. All the while, a musical motif is repeated in the background and overlapped with itself at different intervals, just as the animations are, typifying the theme of the musical canon where the same melody is introduced in different parts so that the successive waves coincide in pleasing ways. The relative simplicity of its visuals and choreography, the concept of overlap or superimposition, and the deep connections between Norman McLaren and the NFB to Montreal, meant that *Canon* was historically, stylistically, and conceptually amenable to a reinterpretation through a participatory outdoor projection.

McLarena presented an interesting mix of cinematic techniques re-purposed for the scale and context of the built environment: the literal superimposition of the participant in the diegesis, the superimposition of the larger image within the cityscape, a spatial montage that puts this installation into a relation with the surrounding architecture and flows of pedestrians and cars, and the traditional viewing conditions of seating (i.e., tiered) augmented by an expanded scale and the addition of an interaction space (see Figure 2-13) that sutures the interactant to the image. McLaren's

film was simultaneously viewed by participants in the mobile recording unit, learned, and remediated through their bodies, then processed, amplified, and represented in the very style of McLaren's film on the side of a building. Each of these elements served to deliver the various actants (viewers, participants, and passersby) through a composite dispositif that crucially included direct participation. It connected a publicly funded organisation and archive (the NFB) to the publicly funded *Quartier des spectacles*, thus creating a new public for ludic encounters in a totalising media-space. A unity was inscribed between a collective, a history of media, and a place through participation in a massive moving image.

Participation: Don't Just Sit There and Watch

While *McLarena* is ostensibly participatory, it is important to consider the quality of the participation it engendered as a work of massive media and the qualities of a public sphere it enacted. To what degree does it contribute or support meaningful interaction that is unique to the form? Does it approximate and dramatise productive political positions? Does it create and support spaces of appearances? To what degree is it an extension of the concept of the democratic surround? Claire Bishop is critical of the quality and meaning of the modes of public participation afforded by certain assemblages of expressive displays, digital sensors, and networked devices. In her discussion of relational aesthetics and the idea of activated spectatorship in installation art, Bishop, echoing the sentiments related earlier by Wodiczko and Arendt, notes that 'the public sphere remains democratic insofar as its naturalised exclusions are taken into account and made open to contestation' (2004, 65). In the context of public space, these 'naturalised exclusions' include the exclusions of sociability enforced by the prioritising of flow through spaces, particularly as it is enacted outside of a subway station, for example, as well as the prohibitions related to the rights of the citizen to alter their surroundings or see themselves reflected back in it. While *McLarena* does not necessarily promote direct discourse about the history of Canadian film, arts funding, or other issues that might be associated with the installation (although it certainly does not downplay these either), the inclusion of participation at an architectural scale in public space can be seen to address the naturalised exclusions of public space itself, seeking to create an engaged spectator out of a passerby, and provide a scenario in which sociability is fostered and reflected at an architectural scale.

For Bishop, what is central to authentic participation in art is 'activated spectatorship' (2006, 50), or a scenario that values equality over quality,

collective authorship over singular control, and the ongoing struggle to find artistic equivalents of political positions (2012, 3). *McLarena* certainly embodied these tenets in a number of ways. The resulting 'film' of the collective efforts of participants was by no means a quality reproduction of McLaren's original (and this is part of the contingency that makes it attractive). The artistic scenario it created was one that elevated and amplified individual identities while encouraging sociability through the recentring devices of scale, seating, setting, and participation itself. While, again, *McLarena* did not explicitly address politics, it did symbolise a political position: it can be seen to combat the privatisation, atomisation, acceleration, and flow privileged in public spaces, the inaccessibility of building-scale effects by everyday citizens, and the calcification or sedimentation of history. It critiques spectacle by reproducing it and subverting its logic for alternative ends. That it did so in a way that encouraged public sociability and an active participation in history is also a testament to the larger designs of the *Quartier des spectacles* to create temporary publics and ludic interludes that foster the bending and breaking of proscribed social protocols in the city. *McLarena* and the *Quartier des spectacles* can be seen to be striving for a new democratic surround, one in which democracy is extended through access to building scale affects that encourage citizens to self-represent through government supported and sanctioned channels of expression that carry with them a message that is transferred in and through a composite dispositif of media and urban space.

Place Branding and Theatricality

While *McLarena* may be seen to have provided a means to create new associative experiences and rituals with media, the memorial, and the monumental, as well as having provided a critique of spectacle as it relates to public space, it can be seen to have been captured by spectacle at a larger scale, that is, at the level of place branding and entertainment that have become economic imperatives for cities competing at a global scale. Susan Bennett specifically argues that the extension of the cinematic and theatrical to the city and passerby via large-scale public projection events as evidenced by *The Image Mill*, and, I would add, by *McLarena*, represents a key tactic for differentiation and status within a globalised tourism industry. *McLarena* certainly contributed to the wider socio-economic goals of changing the image of public space in Montreal and in the *Quartier des spectacles* in particular, an area once permeated by seedy bars and strip clubs. This was achieved, according to Bennett, through a 'mobilisation of theatricality'

(2009, 9) which refers to the way works such as *The Image Mill* and *McLarena* encourage people to see space as fundamentally theatrical and thus as venues for entertainment. *The Image Mill* did this to the whole of Quebec City by presenting a work that superimposed a cinema or theatre onto the city's surfaces, while embracing and supporting multiple, incomplete combinations of media forms, or a fragmented or distributed audience — what Bennett describes as 'peripatetic' (ibid., 12) — gathering these disparate groups together first and foremost in the illumination of the space with the moving image. The same can be said of *McLarena*, which made a similar superimposition into public space, creating a theatre with sound, seats, and screen, while taking the peripatetic aspect of *The Image Mill* and expanding it through the movements that are encouraged, captured, and remediated into public space by participation enabled by the mobile recording unit. The result, in both cases, was the infusion of a 'liveness' (ibid., 12) into public space that made it performative and theatrical, and made it useful for the purposes of coding a space as open, playful, progressive, and inclusive. In other words, the experience was seen as *valuable* in the eyes of the city, many of its citizens, and developers. As such, through these composite dispositives of massive media, media archives were mined, processed, animated, and delivered to audiences (as audiences were delivered to them) to enliven and entwine the archive, the space, the spectator, and the city, as well as to bolster economies of tourism and migration.

A (New) New Monumentality?

The coupling of the digital, the moving image, architecture, archives, and public space present unique challenges for the arts and public culture, providing the potential for new democratic and historical registers of monumentality. It also threatens to dehistoricise, commercialise, or aestheticise public space and the public sphere. While massive media furnishes new opportunities to shape collective experience, it also, as Joel McKim argues of the *Quartier des spectacles*, does not guarantee artistic innovation and can just as easily contribute instead to the 'general aestheticisation' (2012, 135) and branding of the city for touristic and economic purposes. This concern was perhaps most clearly demonstrated in the Nokia example discussed earlier in this chapter but still exists, to a degree, for all massive media works.

While the realisation of the self both in and against the image and interaction space in public space has democratic and progressive implications for the

future of public sociability, there remain deeper political questions regarding the commodification of cities and public space as well as the exploitation of the attractive potential of participatory and theatrical public spheres. Although not overtly commercial ventures, the crowds that assemble for events like *The Image Mill* and *McLarena* invariably become part of the symbolic capital assets of the city and thus enter into the wider scale of civic economics. In this way, cities like Montreal run the risk of becoming addicted to developing and maintaining a 'symbolic primacy' (ibid., 76) through large outdoor installations that seek first and foremost to demonstrate their global identity rather than carefully considering how local economies, histories, and residents may be affected. A general concern of massive media works is that, given the outlay of funds required to support them, revenue from tourism will impact artistic autonomy and diminish the quality of works. Art, culture, and the public sphere can quite easily be further commodified when buildings become screens. Signalling this, Mayor of Quebec City Regis Labeaume notes a trend in tourism that he calls a return to 'the era of the city' in which the key metric for differentiation between cities is 'culture'. Labeaume highlights the strategic importance of cultural activities within the highly competitive world of cities to attract tourist dollars, skilled workers, and economic investment. Similarly, comparing Tunis to Quebec City, Saidi notes that 'heritigisation and touristification policies in these two cities, especially policies that lead to their museumification through the promotion of practices and aesthetic values transform them into open-air museums' (2012, 75). To that end, the government support of *The Image Mill*, a $4.3 million dollar a year project (La Presse Canadienne 2013), is a clear investment in developing a tourist clientele for the city and reinforcing the 'symbolic capital asset' (Saidi 2012, 75) of the city through massive media. As in the cinema, the crowd is a semiotic and economic resource regardless of the reason for its gathering. Despite this, the sites analysed in this chapter in Montreal and Quebec City, while susceptible to commercialisation and aestheticisation, do transcend these challenges to a degree in both their experimental superimpositions of the theatre and cinema onto the city, and their content that attempts to reflect and refract citizens and their shared history through architectural space and interactivity, thus creating new practices for ritualised public sociability and political positions in public space more closely associated with democracy than their crassly commercial counterparts.

Perhaps more importantly, the provision of permanent or semi-permanent projection sites as found in *The Image Mill* and *McLarena* — something that lies beyond the means of individual artists, curators, or citizens — allows for

greater syncretism and experimentation with new rituals of monumentality that make these sites more legible and habituate audiences to new modes of reception, allowing the sites to exist beyond frivolous spectacle, advertisement (civic or otherwise), or decoration. The coordination, curation, and long-term planning for these sites is a key component for invoking new, meaningful connections with massive media in public space (something that is addressed in detail in Chapter 4). In this way, large-scale projection sites can represent a new 'new monumentality' (Mumford 2000, 151) when artists are allowed to develop audiences, spaces, and images that attempt to reflect and renovate the social and communal life of a place with elements that borrow from practices of public space, monumentality, cinema, and digitality.

As noted earlier, it was Giedion, writing in the mid-twentieth century, that argued for a revolution in monumentality, a new monumentality that would see monuments become better unified with their architectural background and where people would play a key role in the emotional events centred upon them. New experiments that are transforming buildings into screens can represent an extension of these ideals, producing new audiences and spaces with new rituals and habits of identity and place formation that transform Giedion's tenets in a digital, globalised, and fragmented age in need of tangible collectivity. Massive monumental projections, particularly those that involve collective interaction actualised on an architectural scale signal a new dimension of networked media saturation and superimposition that captures the attention, actions, and image of a diverse audience and merges it with the cityscape in unique ways that make memory and history affective, embodied, collective, and temporarily concrete.

Equally important to this new monumentality is the concept of 'post-production', or the documentation, dissemination, and archiving that occurs officially and unofficially before, during, and after the production of massive media such as *The Image Mill* and *McLarena*. Hito Steyerl argues that 'post-production' is the mode of contemporary image production *par excellence*. Presentations such as *The Image Mill* serve as important catalysts for this form of image production. As Steyerl notes, 'We are embedded within a post-cinema that has been completely transformed, mutated into whole environments, permeating reality to the point that we can now understand it with media thought and alter it via post-production' (quoted in Shental 2013). This certainly fits within the theories of the competitive city as museum as it envisions its tourist clientele as co-producers and co-promoters of a city and seeks to cater to them through experiences situated within the city as stage or theatre. Of course, with the inclusion of interaction spaces, such

as those found in certain outdoor projections in Montreal's *Quartier des spectacles*, the city becomes more stage-like, more theatrical, and eminently more attractive and capable of post-production at and beyond the site and time of projection. That said, it is the communal character and scale of the massive media event upon which this economy is centred even as its traces are scattered long after the crowds have dispersed. Massive media are necessary, temporary substantiations of media, like the eruption of a geyser, tempering new cultural scenarios for cities.

As another potential aspect of a new 'new monumentality', the installations presented in this chapter can be said to perform a redefinition or rehistoricisation of space through the multiple impressions and transformations they engender. This is exactly what may be needed as space becomes more hybrid and relational: carefully constructed interfaces that incorporate the mutable digital image into shared spaces in order to enact powerful, yet heterogeneous, variable, and impermanent connections. As McQuire (2008) notes, these temporary substantiations better reflect the way we have come to interact with each other in space and through the moving image. While for some like Crary and Virilio this practice might represent the possibility of a dangerous spatial and historical amnesia by way of the fleeting trace of contingent media, exemplified by Freud's forgetfulness at the *Piazza Colonna*, others such as Wodiczko have shown how this can stain or mark a place so that an impression is made that lasts in memory (embodied or electronic). Digital projection in public space is a frontier for the colonisation and/or democratisation of affect and attention, and the renovation of communality and mass culture; a frontier that *The Image Mill* and *McLarena* explore for the purposes of commemoration and civic communication.

Furthermore, the practice of massive media clearly understands and demonstrates that it is on digital screens that our stories and identities are now being formed and presented and attempts to bring this to bear in more tangible, monumental places of congregation: on public facing buildings. While the contingency of surface effects produced by cinema, as outlined by Kracauer, engages affective responses, the digital image multiplies this contingency through its ability to be manipulated in real time, the flexibility afforded to projection locations and geometry by new digital projection technologies, and its amenability to personal appropriation and distribution through mobile ubiquitous media. As Bruno Lessard notes, '*Moulin's* creators implicitly posit that it has become practically impossible to conceive of history without the moving image' (2009, 78). Certainly, they also mean to say that it is the digital moving image, in its ability to remediate archival images

and sounds at an architectural scale, that creates a unique experience of and with history for spectators through superimposition and spatial montage. Similarly, it is clearly the digital dispositif that affords *McLarena*'s playful relationship between the participant and architecture and engages memory as simultaneously embodied, performative, collective, and spatial. Finally, flexibility of the digital projection allows for experimentation, superimposition, and montage at architectural scales, bringing audiences into contact with archives, architecture, and one another, in hybrid, relational space.

In particular, participatory massive media creates a monumentality that engages histories (such as the work of Norman McLaren and the National Film Board) not explicitly through the historical, per se, but through a mixture of the historical and the perpetual present engaged by the digital capture and remediation of the very spectators it seeks to address, mixing the present reality of the crowd (on- and offline) with the civic and the historical, and the logic of digital media with that of the monument. In this way, works such as *McLarena* go further than *The Image Mill* in representing what Giedion speaks of as the 'popular needs and aspirations' (Mumford 2000, 151) of our time, and thus pushes the concept of a new 'new monumentality' further. *McLarena* posits that not only is it impossible to 'conceive of history without the moving image' (Lessard 2009, 78), but that it is impossible to conceive of history without seeing ourselves somehow included within said time-based media (as well as its 'post-production' networked circulation). Furthermore, history itself is now inextricably tied to digital information and thus, there is an impetus to make it operable in and through public spaces which persist as sites of public contestation for their device agnostic accessibility, among other reasons. Buildings that have become screens represent productive venues within which to explore and develop tensions between history, technology, and public space.

Massive media responds to a complex mixture of the desire to communicate in and through the digital image, to expect richer and more flexible interactions with our surroundings, as well as the overarching need for cities and citizens to see themselves within a desirable and globally relevant urban culture. As such, it is the lack of post-production facilitation that represents one of the critiques of *The Image Mill* with respect to its capacity to renovate monumentality. Lessard argues that the apparatus of *The Image Mill* does not go that far beyond that of the familiar positions of the television viewer or film spectator. He says that 'the work's monumentality serves a very conservative historical content that is accompanied by an equally conventional viewing position, which lacks movement and reflexity' (2009, 79). What Lessard would like to see is a more challenging presentation,

for the producers and the participants, one that incorporates networked elements, GPS mapping, or other reactive and algorithmic processes that reflect 'a mobile notion of site and a nomadic subjectivity' (ibid., 80). Lessard argues that the work lacks dimensionality that is demonstrated, I would argue, in something like *McLarena*, available to it by virtue of the digital tools that exist to incorporate real-time capture and processing.

That said, *The Image Mill* takes a distinct step away from the presentation of a historical narrative within the confines of a museum or atop a static monument, and does allow for a degree of mobility and nomadic flows of communication and spectatorship, capturing something of the popular needs and aspirations of its audience and milieu, creating a relational space in the process. What the examples in this chapter maintain are the special effects of cinema, that of montage (albeit in a spatial form), superimposition, and dispositif (albeit in a composite form), which help to connect it to tried and true conventions of spectatorship and theatricality while disrupting public space sufficiently through the affordances of new digital technologies and productively troubling forms of mass culture, the public sphere, and monumentality. The city thus suffused by media enables a new communicative and commemorative environment that must be contested, developed, and claimed by artists lest it aestheticise and obscure history in service of capital.

Experiments in Public Projection

While the examples above highlight the ways that issues of participation, intent, ownership, and history relate to the new complexities of space, monumentality, and the public sphere, a more 'complex and involved participation' (Fuller 2005, 106) with massive media can allow us to better see how this particular aspect of the world operates. As such, I decided to design, propose, situate, experience, and report on the technics (Thain 2008), politics, and practices associated with massive media in order to more closely and directly observe the affordances and limits of, in this case, projection-based massive media. As a result, I present two creation-as-research projects where creation, while inspired by and ultimately in the service of research, stands alone as a form of exposition and generator of 'praxical knowledge' (Smith and Dean 2009, 7) for both myself and my collaborators, but also, potentially, for the spectator. These works provide points of analysis and comparison to the above examples from the direct application of cinematic elements and digitality in monumental public settings.

30 moons many hands

30 moons many hands (2013)[2] was a massive media installation that I created with Patricio Dávila.[3] *30 moons* told the story of Douglas Carr, a shoe sales-man from the small town of Ingersoll, Ontario, who spent thirty months travelling around the world in 1938, cycling from London to Cairo and through Africa to Cape Town. The installation featured a large-scale outdoor projection that displayed a montage of footage of the Archives of Ontario facility in Toronto, Canada as well as photographs, films, journals, and letters related to Douglas Carr that they had recently catalogued and preserved.

Dávila and I initially met with archivist Sean Smith at the Archives of Ontario to discuss potential topics that we could present either on the building itself or on a building in a nearby courtyard. While Sean suggested a number of projects, he also gave us a tour of the facilities and the various labs involved in preserving and cataloguing material. In the end, we decided to tell two stories: the first was the story of cyclist Douglas Carr who cycled around the world in the 1930s in part because this material had just been donated and had yet to be used by other researchers or artists but also because of the richness of the imagery and text that in this particular fonds. Like *McLarena*, we realised that a key element in creating an engaging outdoor projection from historical material was to find existing audiovisual elements that would play well at scale and for a peripatetic audience. The Carr fonds contained a large selection of rich photographs, documents with interesting graphical elements and patinas that evoked their age, and reels of silent films shot on 16mm that would capture the spirit of his time and the attention of the audience.

The second story we wanted to tell was that of the Archives itself by creating a porthole into the operations of the building through a circular architectural projection and highlighting the importance of the labour involved in the process of bringing attention to these archives. In this way,

2 See http://thirtymoons.ca/ for documentation of the work.
3 Patricio Dávila and I collaborated to create *30 moons many hands* (2013). We were first introduced to the Archives of Ontario by Dr. Janine Marchessault at York University. Dávila and I carried out research and documentation at the Archives of Ontario with the support of archivist Sean Smith. I was involved in storyboarding, video production, audio recording, web design, and initial video editing. Dávila was responsible for video production, editing, and projection mapping. Both Dávila and I were involved in the final production of the installation. We received in-kind assistance from graphic designer Patricia Pasten (poster), photography assistance from Jamie Webster (documentation photos), and the in-kind donation of the use of two 10,000 lumen projectors from York University's Sensorium: Centre for Digital Arts & Technology.

Figure 2-14: Dave Colangelo and Patricio Dávila, *30 moons many hands* (2013), installation view, Toronto. Photo: Jamie Webster, courtesy of the artists.

we wanted to capture the performance of archival work and present it with another kind of performance: the theatricality of a public projection. *The Image Mill* provided some inspiration for this in the way the archival images collected and processed in its presentation were animated and made to perform across the 300m wide screen, directly referencing the space around it. In presenting the work of the archives in this way, we saw ourselves as the last link in a chain of labour and inspiration that began with Carr's documentation, continued through its generous donation by his family, careful processing and preservation and digitisation by Archives of Ontario staff, and finally its presentation centred upon a large-scale public projection adjacent to the very site of the Archives. The mobile website we created for the project, containing scanned versions of various documents, letters, and newspaper clippings from Carr's journey, served as a vehicle to make these images available to spectators for closer inspection or to be circulated: a 'post-production' (Steyerl quoted in Shental 2013) opportunity that opened the archives to wider scrutiny and circulation. The mobile site provided yet another window into the archive and engaged a composite dispostif (Verhoeff 2012) at the site that would recentre audiences to this material as they moved through the website and the campus.

30 moons was presented at the HASTAC 2013 digital humanities conference, from April 25-28 at York University in Toronto. It attempted to 'ventilate'

the Archives, that is, it attempted to create an ontological bridge that connected the interior of the Archives to the public space around it through superimposition in order to narrow the perceptual and ontological gap between Carr's story, the Archives, and the campus — between mediation and the built environment. Stylistically, we used the metaphor of the 'porthole', shaping our projection to appear within a circular vignette to emphasise this encounter between the ontologically disparate spaces and times. This superimposition was extended into real and virtual space by the use of voice-over narration and a soundtrack that filled the courtyard in which it was presented, an important element of the dispositif that drew spectators to the image and helped to maintain their attention. Since views of the projection were limited to the courtyard, we did not have to consider adding a mobile component for the audio as they had in *The Image Mill*. Instead, we worked at a scale closer to that of *McLarena* which focused on attracting and maintaining viewer attention in a small space through non-individuated, coordinated image and sound. One fortuitous superimposition that contributed to the spectacle of our presentation was the appearance of a full moon in the night sky for the three nights of our installation. While we did not plan on this occurrence, it pointed to the syncretic possibilities of spatial montage that are opened up by massive media, much like the juxtaposition of projected and real ships (and their sounds) in the projection of *The Image Mill*.

In terms of monumentality, *30 moons* was designed to appear at a specific scale and in a particular setting in order to engage the displacement and condensation that Lefebvre (1997) notes of monumentality in general. Scale and setting condensed the space between the mass of the Archives building nearby and its projected extension, displacing the borders between part and whole. It allowed for the transfer of power of one institution to the other and vice versa: the authority of memory was transposed onto public space and the power of the public sphere was brought to witness and engage with the Archives and the stories contained within. This connection was also reinforced through various rituals, an important aspect of monumentality. These rituals included the rituals of cinematic spectatorship, of congregation in public space, and of interacting with mobile media. Together these reinforced the composite nature of this massive media installation, as well as the 'accelerated' (Crary 1999) rituals involved in it. While these rituals might be seen as distracting and dehistoricising, they can also be seen to better reflect and harness the affordances of hybrid, relational space, thus rehistoricising the space by focusing not on the loss of sites of memory by way of the media trace (Nora 1989), but instead by maximising the potential

Figure 2-15: Dave Colangelo and Patricio Dávila, *30 moons many hands* (2013), installation view, Toronto. Photo: Jamie Webster, courtesy of the artists.

of the transmissive and syncretic qualities of all of the elements involved: public space, projection, architecture, networks, mobile ubiquitous media, and sound. *30 moons* hypothesised that public projection, coupled with a mobile-enhanced website, could uniquely contribute to collective memory and communal experience to better reflect contemporary culture lived in and through the moving image and networked devices. It used the collectivity and publicness of the campus and the Internet as a springboard for publicising not only the story of Douglas Carr but that of the Archives as well.

Directly witnessing the attention that we captured by presenting moving images and sound in the space and at the scale that we did taught us a number of lessons. While we presented this work on a university campus after the academic year at a time when few students were around, we were still able to draw people into the work by the public address created with sound and image. One of the weaknesses of the project was that attention waned quickly and many people did not stay to watch the entire 15-minute loop. Our project lacked a physical referent at the site — a didactic explaining what the project was about. Instead, we had to rely on people searching online for the title of our project (prompted by the title sequence of the projection or by printed posters in the vicinity) and finding our website. This proved to be an unrealistic expectation. To ameliorate this, we felt that it would be important to place more information at the site, install a dedicated

Figure 2-16: Dave Colangelo and Patricio Dávila, *30 moons many hands* (2013), installation view, Toronto. Photo: Jamie Webster, courtesy of the artists.

kiosk or interface, or to have a project run for a longer period of time to allow for information to disseminate through word of mouth or through stories of people that had already experienced it, as was the case in either *The Image Mill* or *McLarena*. *The Image Mill* and *McLarena* also benefitted from promotion by tourist boards and dissemination through print, broadcast, and online media. Repetition and clear signals for participation and spectatorship, at the site and beyond, is a key element in entrenching in a space and in an audience the messages, meanings, and practices intended by the creators of otherwise ephemeral massive media.

Another weakness of our project was the lack of comfortable seating in the courtyard that could have helped to recentre our audience. With more funding (the project received a small amount of funding from York University as well as the in-kind donation of the space and the projectors), we could have installed bleacher seating in front of the projection to indicate to people that they were welcome to stay and watch the presentation. This was a tactic employed skilfully in *McLarena* in the tiered seating they provided, placed strategically so that people could watch both the projection and the performances of participants in the mobile video booth.

Designers of *The Image Mill* had to consider the scale of the entire city, working with existing architectonic and geographic elements, and they had to design the space around the screen as such strategically. This led to their

taking control of the street lighting across from the projection, providing ample signage, engaging tactile cues such as the subwoofers that vibrated in the viewing area, as well as placing the projection at the foot of a hill that naturally provided a kind of tiered seating for thousands. The importance of the elements of apparatus, borrowed from a history of spectatorship and specifically from a history of cinema, cannot be underestimated in creating a successful public projection: the space around the screen must be considered as carefully as the screen itself.

Finally, as noted above, and limited again by time and money, we were not able to incorporate more participatory elements into the presentation. This certainly would have helped to recentre the audience and would have better reflected the digitality in which they, and these images from the early twentieth century, now exist. Our concept of presenting 'many hands' was meant to include the hands of the viewers themselves, evoking a sense that their hands were part of a continuum from the hands of Douglas Carr, through the hands of the archivists, and finally our hands as research-ers and artists, that could be connected through digital means and seen, altogether, as a public good that could connect us more strongly to the past. Our mobile-enhanced website represented a small concession towards this, but a deeper involvement with the artifacts, perhaps a means to call up 3D-scanned objects on the screen and observe them from different angles, or an interface in the form of a globe that spectators could rotate to engage specific locations on Carr's journey, would have helped to strengthen the connection between the content and the audience.

The Line

Working once again with collaborator Patricio Dávila,[4] our next massive media probe attempted to question the spatio-political assemblages of the suburbs in a site-specific exhibition using a mixture of sculpture and outdoor projection. *The Line* (2013)[5] was a two-part installation that included

4 Patricio Dávila and I collaborated to create *The Line* (2013). We were involved in early conceptual meetings with Janine Marchessault and other artists and curators. We were also involved in the concept, design, and planning of the installation as well as in the construction of installation materials and the production of the sound and video elements of the piece. Dávila's time was mostly spent creating and editing the final video while my time was directed towards logistical and production concerns at the site. We received in-kind assistance from photographer Will Pemulis (photographic documentation) and an in-kind donation of the use of two 10,000 lumen projectors from York University's Sensorium: Centre for Digital Arts & Technology.

5 See http://davecolangelo.com/project/the-line/ for documentation of the work.

Figure 2-17: Dave Colangelo and Patricio Dávila, *The Line* (2013), installation view (snow fence), Markham, Canada. Photo: Will Pemulis, courtesy of the artists.

Figure 2-18. Dave Colangelo and Patricio Dávila, *The Line* (2013), installation view (projection), Markham, Canada. Photo: Will Pemulis, courtesy of the artists.

a 70-foot long snow fence set in a marsh and a 15-min outdoor projection on
a 200-year-old barn, both on the site of the Markham Museum, a historical
recreation of a pioneer village in the heart of one of North America's fastest
growing suburbs. It was presented as part of *Land\Slide: Possible Futures*,
an exhibition that explored issues of land-use, food security, and cultural
history. We chose to base our installation on the concept and image of the
snow fence. Snow fences are built to shape the way drifting particles settle,
usually to make roads safer for fast moving cars travelling in a straight line. It
seemed fitting to include this as an iconic figure for our critique of land-use
and migration, the loss of arable land, and suburbanisation. The projection
told the story of the snow fence travelling around Markham, stopping at
strip malls, parking lots, housing developments, farms, hydro fields, and
so on, tracing the lines of land-use signatures etched over time. *The Line*
attempted to ask how and where we draw the line, as the lines that manage
the flow of people and things — borders, roads, bike lanes, fences, pipelines,
green belts, flight paths, etc. — represent the physical manifestations of
our fears and desires, and serve to shape our values and beliefs.

The Line emerged through a curatorial process led by professor and curator
Janine Marchessault. She approached us in 2011 and asked if we would be
interested in creating a large-scale outdoor projection in response to themes
of land-use, food security, suburbanisation, and memorialisation at the site
of the Markham Museum, a heritage village consisting of a collection of
structures and artefacts from the 1800s, salvaged and maintained on the site.
We were assigned the Kinnee Barn, a 200-year-old structure that had been
relocated from its original home approximately 40km away due to on-going
development of farmland around the growing city and suburbs of Toronto.

Given the context of the exhibition and the site we were given, we decided
it would be best to mirror the journey and displacement of this barn by
building a large, slatted, wooden structure — a snow fence — and filming
a section of it as we transported it around the vernacular architectural
sites of Markham that included sports fields, construction sites, housing
developments, and strip malls. We used the displaced barn as the canvas
for our projection of the story of the snow fence traversing the lines that
bisect the last available fertile land within 100km of the city, transforming
the landscape and its culture in the process.

A great deal of work went into recreating elements of the cinema on
the barn and in the field that surrounded it. In effect, we attempted to
create an apparatus to capture the attention of the audience that would
be wandering around the pavilion in the dark. First and foremost, the
massive projection (approximately 60ft wide and 25ft high) within the

Figure 2-19: Dave Colangelo and Patricio Dávila, *The Line* (2013), installation view (projection), Markham, Canada. Photo: Will Pemulis, courtesy of the artists.

darkened space of the Markham Museum grounds provided the strongest beacon for attention, calling out to visitors from a distance in its setting at the back of the property. While this served to draw people in from afar, once spectators were within 100ft of the projection they began to hear the audio associated with the projection, a mix of recorded sounds from the sites we visited with the fence and ambient music, and were drawn into the ideal space for viewing the video on a set of benches — another line — that mimicked the thematic material and were embedded with speakers. Finally, the projector was carefully hidden in the attic of a nearby farmhouse, once again mimicking the apparatus of cinema in order to mystify the audience. These affordances delivered the audience to the content of the installation without undue distraction. Through these elements, we carefully extended the affective and effective use of cinematic techniques in a rural setting in order to create a composite dispositif of capture and ideological delivery.

With the projection, scale was an important factor in capturing the attention of the audience. It allowed the images to exist on par with its surroundings, or perhaps exceed them in their luminescence. It also allowed us to present images of our snow fence at a 1:1 scale, thus, through superimposition and spatial montage, allowing the audience to measure their experience in reference to their bodies in the space of the outdoor museum and thus have a more embodied experience. They could understand

their place within the environment of the museum and the environments
we presented on screen to be connected. With a full-scale sculpture of
the snow fence located in another area of the pavilion, *The Line* further
extended its spatial montage with this physical element to make a correla-
tion between the moving image and its surroundings through scale and
correspondence, much like *The Image Mill* in its conscious congruencies
between itself and vernacular architecture in Quebec City. The scale
of the projection and its setting also intentionally created a communal
experience and ritual, much like gathering around a campfire, in which
these scenes and ideas would be witnessed collectively, allowing viewers
to reflect on the collective impact of their actions on the environment and
their lifestyles over time. Here, the collectivity of experience should not
be downplayed in the experience of large-scale outdoor projections: the
health of a public sphere is dependent upon exposure to a specific discourse
through media and the affordance of channels through which debate and
discussion can take place. While this can be achieved asynchronously as
it most often is in online environments or in separate environments as
it is in televisual broadcasts, a unique sanctity and gravity is afforded to
the communal spaces of public address that massive media tap into. By
virtue of their publicness, transformations of buildings into screens in
presentations such as *The Image Mill*, *McLarena*, and *The Line* attempt to
engage and entrench the sense of shared history that an amplified public
address can afford.

In addition to the communal aspects of public projection engaged
by *The Line*, the installation also attempted to present the memory of
a structure to be something contained within the structure that could
be made public through projection, thus enacting an ontological bridge
through superimposition. Essentially, *The Line*, like *The Image Mill*,
evoked what a building may have witnessed in its history. At the very
least, the audience witnessed the conditions that relate to the building
and its situation, displaced as it was by development and located within a
heritage recreation site, and could measure their own bodies and experi-
ence against this. In this way, *The Line* demonstrated the potential for a
rehistoricisation of space, both at the site of the projection itself, but also
reaching beyond it through displacement, condensation, metaphor, and
similarity (Lefebvre 1997). It demonstrated, like *McLarena* and *The Image
Mill*, that media in public space need not necessarily estrange us from the
terrestrial plane as Virilio (1986) once noted: it can show this terrestrial
plane to be malleable and personal through ambivalence and contingency.
Through projection at the scale of architecture, every structure might be

seen to be a monument or memorial in the making, its potential waiting to be unearthed, gathered from its surroundings and/or archival wake, and represented directly on it to allow for its reanimation and collective embodiment in shared memory.

The Line improved upon our experiments with *30 moons* in that it provided a clear and comfortable space for congregation, enhanced by the localised provision of sound. This allowed us to capture a peripatetic audience in this semi-public space and to hold them within the embrace of our installation despite it being located in the middle of an open field. *The Line* also benefitted from the repetition and longevity afforded to it over the course of the installation, allowing visitors to visit and revisit the installation at their leisure. Spectators were also primed for the content through the exhibition program and by the didactic information at the site. It is clear that the success of a large-scale public address depends on the space around it, which includes the spaces of permission, dissemination, and curation that allow it to exist and flourish, legitimising its place, and entrenching it within a space in memory despite its ephemerality.

What *The Line* was not able to achieve, again due to time and budgetary constraints, was some aspect of interactivity akin to the interactivity that contributed to the success of *McLarena*. We had initially toyed with the idea of having various segments of the snow fence in *The Line* appear or disappear depending on the proximity of the viewer to the screen, or to have pressure sensors embedded into the benches to cause different video segments to appear as viewers sat down to view the work. This would have integrated the viewer more directly into an identification with the images and their role in engaging the various lines that criss-cross the landscape, expressing and constituting the conditions of suburban life. It would have also created the possibility for cooperative play and greater communal identification with the images if the simultaneous, coordinated efforts of spectators (all approaching the screen at once, or all sitting down across the benches at the same time) could have been reflected in coherent line segments or could have triggered hidden material. This would have better approximated a democratic surround and an activated spectatorship — a space of appearance. The message of such coordinated efforts would have helped to instil a sense of empowerment and responsibility in the construction of (semi-)public space (through the construction of the public image), thus approximating a political position through massive media, a democratic surround in which our collective future and past, as well as individual autonomy, might be better expressed through the public, interactive image.

A Perceptual Laboratory

Assemblages of media, architecture, and space centred upon the composite dispositif of large-scale public projection — one form of massive media — challenge practices of monumentality and the development of public culture. In their efforts and ability to interface with space, something we can analyse through lenses borrowed from film studies, namely superimposition, montage, and apparatus/dispositif and through direct engagement with the medium via creation-as-research, these installations create ontological bridges between diegetic and the extra-diegetic realms, suturing them together such that a hybrid and relational space is created between the moving image and its surroundings, merging the logic of the screen and the logic of architecture and monumentality. The affective and attractive potential of the screen, particularly when it is coupled with the manipulation and networking capabilities of digitality, are merged with the solidity, visibility, history, and stature of public spaces, their buildings, and their objects and sites of public representation. The new narrative and associated potentials that emerge from this confluence lay the groundwork for the possibilities of rehistoricising a space, that is, of opening it up to alternative meanings, relational identity formation, and unexpected encounters with historical and archival site-specific material. In many ways, massive media, still in many ways in a nascent phase, mirrors the early days of cinema in which the medium both oriented and disoriented audiences, providing a 'perceptual laboratory' (McQuire 2008, 114) in which audiences could understand time, space, identity, and the city, in new ways.

The examples presented in this chapter of the transformation of buildings into screens through projection begin to outline some of the possibilities for this new perceptual laboratory. For example, *The Image Mill* attempted to capture a peripatetic audience by engaging a composite dispositif that incorporates various combinations of sight, sound, scale, and touch, in order to approximate a democratic surround, that is, to provide multiple sensory inputs that the viewer recombines in their own unique way. Works such as *McLarena* at the *Quartier des spectacles* extend the democratic possibilities of the medium by incorporating a more active spectatorship through direct participation in and through the image. Critical and creative practices with massive media run counter to the equally plausible and probable expansion of advertisements that tap into the novelty of the form, as well as its affective potential generated

through the moving image, to recentre generalised audiences in urban spaces towards a capitalist address. That said, due to the high cost of producing and maintaining large-scale public projection works, projects such as *The Image Mill* and *McLarena* invariably rely on public funds and access to crucial zones of commerce and tourism in cities, and thus must also remain, to a degree, vehicles for the promotion of the city as an attractive, engaging, progressive destination: a perceptual and commercial laboratory.

Regardless of their purpose and content, all works of large-scale public projection challenge the naturalised exclusions of public space, that is, they begin to allow for a certain level of ambivalence and contingency in the expressivity (or lack thereof) of architectural surfaces. They also represent a dense transfer point and focus for personal and public post-production practices through image appropriation and remediation that serve to deeply embed architecture and public space in contemporary image practices. Beyond this, though, massive media must continue to be developed by cities, curators, and artists, opening sites to greater experimentation and criticality in order to achieve more reflective, productive, and democratic forms of monumentality. *Quartier des spectacles* remains a promising model in this sense, providing year-round access and interactive programming that allows for a greater degree of artistic expression, a wider variety of interpretations of a space, both through the image and through the movement of peripatetic audiences, and a deeper development of the capacity for audiences to engage with this new medium. This, I would argue, is an example of how massive media can better reflect the 'popular needs and aspirations' (Mumford 2000, 151) of our time. Artists and curators must see the value in developing a capacity in both public space and the public audience, on- and offline, near and far, to address the potential of an architecture and monumentality of expanded cinema and new media art. In the next chapter, I shift the focus to an arguably more durable and architecturally integrated form of massive media — low-resolution LED façades — in order to further explore the narrative and associative potential of massive media and its implications for the co-evolution of space, media, and identity.

An early version of this chapter titled, 'An Expanded Perceptual Laboratory: The Cinematic Effects of Superimposition, Montage, and Apparatus/ Dispostif in Public Art' has been published in *Public Art Dialogue* 5(2): 112-130 (2015).

References

Arendt, Hannah. 1958. *The human condition.* Chicago: University of Chicago Press.

Bennett, Susan. 2009. The peripatetic audience. *Canadian Theatre Review* 140 (Fall): 8-13.

Berman, Marshall. 2001. Metamorphoses of Times Square. In *Impossible presence: Surface and screen in the photogenic era*, ed. Terry Smith, 39-69. Chicago: University of Chicago Press.

Bishop, Claire. 2012. *Artificial hells: Participatory art and the politics of spectatorship.* London: Verso Books.

———. (ed.). 2006. *Participation.* London: Whitechapel.

———. 2004. Antagonism and relational aesthetics. *October.* 110: 51-79.

Blatchford, Andy. 2008. Massive Robert Lepage projection show tells 400 year story of Quebec City. *The Canadian Press*, July 9, 2008.

Brougher, Kerry. 2008. The cinema effect. In *The cinema effect: Illusion, reality, and the moving image.* London: Giles.

Colomina, Beatriz. 2009. Enclosed by images: The Eames's multiscreen architecture. In *Art of Projection*, eds. Stan Douglas and Christopher Eamon, 36-56. Ostfildern, Germany: Harje Cantz.

Crary, Jonathan. 1999. *Suspensions of perception: Attention, spectacle and modern culture.* Cambridge, MA: MIT Press.

Debord, Guy. 2009. *Society of the spectacle.* Trans. D.N. Smith. New York: Zone Books.

Demers, Amélie. 2010. L'Offre nocturne de la ville de Québec: Vers un tourisme de la nuit. *Rabaska* 8: 43-49.

De Souza e Silva, Adriana. 2006. From cyber to hybrid. *Space and culture* 9(3): 261-278.

Doane, Mary Ann. 2009. The location of the image: Cinematic projection and scale in modernity. In *The art of projection*, eds. Stan Douglas and Christopher Eamon, 151-166. Stuttgart: Hatje Cantz.

Dubé, Philippe. 2012. The Image Mill: A sense of place for a museum of images. In *Making Sense of Place*, eds. Ian Covery, Gerard Corsane, and Peter Davis. Woodbridge, UK: The Boydell Press.

EX MACHINA. 2014. The Image Mill™. *Ex Machina.* Accessed October 16, 2016. http://lacaserne.net/index2.php/other_projects/the_image_mill/.

EX MACHINA. 2015. Reviews. *Ex Machina.* Accessed October 16, 2016. http://lacaserne.net/index2.php/reviews/the_image_mill/le_moulin_images_making_history_for_quebec_citys_400th/.

Fuller, Matthew. 2005. How this becomes that. In *Media ecologies: Materialist energies in art and technoculture*, 85-107. Cambridge, MA: MIT Press.

Giedion, Sigfried. 1944. The need for a new monumentality. In *New architecture and city planning*, ed. Paul Zucker, 549-568. New York: F. Hubner & Co.

Gunning, Tom. 2007. To scan a ghost: The ontology of mediated vision. *Grey Room* 26(Winter): 94–127.

Hansen, Miriam Bratu. 1993. Unstable mixtures dilated spheres: Negt and Kluge's the public sphere and experience, twenty years later. *Public Culture* 5: 179-212.

Kenner, Hugh. 1975. *A homemade world: The american modernist writers*. New York: Morrow.

Kracauer, Siegfried. 1965. *Theory of film; the redemption of physical reality*. London: Oxford University Press.

Kracauer, Siegfried, and Thomas Y. Levin. 1995. *The mass ornament: Weimar essays*. Cambridge, MA: Harvard University Press.

La Presse Canadienne. April 1, 2013. La Ville De Québec confirme que Le Moulin à Images en sera à sa dernière année. *Huffington Post*. Accessed October 16, 2016. https://quebec.huffingtonpost.ca/2013/04/01/la-ville-de-qubec-confir_n_2993919. html?utm_hp_ref=qc-pc.

Lefebvre, Henri. 1997. The monument. In *Rethinking architecture: A reader in cultural theory*, 133-137. London: Routledge.

Lepage, Robert. 2011. *Le Moulin à images: L'événement phare du 400ᵉ anniversaire de la ville de Québec*. DVD. Quebec: National Film Board, 2011.

Lessard, Bruno. 2009. Site-specific screening and the projection of archives: Robert Lepage's *Le Moulin à images*. PUBLIC 40: 70-82.

Lynch, Kevin. 1960. *The image of the city*. Cambridge, MA: MIT Press.

McKim, Joel. 2012. Spectacular infrastructure: The mediatic space of Montreal's 'Quartier des spectacles'. PUBLIC 45: 128-138.

McQuire, Scott. 2008. *The media city: Media, architecture, and urban space*. London: Sage.

Moholy-Nagy, Laszlo. 1969. *Painting, photography, film*. London: Lund Humphries.

Mumford, Eric Paul. 2000. *The CIAM discourse on urbanism, 1928-1960*. Cambridge, MA: MIT Press.

Nora, Pierre. 1989. Between memory and history: Les lieux de mémoire. *Representations* 26(Spring): 7-24.

Phillips, Patricia C. 2003. Creating democracy: A dialogue with Krzysztof Wodiczko. *Art Journal* 62(4): 32-47.

Rancière, Jacques. 2000. *The politics of aesthetics*. Trans. Gabriel Rockhill. London: Continuum.

Rowell, Margit. 1978. Vladimir Tatlin: Form/Faktura. *October*, 7: 83-108.

Saidi, Habib. 2012. Capital cities as open-air museums: A look at Québec City and Tunis. *Current Issues in Tourism* 15: 1-2, 75-88.

Shental, Andrey. 2013. In the junkyard of wrecked fictions. *Mute*. 14 May. Accessed
 July 4, 2014. www.metamute.org/editorial/articles/junkyard-wrecked-fictions.

Simmel, Georg. 1950. The metropolis and mental life. In *The Sociology of Georg
 Simmel*, trans. Kurt Wolff, 409-424. New York: Free Press.

Smith, Hazel and R. T. Dean. 2009. *Practice-led research, research-led practice in
 the creative arts*. Edinburgh: Edinburgh University Press.

Thain, Alanna. 2008. Affective commotion: Minding the gap in research-creation.
 INFLeXions 1: 1-12.

The Canadian Press. July 10, 2008. Massive Robert Lepage show reflects Quebec
 City's story. *CBCnews*. Accessed October 16, 2016. http://www.cbc.ca/news/canada/
 montreal/massive-robert-lepage-show-reflects-quebec-city-s-story-1.706088.

Turner, Fred. 2012. *The family of man* and the politics of attention in Cold War
 America. *Public Culture* 24(1): 55-84.

———. 2013. *The democratic surround: Multimedia & American liberalism from
 World War II to the psychedelic sixties*. Chicago: The University of Chicago Press.

UNESCO. 2014. Historic district of Old Québec. *UNESCO World Heritage Centre*.
 Accessed October 16, 2016. http://whc.unesco.org/en/list/300.

Verhoeff, Nanna. 2012. *Mobile screens: The visual regime of navigation*. Amsterdam:
 Amsterdam University Press.

Virilio, Paul. 1986. The overexposed city. *L'espace critique* (Paris: Christian Bourgeois,
 1984); translated in Zone 1-2 (New York: Urzone, 1986), trans. Astrid Hustvedt:
 14-31.

Wodiczko, Krzysztof. 2015. The Inner Public. *FIELD*, 1. Accessed June 1, 2015. http://
 field-journal.com/issue-1/wodiczko.

Youngblood, Gene. 1970. *Expanded cinema*. New York: Dutton.

3. Low-Resolution Media Façades in a Data Society

Abstract

The highly visible and data-reactive low-resolution displays of buildings like Toronto's CN Tower or New York's Empire State Building shape the texture, tempo, and legibility of the urban experience, an experience that is produced (and consumed) in a unique combination of on and offline activity. I argue that these expressive surfaces increase the ambivalence and contingency of the ways we read (and write) the city, enabling the formation of temporary publics through public data visualisations that combine elements of democratised urbanism, critical debate, emotion, control, and commerce. Through historical research, social media analysis, and research-creation, this chapter focuses on the specific case of the Empire State Building and reports on the relationships between information, public space, and architecture that are sustained and supported by low-resolution, expressive architectural façades. The chapter ends with a discussion of the potential for artistic and activist uses of low-resolution digital architectural displays.

Keywords: media façades, media architecture, social media, digital culture, information aesthetics

This Building is on Fire

It certainly was not the first time New Yorkers saw flashing lights atop the Empire State Building; but, it was the first time the lights danced as they did, synchronised to Alicia Keys' singing two of her songs, 'Girl on Fire' and 'Empire State of Mind', appropriately selected for the launch of the building's newly installed programmable LED lighting system. Amidst the ambient glow of the surrounding buildings, bright orange and red hues shifted to blue, purple, and yellow with the pulsating rhythm of the music. The colours mixed and faded into one another, rippling across the

Colangelo, D., *The Building as Screen: A History, Theory, and Practice of Massive Media*. Amsterdam: Amsterdam University Press, 2020

DOI 10.5117/9789462989498_CH03

The NEW Empire State Building Lights - Live Show with Alicia Keys
41,799 views

Rommel102
Published on Nov 26, 2012

Alicia Keys officially opens the new lighting on the Empire State with Girl on Fire and Empire State of Mind. Broadcast live on Z100. Filmed out of our bathroom window in Chelsea!

SHOW MORE

Figure 3-1: Empire State Building, live light show with Alicia Keys, November 26, 2012, YouTube, screenshot. Google and the Google logo are registered trademarks of Google LLC, used with permission.

façade and rising up and down the antennae to Keys' voice. As Megan Garber (2012) of *The Atlantic* described it, it was like 'a fireworks show, with the illumination in question coming not from controlled explosions, but from controlled LEDs'. It was a firework-like show that in its apparent silence could be completely ignored or misinterpreted by thousands while remaining a formidable centre of attention for those who knew what to look and listen for by tuning in to the synchronised audio on a local radio station. Furthermore, the show rippled out into the night (and the days thereafter) on screens of those near and far via YouTube (see Figure 3-1), Instagram, and Twitter, and Facebook.

That evening in November of 2012 marked the beginning of an increasingly varied and experimental program of lighting atop the Empire State Building, a distinct shift in the lighting tradition of the building that began in its first years of operation in the early 1930s. The Empire State Building's new lighting program is itself a part of a larger shift in monumentality, architecture, public space, and digital culture characterised by

the transformation of iconic buildings and significant architectural sites such as Toronto's CN Tower or Paris' Eiffel Tower into, essentially, very large screens. An emerging collection of new, purpose-built structures, such as the Ars Electronic centre in Linz, Austria, and the Ryerson Image Centre and Ryerson School of Image Arts (RIC/IMA) in Toronto, have also incorporated low-resolution, expressive lighting elements into their façades from the start. As evidenced by the Alicia Keys event on the Empire State Building, these structures, with their new communicative surfaces, are capable of creating connections between people and the city in order to produce new collective, embodied, and emotional experiences.

Not unlike their public projection counterparts, these buildings-as-screens, when combined with the expanding field of digital media — the 'possibility machines' (Galloway 2012, 55) that include all manner of ubiquitous computing and sensing devices, and the social networks that encourage their situated use — contribute to the formation of a 'composite dispostif' (Verhoeff 2012, 105) where screen spaces cooperate and compete in an increasingly geographically distributed, hybrid (De Sousa e Silva 2006), and relational space characterised by ambivalence and contingency (McQuire 2008). Like public projections, they incorporate and extend established environments and practices of spectatorship (the city, the cinema, and the radio, for example), with their affordances and attendant ideologies in order to co-constitute a relational experience through spatial montage and superimposition. That said, low-resolution media façades can be seen to more easily incorporate social and mobile media into their composite forms, often requiring these channels to encourage engagement with their content through various levels of participation, or help decode and disseminate their ephemeral, abstracted messages to an audience that is, like public projection, geographically dispersed and peripatetic (Bennett 2009).

Furthermore, these low-resolution surfaces, in their limited expressive capabilities, often display fluctuations in one or two variables at most, thus creating what Dávila and I (2011) have termed 'public data visualisations', or what Vande Moere and Hill call 'urban visualisations' (2012, 26), that dramatise architecture and data in order to make data more public and visible, to make the city more expressive, and to involve citizens in urban issues in novel ways. Public data visualisations represent a unique confluence of data, networks, architecture, and public space, allowing for the mapping of context and site-specific data in real-space and real-time onto physical space in ways that can be engaged on- and offline. Thus, public data visualisations, like public projection, can also engage temporary publics and reimagine monumentality by creating focal points for transversal communication that

combine elements of democratised urbanism, collective memory, debate, emotion, control, and commerce.

Finally, as they are directly integrated into architectural surfaces — as opposed to the ephemeral application of projected light — low-resolution media façades and media architecture (Media Architecture Institute 2015) represent an important shift in architecture that merges the logic and presence of the screen with the logic of the building and the monument in durable, permanent ways. As such, this form of massive media, more consistently than public projection, evokes debates of attention and/or distraction through the increased contingency and ambivalence of architectural surfaces and the subsequent strengthening or weakening of a historical consciousness associated with space and architecture. As a result, I argue that embedded, low-resolution buildings-as-screens most clearly represent the development of a supermodernism (Ibelings 2002) in architecture characterised by the irruption and imbrication of the 'infoscape' and the cityscape, where data-rich public spaces of identity, congregation, and contestation seek and find appropriate and consistent outlets in said structures.

Specifically, in this chapter, I argue that these assemblages of media, architecture, and space challenge our ideas of what public culture is, and how things like collective unity, civic pride, nationalism, and progress are expressed through space and artistic expression. Focusing on the Empire State Building as a case study, a structure with a long history of expressive, low-resolution public display, I trace the history of expressive lighting on the building, demonstrating they ways it has become more varied in its lighting program and more integral to the life of the city as a result. I analyse current social media traces incorporated into its lighting schemes, isolating representative examples from the official @EmpireStateBuilding Twitter and @empirestatebldg Instagram feeds, extending an analysis of the ways massive, networked, low-resolution public data visualisations now change and challenge notions of space, monumentality, and the public sphere by engaging diverse, transversal, and (sometimes) participatory publics. More practically, I explain, by way of a number of examples, how data, networks, and animations combine to create massive media that are situated, functional, and informative (Vande Moere and Hill 2012) and how they are shaped by and relate to their environment, content, and carrier (Vande Moere and Wouters 2012). Finally, by presenting two of my own works engaging with low-resolution LED façades on buildings, *E-TOWER* (2010) and *In The Air, Tonight* (2014-), I argue that the preceding characteristics can be applied to evaluate the efficacy of low-resolution media façade installations while also arguing for the importance of experimentation in

this emerging interdisciplinary form, one limited in its expressive register and primarily attached to highly controlled and corporatised spaces that often preclude alternative uses. This can be achieved through persistent advocacy and action focussed on participatory, open, and accessible design, and well-informed and funded curatorial support (discussed in greater detail in Chapter 4).

A Short History of the Empire State Building

Although completed in 1931, it was not until November 1932 that the Empire State Building installed its first proper lighting system. A searchlight beacon was mounted at the top of the building to mark the election of native New Yorker, Franklin D. Roosevelt, to the office of the President of the United States of America (Empire State Building 2014). In this new role as iconic information signal the building showed Americans that they were united under the guiding light of a new administration, performing the displace-ment and condensation that Lefebvre (1997) describes of monuments: condensing an entire nation's desires onto the spire of the building now imbued and expressive of the spirit of a nation. Furthermore, by combining the celebration of an election with a powerful symbol of civic pride, the lighting designers and management of the Empire State Building intensified the meaning of both in the process (Rowlands and Tilley 2006), transferring power from the office of the president to the building and back again.

The combination of architectural lighting and information was far from a novel phenomenon in New York in 1932. Other building types and lighting configurations dotted the skyline with dynamic displays. Architectural lighting was a mark of sophistication and status for a building and the city. The dynamic floodlighting of the Empire State Building simply allowed the icon to 'join ranks with others of its age' (Tauranac 1995, 188). In fact, the original plans for lighting the Empire State Building were influenced by the appearance of communicative and dynamic context-specific light displays on other prominent buildings. Since the 1920s, the Metropolitan Life tower on Madison Square and the Con Edison Building on Fourteenth Street flashed white every hour and red every quarter of an hour (ibid., 188). Douglas Leigh, the man responsible for creating numerous advertising 'spectaculars' in Times Square and Broadway in the first half of the twentieth century, sensed at the time 'an insatiable yearning for constantly knowing the time and temperature' (Sellmer 1946, 48) amongst the rapidly growing crowds in Manhattan. Consequently, a seven-story high thermometer for

Figure 3-2: Canada Life Building weather beacon guide. Courtesy: Great-West Life/
Canada Life.

an ale company and a clock for the Gruen watch company were among
Leigh's many proposals for clients at the time.

The Canada Life Building in Toronto was another example of the early
use of expressive architectural lighting to draw attention to buildings by
providing timely and noteworthy information. Although the building opened
in 1931, it was not until 1951 that a 12.5 m tall spire of lights was installed on
its roof, 98m above the street.

The lighting system featured a long stem of yellow lights that were timed
to create a rising or falling effect depending on the forecasted temperature.
It also featured a tip that flashed red or white, indicating rain or snow
respectively. Solid green meant the weather ahead was clear, and solid red
meant it was going to be overcast (see Figure 3-2). The president of Canada
Life, E.C. Gill, told the Toronto Star in 1951 that the building should provide
both a useful service as well as a point of general interest and connection
for people of the city. Gill added, 'For most people the weather provides
a topic of conversation at all times' (quoted in Bateman 2013). Expressive

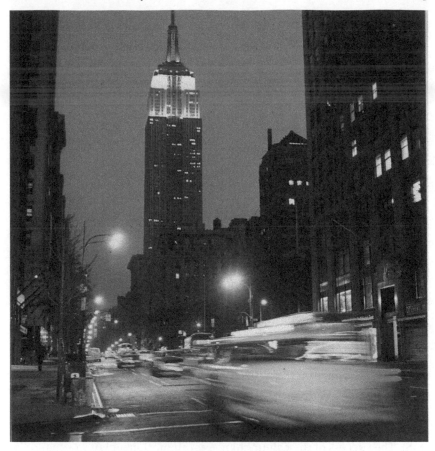

Figure 3-3: The Empire State Building's 'Freedom Lights' in 1976.

lighting enhanced the function of civic architecture, making it both a point of reference geographically but also spatially and socially by combining site and context-specific information with the status and visibility of a building.

Thus, from an early stage, the communicative use of architectural lighting could be seen as unifying, informing, and stimulating conversation amongst city dwellers while also elevating the esteem of structures and the organisations attached to them. It became part of how the city was 'read' (Henkin 1998), and thus shaped and reflected the shifting publics around them. Beyond the relatively static nodes and landmarks described by Lynch (1960), these buildings in their screen-like behaviour, captured attention through contingency and dynamic, context-specific relevance. They introduced elements of ambiguity, ephemerality, and expressivity into practices of monumentality. Additionally, by furnishing conversation, architectural lighting enhancements went beyond providing useful

information by adding a new dimension to the public realm and the public sphere. Rituals of collective activity were stimulated by these structures and the structures became, as Warner (2005) points out of contemporary public spheres after Habermas, more emotional, playful, apolitical, and agnostic. Early public data visualisations created and recentred publics by providing dynamic information that prompted city dwellers to look with regularity and to share the implications and outcomes of this contextually relevant information with others, thus transforming the social life of the city, its inhabitants, and, consequently, the status and function of its buildings.

Colours and Meanings

In 1976, Times Square's lighting impresario Douglas Leigh was serving as chairman of City Décor for the National Democratic Convention and the Bicentennial that year. Having once been denied an opportunity to work with the building's lights,[1] Leigh was determined not to be turned down again. While looking for a way to celebrate the Bicentennial events he was presiding over, Leigh asked management to change the white lights atop the building to red, white, and blue (see Figure 3-3). Leigh called it the application of 'color with meaning' (quoted in Tauranac 1995, 358). The new scheme proved to be quite popular. Architect Charles Linn said the building became 'the toast of the town' (quoted in Tauranac 1995, 358). The success of the colour change set in motion a plan to expand the colours to include more 'meanings'. For Martin Luther King Jr. Day the tower glowed red, black, and green; for Valentine's Day, red and white; for Easter Week, white and yellow; for police memorials, blue, and so on. As Tauranac notes, 'These colours became traditional as did celebrating specific events' (Tauranac 1995, 358). In addition to these traditions, new uses for the lights and their semiotic potential were explored. In this inaugural year of expanded programming, a creative solution for celebrating the Camp David peace accord was presented where two sides of the building were lit in the state colours of Egypt and the other two lit in the colours of Israel (ibid., 359). In their expanded format the lights now inserted the Empire State

1 Leigh had considered the Empire State Building as the canvas for one of his 'spectaculars' but his pitch was eventually denied due to citywide restrictions resulting from America's entry into World War Two. As Tauranac notes about this failed pitch, 'His dream was to light it like a cigarette, with ashes at the top and smoke curling up into the heavens, an advertising colossus created by a million white electric bulbs, a few thousand red lights to paint a burning tip against the night sky, and the Lucky Strike name emblazoned in neon on all four sides' (1995, 313).

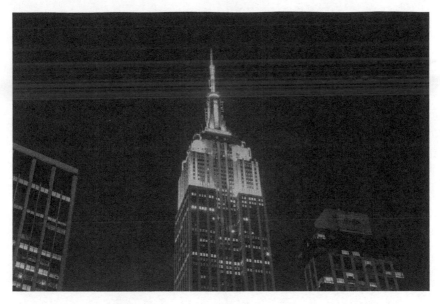

Figure 3-4: The Empire State Building with Philips Color Kinetics System. Photo: Anthony Quintano.

Building more deeply into the fabric of the city, and of the world, creating a focal point for a growing list of events, milestones, holidays, and causes. This expansion was limited only by the investment of time and money required to change the lights — a six-hour process that called for a team of at least six workers to replace coloured filters on the fixtures (Collins 2007). Over time, the building had become more sensitive and expressive of its unique time and place, growing into its new role as a monumental marker of contextually relevant information.

Indicative of the growing popularity of the practice of expressive architectural lighting and improvements in lighting technology, in 2012 the Empire State Building installed a Philips Color Kinetics programmable LED lighting system (see Figure 3-4) capable of displaying an array of over 16 million colours in 'virtually limitless combinations', all at the push of a 'computer controlled' button (Philips 2012). Shortly after this change, the lighting system was called upon another presidential election. Times had changed: instead of simply and poetically indicating the final result as it did 80 years earlier with a single white searchlight, the building was programmed to display an up-to-the-minute tally of votes during election night coordinated with real-time coverage on television, the Internet, and social media (see Figure 3-5). The CNN Press Room website described the lighting event as such:

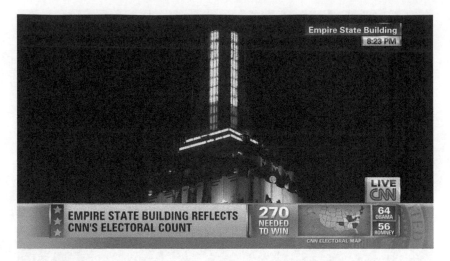

Figure 3-5: Empire State Building with CNN election results for Presidential election, 2012, screenshot.

The four-sided tower, which sits atop the building more than a quarter of a mile from the streets of Manhattan, will be illuminated in patriotic red, white and blue vertical stripes, while the mast will be lit in blue and in red on two sides each to represent President Obama and Gov. Romney's respective electoral vote totals. CNN, which will exclusively shoot footage from the rooftop of a neighboring building, will air live images of the illuminated tower as the evening's results progress. When CNN projects a winner of the presidential election, the tower lights of the Empire State Building will change color to all-blue or to all-red (CNN 2012).

Changes in the media landscape over the past century (i.e., satellite television, the Internet) meant that the building would now be a central figure not only in the city, but for countless social media posts. It would also be the epicentre of attention and action for one of the world's largest news networks on one of the biggest news nights of the decade — a focal point in a global composite dispositif. It could call out to and capture an audience in a number of coordinated ways, drawing them in with the promise of real-time updates, animation, and participation. The level of detail of its message, its amenability to appropriation and transformation by media outlets and viewers, had changed greatly since 1932 (see Figure 3-6), and its status as a global icon was supported and reinforced in the coordinated and distributed mixture of localised and globalised communication.

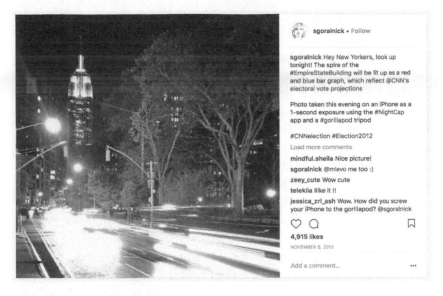

sgoralnick • Follow

sgoralnick Hey New Yorkers, look up tonight! The spire of the #EmpireStateBuilding will be lit up as a red and blue bar graph, which reflect @CNN's electoral vote projections

Photo taken this evening on an iPhone as a 1-second exposure using the #NightCap app and a #gorillapod tripod

#CNNelection #Election2012

Load more comments

mindful.sheila Nice picture!

sgoralnick @mlevo me too :)

zeey_cute Wow cute

telekiia Ilike it !!

jessica_zrl_ash Wow. How did you screw your iPhone to the gorillapod? @sgoralnick

4,915 likes

NOVEMBER 6, 2012

Add a comment...

Figure 3-6: sgoralnick, Instagram, screenshot.

This agglomeration of media saw the Empire State Building assume a prime position during the 2012 election as a massive data visualisation — a big canvas for big data (and big business). The Alicia Keys event that officially kicked off the new lighting scheme further demonstrated how programmable low-resolution façades have expanded the role of architecture in contemporary cityscapes. These events substantiate an important trope of the building as screen focused on data collection, participation, and visualisation in order to support new and contested public spheres and rituals of mass culture, collective memory, and communal experience. We might consider these new examples of Giedion's 'new monumentality' (Mumford 2000) as they work to better reflect and include a transverse community that congregates around a monumental symbol both in person and online. Public data visualisations, a category supported directly by lighting systems such as those found on the Empire State Building, allow for expanded possibilities for the buildings and spaces they occupy and the audiences they address, enabling a re-coding of space and a recentring of local and geographically distributed audiences. At the same time, as in the 1932 example, today's low-resolution media façades carry on a tradition that sees highly visible buildings as sites for the display of 'public' information to be digested, consumed, circulated, and shared.

Public Data Visualisations

The current complexity in contemporary expressive architecture can be theorised through the concept of public data visualisation (Colangelo and Dávila 2011) — that is, assemblages of light, data, and space that make data publicly visible and legible, dramatising architecture and data in the process. Vande Moere and Hill see the potential for public data visualisations, or what they call 'urban visualisations', for improving the quality of life in cities by involving the local population in understanding the key drivers of urban issues (2012, 26). This includes constituting an 'activated spectatorship' (Bishop 2004) and a new register for public discussion and debate via public displays of data. As such, the authors state that successful and effective urban visualisations must be *situated*, *informative*, and *functional*. An urban visualisation is *situated* if it is embedded in a real-world environment and both borrows and contributes to it (Vande Moere and Hill 2012, 26). As the authors note, if an urban visualisation is properly situated, it should not require much in the way of a detailed explanation to be understood. For example, the urban visualisation found in *Pollstream-Nuage Vert* (2008) in Helsinki, an installation that incorporated laser light to illuminate a proportion of CO_2 emissions emanating from a smoke stack based on local energy consumption levels, uses a symbol of energy consumption as its canvas in order to become more legible and impactful through self-referentiality (see Figure 3-7). An urban visualisation is *informative* if it allows onlookers to create meaningful insights or provide feedback (Vande Moere and Hill 2012, 26). *Pollstream-Nuage Vert* certainly allows for the creation of meaningful insight, but does not directly provide a feedback mechanism, so it does not fully satisfy this criterion. Finally, an urban visualisation is *functional* if it reaches a significantly large audience, does not impede other civic functions, blends into the urban fabric in a pleasing manner, provides trustworthy information by being fair and accurate, reveals its sources, and is persuasive in some way, calling for some sort of reflection, change or action (ibid., 26). Again, *Pollstream-Nuage Vert* is functional in that its scale allows it to reach a large audience, its presentation does not impede the functioning of the smokestack, its sources are revealed to be fair and accurate on its website, and it is certainly persuasive in terms of encouraging energy saving measures. Overall, it functions as a public data visualisation in that it makes information more visible and legible, dramatises architecture and urban space, and involves the local population in a key urban issue.

Figure 3-7: HeHe (Helen Evans and Heiko Hansen), *Pollstream-Nuage Vert* (2008), Helsinki.
Photo: Helen Evans and Heiko Hansen, courtesy of the artists.

In addition to functional, informational, and situational considerations, Vande Moere and Wouters discuss the importance of aligning public data visualisations with the overall *context* in which they exist. To unpack context, they focus on the importance of the interplay and cohesion between the *environment* (surrounding buildings, local culture, atmosphere), *content* (the information displayed and any interpretations that may be generated by it), and *carrier* (the building, square, façade, or any other element that supports the medium). They advocate for a 'context-awareness' (2012, 1) as a design characteristic for media architecture along these axes to ease community acceptance and improve the efficacy of these structures in society so that they might be less susceptible to falling out of use or favour. One example of media architecture failing to remain sustainable due to a change in *environment* and *carrier* context is that of the Dexia Tower in Brussels, Belgium. The 145m tower, equipped with individually controllable LEDs, was initially the site of several artistic media installations including *Weather Tower* (2008), an installation that turned weather data into abstract forms on the building. The tower had been unused since 2008 apart from a persistent 10-minute animation that ran sporadically to demonstrate the system's capabilities. The disuse of the Dexia Tower's LED façade coincided with the dramatic collapse of Dexia Group in 2011, and the bank has since

Figure 3-8: Onur Sönmez and Tamer Aslan, *NOX* (2013), Ars Electronica Center, Linz.
Photo: Onur Sönmez, courtesy of the artists.

decided that the changes in the public's perception of the company no longer allowed for the kinds of displays they had once sponsored and supported. The Media Screen Flagey Square, also in Brussels, presents another example of contextual friction caused by media architecture. The 12m² screen had been vandalised with paint and its supply wires were set on fire on a number of occasions as a result of it being perceived as an unwanted 'commercial invasion' for displaying ads for luxury retailers in a low-income area of the city. This represented a failure in contextual sensitivity with respect to the *content* and *environment* of the media façade, resulting in a form of community-initiated dissent or counter-monumentality.

One particular example of a media façade that has struck a balance between environment, content, and carrier is the Ars Electronica Center in Linz, Austria (see Figure 3-8). The building, consisting of 1085 3'x1' back-lit glass panels, has consistently been used for artistic experimentation since 2009. Part of the official mandate of the Ars Electronica Center involves 'testing ways in which we might be interacting and communicating

2 The official Empire State Building Twitter feed, @EmpireStateBldg, also tweets lighting information nightly, while interspersing these tweets with non-lighting related information about events and activities at the venue. @EmpireLights was selected as it reports exclusively on the lighting scheme of the tower every night.

with our surroundings and other human beings in the very near future, and getting an impression of what these changes will mean for us and our society' (Ars Electronica 2015). As such, the Center deliberately and consistently seeks to develop its façade as a coordinated exhibition space for experimental public data visualisations. The Ars Electronica Center thus occupies a unique space in the massive media world in that it supports access to the façade and its surrounding space of exhibition and interaction through curation and actively develops an audience for its presentations. One of Ars Electronica's projects for their façade, *NOX*, consisted of a pull switch suspended in the middle of a viewing area in front of the building that, when activated, turned all of the pixels on the building on or off like a lamp. The simplicity of the installation posed a simple yet crucially relevant conceptual question about massive media: are such façades seen as purely aesthetic embellishments and superficial gadgets layered over architecture, or do they signal an important shift in our urban fabric that seeks to make buildings more performative and expressive of the actions and desires of citizens? Can they be designed and programmed to be more accessible and representative of the wishes of a certain public? It made the façade itself into an urban issue central to the emergence of expressive, programmable architecture. The Ars Electronic Center, with installations like *NOX*, point to the promises and pitfalls of digital communication (and communion), and the possibility for the low-resolution building as screen to engender and engage community and debate through public data visualisations that are situated, informative, and functional.

The Empire State Building

What particular challenges and possibilities for monumental public data visualisation exist for a building of the scale and stature of the Empire State Building? In the following section, I describe the Empire State Building's lighting program as well as its associated traces on Instagram and Twitter. Based on this analysis, I evaluate the role of the Empire State Building against the criteria set out in the previous section: how is it *situated, informative,* and *functional,* and how does it manage aspects of *environment, context,* and *carrier*? I also consider how these changes in architectural lighting affect monumentality, public space, and the public sphere.

An analysis of the data from the @EmpireLights Twitter feed, an unofficial account announcing daily lighting event information culled from the Empire State Building's official site,[2] shows that since 2009, when the first

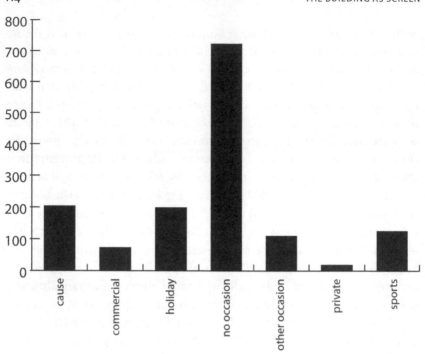

Figure 3-9: Categorised uses of the Empire State Building's lights, 2009-2013.

LED lighting system was installed (later fully upgraded in 2012), the lights have represented holidays, charitable causes, sporting events, commercial promotions, private lighting events, and other occasions (such as memorials or parades), while also defaulting back to 'all tiers white' for 'no occasion' in between. The following chart (see Figure 3-9) presents a breakdown of these categorised uses based on a total of 1454 tweets collected from the account between 2009 and 2013.[3]

Examples of lighting programs characterised as a 'cause' include events and milestones of not-for-profit organisations such as '@boyscouts 100th #Anniversary' (red, white, blue), and 'Autism Awareness Month @autism-speaks' (all tiers blue). These represent 14% of the total uses. Commercial lighting events, representing 5% of the total, have included promotions for 'Caribbean Week @ctotourism' (blue, green, yellow), and '@MammaMia-Musical's 10th anniversary' (blue, pink, white). Holiday lighting schemes, representing 14% of the total, have included multiple nights of '#Christmas'

3 The R statistical analysis program, along with the twitteR plugin, were used to gather historical tweet data from the @empirelights account. See www.r-project.org and http://cran.r-project.org/web/packages/twitteR/index.html.

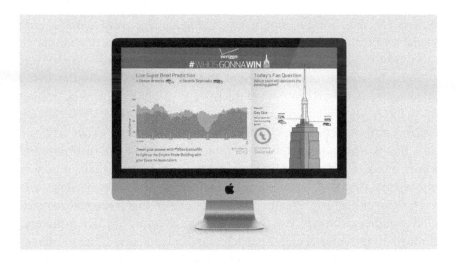

Figure 3-10: Verizon's #WhosGonnaWin promotion for the 2014 Super Bowl, screenshot.

(red, green, green) and '#Hanukkah' (blue, white, blue). Approximately 50% of all lighting days have been 'no occasion' (all white), although this has become less frequent over time. Other occasions have included 'Mexican Independence Day @MCINY' (red, white, green), and 'Family Day' (blue, red, blue), representing 8% of the total. Occasionally, the building's lights are used for private events or film shoots, although this represents less than 1% of total use since 2009. Finally, sporting events make up 9% of the total lighting schemes, with events such as '#SubwaySeries' baseball games illuminating half of the tower in 'blue, white, blue' for the Yankees and the other half 'blue, orange, blue' for the city's other baseball team, the New York Mets. In addition to the categories listed above, certain uses can fall under more than one category. For example, appeals to donate money to charity (@FoodBank4NYC) appear during Christmas and Thanksgiving lighting tweets. Commercial and charitable causes can also be mixed: EsteeLauder's #BreastCancer awareness campaign is one example (all tiers pink).

The Empire State Building has also included more dynamic and complex uses as a public data visualisation. In addition to the public data visualisation of the 2012 election, during a promotion for the 2014 Super Bowl, in the week leading up to the game, fans had the opportunity to pick which team's colours would appear each night by tweeting either 'Broncos' or 'Seahawks' to #WhosGonnaWin (see Figure 3-10). The information about how to participate, widely distributed online and through various media

outlets, formed both the impetus to participate in a massive public data visualisation and the means by which its meaning could be disseminated.

#WhosGonnaWin can be evaluated based on the level with which it was situated, informative, and functional. In terms of this visualisation being *situated*, it existed in the midst of the hype surrounding the week leading up to the Super Bowl in the city in which it was to be hosted, thus having a direct and immediate relationship to the local context. That said, the data that was acquired extended beyond the local context, incorporating information gathered from fans around the world. The visualisation was *informative*, in that it created meaningful insights into the enthusiasm and support for either team. Finally, it was *functional* in that it was able to reach a large audience by virtue of the scale of the building in Manhattan and through the provision of online participation and promotion. This particular example demonstrates one of the roles massive media, in its ambivalence and contingency, can play: as an urban spectacle and as an advanced site of advertisement that can anchor a promotional campaign.

Furthermore, while the visualisations, causes, and events featured on the Empire State Building reflect issues that are closely relevant to the social, cultural, and commercial reality in its vicinity, the building still requires and feeds off of the support of social media to reach its audience, that is, to be truly *situated*. For example, there is no difference between the lights (blue, white, blue) used to celebrate Hanukkah, the Yankees, Columbia University commencement, or the 200th Anniversary of Argentina, except as indicated online. In this sense, the building must be considered to be situated through the hybrid relationality of on- and offline spaces. From this, we might conclude that the environment of a building such as the Empire State Building, and its associated lighting and social media, help to transfer meaning and power between on an offline spaces, just as monuments have transferred meaning and power with their surroundings in the past (Rowlands and Tilley 2006).

By connecting to a social network, particularly forums such as Twitter, Facebook, and Instagram, the Empire State Building integrates its media façade into the flows and associations of online discourse, expanding the reach, visibility, and function of the building as a public data visualisation and monument. It produces a public sphere of experience and ritual, creating a novel 'space of appearance' (Arendt 1958, 198), that bridges the gap between on- and offline space. The Empire State Building engages with its *environment*, that is, its immediate vicinity in an expanded sense, one that includes online spaces, extends its *content*, that is, the information displayed via the LED lighting system, to online environments, and fulfils

an augmented role as *carrier* in that it piggybacks on networks to support its broadcast, shaping the interpretation of the content it displays beyond its immediate physical surroundings. It demonstrates the role that massive media plays in enabling a hybrid or relational space (De Souza e Silva 2006; McQuire 2008) through the contingency and ambivalence introduced into public space via supporting communication networks and ubiquitous mobile devices. It also exemplifies the concept of composite dispositif, combining semi-coordinated standardised environments of spectatorship such as urban space and the smartphone to co-constitute a relational experience (Verhoeff 2012). Furthermore, massive media like the Empire State Building transform the role of the monument, enabling more dynamic, participatory, transverse, and participatory rituals that can be connected to a public sphere that exhibits new 'spatial, territorial and geopolitical parameters' (Hansen 1993), and that contends with competing discourses of art, politics, and commerce.

A closer look at some examples from Twitter and Instagram conversations related to the latest incarnation of the Empire State Building's lights provide greater insight into this phenomenon. They demonstrate how relationships between an expanded environment-carrier-content context are stimulated and maintained through the new monumental and relational spaces created by public data visualisations and associated media: how buildings-as-screens merge the logic of screen media and the monument to engage mass culture, collective memory, and communal experience.

The first example is from the @vanityfair Instagram account. It depicts the Empire State Building in the middle of the New York City skyline, lit in blue to indicate the victory of the democratic candidate, Barack Obama, in the 2012 presidential election. The text provided by @vanityfair simply states 'The Empire State Building is blue' which means that those who responded must have heard about the meaning of the lights beforehand through another media channel (Internet, Twitter, television, radio), word of mouth, or would have inferred its meaning from knowing it was election night or from other comments on the post. Most of the comments are positive, featuring heart and hand-clap emojis. The comments range from elation to relief; also, 886 people liked this post, and a total of 18 people commented on it, making it visible to their own followers in addition to those who follow the @vanityfair account. For a brief moment, until this post was buried under subsequent posts vying for attention and screen space, this composite of light, social media, and monumental space took on an intensity and an emotional resonance as well as an associated corporate value for entities such as Vanity Fair, the Empire State Building itself, and New York City.

On Twitter, at roughly the same time as the Instagram post, a sample of tweets containing the term 'empire state building' provided a glimpse into how the election and the associated lighting event on the tower were discussed online. Responses ranged from gratitude (from celebrity Denise Richards) to a tweet from Vanity Fair linking us back into the Instagram post discussed above. There was ridicule ('CNN's empire state building color thing is super stupid. #CNN #superstupid'), and even international envy ('Imagine our twin towers doing that on election night in [Malaysia]').

One final example involves a lighting configuration honouring South African political figure Nelson Mandela shortly after his death on December 5, 2013. That night, the tower was lit in the colours of the South African flag. Most of the associated comments were positive and supportive, yet traces of dissent were also present. As Instagram user cvtrapp writes, 'South African colors on Pearl Harbor Day? Seriously? Mandela was an amazing man, but I'm not sure his death trumps that other attack of terrorism/war in our country'. This comment shows how the signifying power of the building and its lights, combined with the public function of its visibility, on- and offline, and the facilitation of feedback, can furnish transverse and asynchronous micro-publics of discussion, association, and debate within an expanded sense of carrier, content, and environment. Temporary nodes of intensity within increasingly contingent, networked spaces are created that extend the way that buildings like The Empire State Building can be considered to be situated, informative, and functional. The building becomes *situated* through a matrix of on- and offline references (the status of the building as an icon, and its online status/followers), *informative*, by broadcasting information about causes and events through multiple, connected channels, and *functional*, by generating and facilitating communal, habitual communication and attention for the building and, from time to time, its sponsors.

Despite this, there are limits to its ability to function as a *public* data visualisation. One of the key concerns with all media forms — and media architecture is no exception — is access and moderation. While the Twitter, Instagram, and Facebook feeds related to the Empire State Building remain relatively unmoderated, protocols and procedures for determining what gets commemorated and represented by the lights remains highly controlled by the building's management. The Empire State Building's gatekeeping structures[4] must balance the building's role as private entity and public

4 See the 'lighting partner' application for the Empire State Building http://www.esbnyc.com/pr-pop-culture/tower-lighting-request.

icon carefully. While the building does entertain lighting requests, manage-
ment clearly states that the building is privately owned and thus has its
own selection and review policies. These policies include maintaining full
discretion over selection and denying any requests for political figures and
campaigns, religious figures, organisations, and holidays outside of the
holidays they sanction (Easter, Eid al Fitr, Hanukah, and Christmas). That
said, exceptions are made, seemingly arbitrarily, in instances such as the
Nelson Mandela memorial lighting scheme and the presidential election
coverage, to accommodate sponsors and popular sentiment. Examples
such as #WhosGonnaWin, where control over the lighting scheme is given
to masses of sports fans willing to vote for turning the building the colour
of their preferred team show that when access is (provisionally) granted
to the public it is ultimately brokered by the sponsor, Verizon, and limited
to two choices whose referent has been predetermined. The public sphere
that it substantiates in this instance is severely limited and does not foster
meaningful dissensus and debate but channels this energy into drawing
more attention to a sporting (and advertising) spectacle. While it does reflect
a 'new monumentality' in that it embodies a 'collective emotional event' that
attempts to allow people to play an important role in the unification of an
architectural background, a population, and their shared symbols (Mumford
2000, 568) through its dynamic display, it also captures said elements in
order to sell more phone plans for its sponsor and fuel the hype for a mass
spectacle. Similarly, in the CNN election example, the building's lights are
made to be dynamically responsive, but the choice of the lighting program
is ultimately out of the hands of the public. While election information does
provide an informative function, the participation afforded to the citizen by
the public visualisation is merely a token and does not (and cannot) reflect
the direct result of an individual's participation. In both examples, the space
of debate and dissensus, the 'space of appearance' (Arendt 1958, 198), is
limited to the Twitter sphere. While the powerful and highly visible building
draws attention to this debate, it remains limited to a small, fragmented
reception by those sifting through a stream of comments online.

That said, even this diluted form of interaction with buildings allows for
the formulation of new kinds of publics and rituals that merge the embodied
experience of the urban with 'disembodied' online experience. Where
publics are sites of discursive contestation circumscribed by the spatial
and technological means that enable them, massive media can be seen to
merge the originary public of concentrated visibility and assembly with
more contemporary, fragmented, ephemeral groups of dispersed digitality.
Massive media functions through the immediate visibility and feedback of

a body politic with the fragmented, asynchronous feedback of a transversal public that is made apparent through various platforms and protocols of networked communication. The result is a '(re)embodiment through technics' (Hansen 2006, 95) of a public which creates a new connection and a new register of 'being together', where those present at a physical site are connected through architecture and networked media to those watching and participating from afar. The practices described in the examples above denote new rituals of monumentality (liking, voting, debating, clicking, tracking), commemoration (ephemeral repetition of historical remembrance), awareness (ambient representations that can increase the legibility of the city), and, of course, commercialism (through syncretic association of iconic buildings and brands, as well as the direction of audiences and consumers to various sponsors through the recentring qualities of participation).

Essentially, a building like the Empire State Building, as a site for public data visualisation and a massive media monument, collects on- and offline audiences and their associated techno-social capabilities, allowing for a diversity of discourses associated with buildings that did not previously exist. It does so through the effect of making the building either directly or indirectly representative of a collection of individual impulses or by its availability for temporary recoding and appropriation through associated media in 'post-production'. The city, regardless of the discourses associated with it via massive media, becomes more like a shared resource, a critical site for the formation, moderation, commercialisation, and critique of what we might consider public debate and civic identification. It becomes at once more communicative, communal, and commercial. Sutured as we are to the means to decode and interact with these buildings (via mobile ubiquitous media), when buildings become screens we become the readers, writers, and consumers of a contingent, ambivalent city that creates powerful spatial and emotional associations and intensities.

Experiments in Public Data Visualisation

The development of the Empire State Building's lighting program raises some important questions about the practice of public data visualisation, monumentality, and massive media. Namely, how can the use of similar façades best translate and direct our current dynamic reality towards artistic, political, and social ends? How can a low-resolution media façade better engage a democratised urbanism, engender debate, or elicit emotion? I used these questions as the starting point for a creative exploration of

this particular form of massive media. Employing a creation-as-research framework, I once again designed, proposed, situated, experienced, and reported on the technics (Thain 2008), politics, and practices of massive media in order to explore affordances and limits in all of these areas. The following participatory public data visualisations serve as practical probes and points of comparison to the preceding analysis of the Empire State Building.

E-TOWER

E-TOWER (2010), a project I created with collaborator Patricio Dávila,[5] was an interactive cell-phone based installation with one of the tallest and most visible low-resolution LED façades in the world, Toronto's CN Tower (see Figure 3-11). The CN Tower, a federally owned and controlled building initially built by CN Rail in 1976 to boost television and radio broadcast signals and to create a landmark for the city, was outfitted with a computer-controlled LED lighting system in 2007. It has since followed a similar trajectory as the Empire State Building, commemorating holidays, special events, memorials, and special causes, while otherwise defaulting to its signature red colour to symbolise Canada. The CN Tower broadcasts this information via Facebook, Twitter, and Instagram feeds. The building that has now become a screen: it merges the logic of the screen with the logic of the monument to create a hybrid, relational space of collective memory and identity with accelerated rituals of identification and participation.

After a period of negotiation with the tower's management and careful vetting and revision of our concept (it could not be seen as politically or commercially driven as the federally owned CN Tower is technically a government building), as well as securing technical support and sponsorship from one of Canada's largest telecommunication companies, Rogers Communications, we were granted access to the tower's lighting system

5 Patricio Dávila and I collaborated on *E-TOWER* (2010). For this project, I was responsible for the initial concept and proposal that was accepted by the Nuit Blanche 2010 committee in Toronto. Together, Dávila and I developed the concept further and we secured permission from the CN Tower and sponsorship from Rogers Communications to pay for production costs. Dávila and I were both involved in developing the final concept as well as in production meetings with Rogers Communications, Nuit Blanche, and the CN Tower. We worked iteratively throughout, with Dávila taking on most of the programming duties while I assumed most of the production duties including web design. We received in-kind assistance from graphic designers Berkeley Poole (flyers) and Jamie Webster (tower animations), as well as in-kind documentation support from Udo Dengler (time-lapse video) and Sarah Lasch (promotional video).

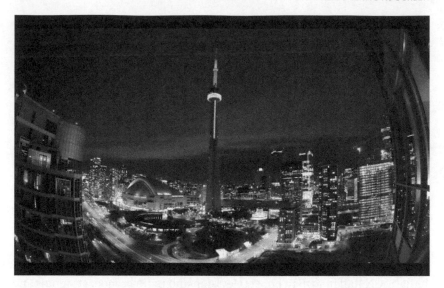

Figure 3-11: Dave Colangelo and Patricio Dávila, *E-TOWER* (2010), CN Tower, Toronto, screenshot. Photo: Udo d., courtesy of the artists.

to present the work during Nuit Blanche 2010, an all-night art party held every year in Toronto. From sundown to sunrise, *E-TOWER* visualised the collective energy of the city on the most visible symbol of the city by asking participants to text the word 'energy' to a specific number, making the lights on the tower grow faster and glow brighter.[6] Throughout the night, individuals and groups participated by sending their 'energy' to the tower, creating links across physical space, in proximity and at a distance, sutured together by mobile phone technology and the tower as a shared represen-tational and communicative beacon. *E-TOWER* allowed participants in the city to communicate with each other through a visualisation combining data, architecture, and urban space. By using the CN Tower as the central transfer point for the city's participation, people's actions were mapped onto a powerful civic symbol, engaging a new register of monumentality that was immediate and representative. Furthermore, *E-TOWER* coordinated the diverse and distributed screens of participants with the tower as a central visualisation, using the visibility and centrality of the tower and the ubiquity of phones to create an attractive experience and a specific gathering point for identification and participation — a composite dispositif. It was able to create and make collectivity and connection massively attractive and

6 See http://www.etower.ca for documentation of the work.

apparent, dramatising architecture and the city by visualising the data of participation.

That said, and despite the tower's omnipresence and visibility, there were significant challenges in developing an audience for this work. The biggest challenge came from the fact that on the night of Nuit Blanche, although there were almost one million people in attendance (Bradshaw 2010), there were also approximately 300 other projects vying for their attention. Not only was the audience highly mobile and geographically dispersed, they were also being acted upon by the sights and sounds of other works and their associated dispositives. The work needed to somehow capture and hold the city's thinly-sliced attention. This brings to mind the concerns of Crary and Virilio, who both warn against the dangers of distraction inherent in the proliferation of technology and moving image in public spaces with no apparent end game. The experience made us realise that single-night experiments in the context of a city-wide art party may not be the best way to construct and test new registers of monumentality through massive media. Longer exposures and deeper involvement with a public through interactive projects that last weeks, if not months, could serve to better develop audiences and help to determine what they see as the best use of these new assemblages of light, architecture, and data.

Another challenge we faced came early in the process. As noted above, our concept changed throughout the course of project development due to pressures from the CN Tower's management. Initially, we had hoped to reflect the relative emotional states of participants on the tower with representative colours by asking them to send us a message with one of five feelings (happy, sad, bored, excited, and angry) and creating a framework for their visualisation. Before developing this concept further, we were told by the management of the CN Tower that this concept would not be acceptable. They were concerned that the tower might be associated with negative emotions. What this shows is a politics of aesthetics in action in which the carrier of the public data visualisation, in this case the CN Tower, sought to pre-emptively protect their reputation by censoring our plan for the public display of emotion on the tower. Clearly, there are limits to what can and cannot be said via public data visualisation, and in the public sphere in general, and these limits are imposed by the owners of the means of communication and representation. *E-TOWER*, although presented in a form that was shaped by these constraints, allowed us to meet, experience, and understand the limits to expression, particularly in the context of such a highly visible and highly regarded symbol of the city.

In The Air, Tonight

For our next project,[7] we partnered with the Ryerson Image Centre and Ryerson School of Image Arts (RIC/IMA), a newly renovated building with a computer controlled low-resolution LED façade on the campus of Ryerson University in downtown Toronto. Although the building was owned and operated by the university and had yet to display content outside of ambient pre-set patterns and school colours, the administration of the building allowed us to test some new possibilities as they were not beholden to sponsors, government mandates, or other corporate stakeholders. This access and freedom from moderation allowed us to present *In The Air, Tonight* (2014) (see Figure 3-12).[8] For one month, during one of the coldest winters on record in Toronto, the LED façade of the building was animated with a blue wave representing wind speed and direction while an intermittent red pulse was triggered by fluctuations in the use of the hashtag #homelessness on Twitter. By visiting intheairtonight.org people could read and retweet messages from our Twitter feed (@itat2014) or compose their own messages. Every message with the hashtag #homelessness amplified the issue online and contributed to a colour change on the building. Our goal with this project was to foreground a pressing social and civic issue through networks and architecture, negotiating access to both, and providing an interface that allowed people to engage with and contribute to amplifying an area of common concern — to create a participatory public sphere around a specific issue through this building turned screen. A key component of this project was to seek out experts in the field to help populate the Twitter feed for the duration of the installation to enrich the public sphere we were attempting to create and amplify. Another main component was making connections

7 *In The Air, Tonight* (2014) was a collaboration between myself Patricio Dávila. We developed the concept, raised funds, and put together a team to complete the project which later became Public Visualization Studio. I was involved in initial programming, building animation design, and computer modelling. Dávila hired and directed Robert Tu in completing the programming for the back-end of the installation (php and Processing) while Maggie Chan was hired to complete the building animations and produce documentation of the month-long installation. The team shared various production duties including refining the concept, installing a remote weather station on the roof of the building, installing a webcam, producing promotional materials, moderating the Twitter feed, and public relations planning and execution. In-kind consultation and support was provided by street nurse Cathy Crowe, public relations analysts Claire LaRocca and Alen Sadeh, professor and media artist David Bouchard, and the staff at the Ryerson Image Centre and Ryerson School of Image Arts (RIC/IMA). For the second iteration of the project, David Schnitmann replaced Robert Tu to provide additional technical support.
8 See http://publicvisualizationstudio.co/projects/in-the-air-tonight for documentation of the work.

Figure 3-12: Dave Colangelo and Patricio Dávila, *In The Air, Tonight* (2014), Ryerson Image Centre and Ryerson School of Image Arts (RIC/IMA), Toronto. Photo: Maggie Chan, courtesy of Public Visualization Studio.

with drop-in centres and homeless shelters in the area around the building that provided computer and internet access to homeless individuals in order to allow those directly affected by this issue to participate in the project.

While many people engaged with the project online through Twitter and through media outlets that had written about the installation, participation and awareness of the installation at the physical site was limited. What the project lacked was a strong referent or tangible user interface on-site in order to make the data visualisation more self-evident; or, in other words, to make it more *situated*. Unlike the *NOX* project at Ars Electronica, where a simple pull evoked quite clearly the function and purpose of pulling it, the lights on the RIC/IMA did not self-evidently refer to the information about homelessness that they were linked to. And, while the building stood at the centre of the highest concentration of drop-in centres and shelters in the city, this much was not clear by simply looking at the building. That said, *In The Air, Tonight* was *informative* in that it was clearly responsive to tweets yet was not necessarily insightful in the sense that it did not easily allow onlookers to create meaningful insights about the problem of homelessness. Instead, it allowed them to do so only if they engaged in the online component of the work and followed links and tweets served up on the interface. Finally, *In The Air, Tonight,* could be said to be somewhat *functional* in that it was

aesthetically pleasing and was persuasive for those that had deciphered its meaning. At the same time, the project was *functional* in that it was able to reach a larger audience by tapping into other associated media: it was able to capture media attention (radio, blogs) from outlets that would not necessarily be concerned with poverty and homelessness (cf. Sokol 2014; CBC 2014) and did increase the prevalence of the hashtag 'homelessness' online, making the issue more visible on a number of fronts. As such it extended the environment-carrier-content meshwork across on- and offline space, extending the reach and impact of the project and the building. It also led to many connections between experts and activists in the field that became aware of one another via the Twitter stream. In short, the low-resolution media façade event was the impetus for the formation of diverse, temporary publics and publicity through the creation of a composite dispositif centred upon a spectacular urban display.

In comparing our work on the CN Tower and the RIC/IMA to the display program of the Empire State Building, it is clear that the creative and critical use of massive media and public data visualisations lies with the mandate of the host organisation and its openness to artistic control and experimentation. As such, our role as (massive) media artists seemed to depend greatly upon our ability to secure access to media architecture by convincing organisations to allow non-commercial, exploratory alternatives to appear on their façades. Essentially, Dávila and I became activists, with both *E-TOWER* and *In The Air, Tonight*, in our task to work towards gaining access to these expensive and highly guarded public displays to make them more public, that is, to open them up to wider participation, debate, and identification. Our role (and goal) was to furnish and amplify cooperation (in the case of *E-TOWER*) and productive dissensus (in the case of *In The Air, Tonight*) by gaining access to massive, programmable architectural surfaces in prominent urban settings and to create interfaces and rules of engagement to approximate more closely political positions that value the public representation and debate of trans-local citizens.

Dávila and I also took on the role of curators in these spaces in our responsibility for appreciating and connecting with the context in which our work was being presented. In fact, the work very much emerged from a careful consideration of and negotiation with contextual factors, such as discussions with CN Tower management or the realisation through consultation and research that the RIC/IMA is situated amongst the highest concentration of drop-in-centres and homeless shelters in Toronto. We were also curators in the sense that we had to learn how to present our work on these highly complicated exhibition spaces with minimal support from

the host institutions. To that end, technical and contextual challenges of producing massive media works, and the role that a curatorial organisation might play in addressing these challenges, are discussed in the following chapter.

Temporary Intensities and Collective Conversations

Low-resolution programmable façades on buildings like the Empire State Building, the CN Tower, and the RIC/IMA participate in an emerging practice of public data visualisation that dramatises architecture, makes data visible, and, at best, connects citizens to important civic issues by creating new spaces of appearance. The transformation of these buildings into screens by way of coloured, programmable light create and support hybrid and relational spaces that activate narrative and associative potentials through their expressivity, networked digitality, and contingency. In these scenarios, the visibility and monumentality of architecture is important in that the power it yields can be harnessed and redirected through associated media on and off the building. Scale and physicality give a new shape, form, and context to data. At the same time, data can give a new shape, form, and context to architecture. Data becomes sensual and perceptible on a large scale (big data can be seen on a *big* scale), and distributed communication can appear more communal in publicly shared spaces coded as such. In this way, large, low-resolution programmable façades are a digital-era update to mid-twentieth century city reading phenomenon such as weather beacons and TV towers, except that they are more expressive, iterative, and communicative, especially through associated technologies and networks of ubiquitous social media.

Programmable architectural media façades can be said to be suggestive of supermodernism, a movement in architecture that involves a new epoch of urban form characterised by buildings seen increasingly as communicative systems that prioritise direct, contextually relevant experience (Ibelings 2002) and thus seek to re-inject specificity and connection into physical environments where it has been seen to have been lost (Crary 1999; Virilio 1984). Supermodernism shifts the traditional notion of architectonics (Frampton 1983), a term that describes the degree to which the material composition and symbolic expression of a building reflects its history and context, to include a responsiveness to data flows in the 'surrounding information environment' (Krajewski 2005, 2), making this data concrete through a spatial expression and the experience of data against the body

in space. While others, such as Virilio (1984) and Augé (1995) have warned that technology has set architectonics adrift, 'exil[ing] all of us from the terrestrial horizon' (Virilio 1984, 550), Ibelings (2002) and Krajewski (2005) focus instead on ways to take back the power of public space to encode meaning by suffusing it with data, and remain more optimistic about the relevance and potential of buildings that can translate or reflect our present dynamic reality through screens.

Apart from providing opportunities for communal commemoration, celebration, and augmenting the presentation of data through context and scale, as buildings such as the Empire State Building and the CN Tower demonstrate, public data visualisations can also play a role in allowing data to surface symbolically and circulate technically in ways that are sensible at sites and scales befitting their effects and importance in contemporary life. While low-resolution architectural façades may, as Felicity Scott points out, 'signify a proximity to technological advancement' (2003, 80) of a certain time (and thus provide an intrinsic value to city builders), just as TV towers once did and modernist monuments such as Tatlin's Tower promised to do, they do more than signify: they converse because they have a public face, a façade, that talks, and, to a degree, listens. This, in the end, is what makes them supermodern; they are, as Ibelings (2002) points out, increasingly seen as important parts of communicative systems and are meeting places for people and things that embody and engender the coming together of mediated communication in its myriad forms.

Like large-scale public projections, the emerging media architecture experiences and practices of buildings with LED façades must continue to be analysed and critiqued through observation, analysis, and practice so that we might better understand their role and potential in society, and their role in commodifying and/or enhancing urban identities and issues. The expanded capabilities of LED façades, coupled with an associated technological milieu which includes mobile ubiquitous media, ever expanding contextually relevant data sets, and social networking, allows for a more dynamic relationship between people, the city, and information through their superimpositions, montages, novel composite interfaces, and opportunities for post-production. Massive programmable low-resolution façades, such as the one atop the Empire State Building, code and recode space in their ever shifting mes- sages and meanings, and allow people to associate (or disassociate) with the city in novel ways while also allowing data to surface through public data visualisations that are situated, informative, and functional. Buildings with media façades, more than large-scale public projection sites, become durable and dense transfer points for digital culture, as well as for the emotions and

identification of diverse groups, reinvigorating mass cultural, communal, and collective experience and accelerating rituals of monumentality. By harnessing the direct participation of publics through social networking (a necessity of their inability to display detailed text or images), programmable low-resolution façades usher in an era of supermodernity that connects architecture within an expanding composite dispositif of screen and non-screen experiences of spectatorship and participation. Low-resolution media façades occupy a central role in the formation of temporary intensities within an increasingly relational space characterised by ambivalence and contingency (McQuire 2008), extending the environment-carrier-content context of public data visualisations into hybrid on- and offline spaces. The intensities created by such assemblages can be directed towards various ends, which, depending on the conditions of ownership and control — perhaps the strongest determining factor in the use and outcome of these assemblages — vary from overtly commercial to artistic, experimental, and critical.

As with buildings with large-scale public projections, structures with low-resolution media façades can become semiotic resources for socially engaged practices and urban activism provided that the proper permissions are negotiated, audiences are sufficiently fostered and developed, and consideration is given to equitable representation through user interface design and context sensitivity. Artists and designers engaged in a practice of massive media must see as their primary objective the furnishing and harnessing of technologies and points of access which include public space, architecture, various fixed and mobile sensors, and networks, to facilitate and amplify collective conversations around issues of common concern.

An early version of this chapter titled, 'The Empire State Building and the Roles of Low-Resolution Media Façades in a Data Society' has been published in Proceedings of the 2nd Media Architecture Biennale Conference: World Cities, Aarhus, Denmark, November 19-22 (2014).

References

Arendt, Hannah. 1958. *The human condition*. Chicago: University of Chicago Press.
Ars Electronica. 2015. About. *Ars electronica*. Accessed April 8, 2018. http://www.aec.at/about/en/.
Augé, Marc. 1995. *Non-places: Introduction to an anthropology of supermodernity*. London: Verso.

Bateman, Chris. August 24, 2013. A brief history of the Canada Life weather beacon. *blogTO*. Accessed September 6, 2015. http://www.blogto.com/city/2013/08/a_brief_history_of_the_canada_life_weather_beacon/.

Bennett, Susan. 2009. The peripatetic audience. *Canadian Theatre Review* 140(Fall): 8-13.

Bishop, Claire. 2004. Antagonism and relational aesthetics. *October.* 110: 51-79.

Bradshaw, James. October 1, 2010. Is Nuit Blanche a victim of its own success? *The Globe and Mail.* Accessed May 27, 2015. http://www.theglobeandmail.com/news/toronto/is-nuit-blanche-a-victim-of-its-own-success/article4327778/.

CBC. March 2, 2014. In the Air, Tonight | Spark with Nora Young | CBC Radio. *CBCnews.* Accessed August 29, 2018. https://www.cbc.ca/radio/spark/spark-243-1.2848149/in-the-air-tonight-1.2848160.

CNN. November 6, 2012. CNN to display electoral results atop Empire State Building. *CNN Press Room.* Accessed September 30, 2015. http://cnnpressroom.blogs.cnn.com/2012/11/06/cnn-to-exclusively-display-electoral-results-atop-the-empire-state-building/.

Colangelo, Dave, and Dávila, Patricio. 2011. Public Data Visualization: Dramatizing Architecture and Making Data Visible. Conference proceedings, International Symposium on Electronic Art (ISEA), Istanbul, September 2011. Accessed March 15, 2013. http://isea2011.sabanciuniv.edu/paper/public-data-visualization-dramatizing-architecture-and-making-data-visible.

Collins, Glenn. April 20, 2007. Lighting New York's tallest. *New York Times.* Accessed May 17, 2014. http://www.nytimes.com/video/nyregion/1194817113448/lighting-new-yorks-tallest.html.

Crary, Jonathan. 1999. *Suspensions of perception: Attention, spectacle and modern culture.* Cambridge, MA: MIT Press.

De Souza e Silva, Adriana. 2006. From cyber to hybrid. *Space and culture* 9(3): 261-278.

Empire State Building. 2014. Historical timeline. *The official site of the Empire State Building.* Accessed December 15, 2016. http://www.esbnyc.com/esb_story_historical_timeline.asp.

Frampton, Kenneth. 1983. *Towards a critical regionalism: Six points for an architecture of resistance.* In *Postmodern culture,* ed. Hal Foster, 16-30. London: Pluto Press.

Fuller, Matthew. 2005. How this becomes that. In *Media ecologies: Materialist energies in art and technoculture,* 85-107. Cambridge, MA: MIT Press.

Galloway, Alexander. 2012. *The interface effect.* Cambridge: Polity.

Garber, Megan. November 27, 2012. The Empire State Building becomes an art installation. *The Atlantic.* Accessed December 17, 2015. http://www.theatlantic.com/technology/archive/2012/11/the-empire-state-building-becomes-an-art-installation/265652/.

Hansen, Mark B.N. 2006. *Bodies in code: Interfaces with digital media*. New York: Routledge.

Hansen, Miriam Bratu. 1993. Unstable mixtures dilated spheres: Negt and Kluge's the public sphere and experience, twenty years later. *Public Culture* 5: 179-212.

Henkin, David M. 1998. *City reading: written words and public spaces in antebellum New York*. New York: Columbia University Press.

Ibelings, Hans. 2002. *Supermodernism: Architecture in the age of globalization*. London: NAI Publishers.

Krajewski, Piotr. 2005. *From monument to market: Video art and public space*. Ed. Violetta Kutlubasis-Krajewska. Wroclaw, Poland: WRO Center for Media Art.

Lefebvre, Henri. 1997. The monument. In *Rethinking architecture: A reader in cultural theory*, 133-137. London: Routledge.

Lynch, Kevin. 1960. *The image of the city*. Cambridge, MA: MIT Press.

McQuire, Scott. 2008. *The media city: Media, architecture, and urban space*. London: Sage.

Media Architecture Institute. 2015. About. *Media Architecture Institute*. Accessed April 7, 2018. http://www.mediaarchitecture.org/about/.

Mumford, Eric Paul. 2000. *The CIAM discourse on urbanism, 1928-1960*. Cambridge, MA: MIT Press.

Philips. May 9, 2012. Press information. *The official site of the Empire State Building*. Accessed June 3, 2014. http://www.esbnyc.com/documents/press_releases/2012_05_09_Philips_Press_Release.pdf.

Rowlands, Michael, and Christopher Tilley. 2006. Monuments and memorials. In *Handbook of material culture*, ed. Christopher Tilley, Webb Keane, Susanne Küchler, Michael Rowlands and Patricia Spyer, 500-516. London: SAGE Publications Ltd.

Scott, Felicity D. 2003. Involuntary prisoners of architecture. *October* 106(Fall): 75-101.

Sellmer, Robert. 1946. Douglas Leigh: The man whose gadgets brightened up Broadway now turns to Main Street. *Time*, April 1, 47-51.

Sokol, Zach. February 4, 2014. Tweeting about #homelessness tonight will change the color of this building | The Creators Project. *The Creators Project*. Accessed March 15, 2014. http://thecreatorsproject.vice.com/blog/tweeting-about-homelessness-will-change-the-color-of-this-building.

Tauranac, John. 1995. *The Empire State Building: The making of a landmark*. New York: Scribner.

Thain, Alanna. 2008. Affective commotion: Minding the gap in research-creation. *INFLeXions* 1: 1-12.

The NEW Empire State Building lights – live show with Alicia Keys. November 26, 2012. *YouTube*. Accessed March 15, 2014. http://www.youtube.com/watch?v=PKVzdqYSkks.

Thrift, Nigel. 2008. *Non-representational theory: Space/politics/affect*. New York: Routledge.

Vande Moere, Andrew, and Hill, Dan. 2012. Designing for the situated and public visualization of urban data. *Journal of Urban Technology 19*(2): 25-46.

Vande Moere, Andrew, and Wouters, Niels. 2012. The role of context in media architecture. ACM *Symposium on Pervasive Displays* (PerDis'12), ACM. Article 12.

Verhoeff, Nanna. 2012. *Mobile screens: The visual regime of navigation*. Amsterdam: Amsterdam University Press.

Virilio, Paul. 1986. The overexposed city. *L'espace critique* (Paris: Christian Bourgeois, 1984); translated in Zone 1-2 (New York: Urzone, 1986), trans. Astrid Hustvedt: 14-31.

Warner, Michael. 2005. *Publics and counterpublics*. New York: Zone Books.

4. Curating Massive Media

Abstract

A curatorial approach to the building as screen is crucial in order to create suitable spaces and opportunities for the development of massive media as a legitimate artform capable of shaping the critical discourse of cities and citizens. Based on two in-depth case studies of curatorial organisations in the field, Connecting Cities and Streaming Museum, I propose that massive media requires the sustained provision of technical support and coordination as well as an ongoing negotiation with corporate, institutional, and civic owners and operators. While massive media exists primarily as a highly commercialised phenomenon it can also be pressed into service through coordinated curatorial and artistic efforts to critique or co-opt commercialisation and to re-envision the role of urban media environments in shaping collective identity, historical consciousness, and public display culture.

Keywords: Connecting Cities, Streaming Museum, digital culture, exhibitions and new media, art and urbanism

Changing Spaces

The social and spatial context of a city changes with the addition of more expressive and connected media architecture in the form of low-resolution media façades, urban screens, and public projection. In the media city (McQuire 2008), feedback associated with urban structures through public screens and personal devices serve to reconstruct contemporary life, instituting new ways of being social and civic. Orientation becomes more contingent and ambiguous, blurring lines between presence and absence, the near and the far, leading to what McQuire calls 'relational space' (ibid., 48), a space defined less by pre-existing relationships of familiarity and solidity and more by temporary, ephemeral connections and impressions. Similarly, theorist De Souza e Silva describes this entanglement and imbrication of media and

Colangelo, D., *The Building as Screen: A History, Theory, and Practice of Massive Media*. Amsterdam: Amsterdam University Press, 2020

DOI 10.5117/9789462989498_CH04

space as 'hybrid space' (2006, 271). For both authors, the key understanding is that space, in addition to being socially constructed (Lefebvre 1991), is also constructed through technological lenses, filters, and devices. Crucially, De Souza e Silva argues that in the hybrid spaces of the media city, 'every shift in the meaning of an interface requires a reconceptualisation of the type of social relationships and spaces it mediates' (2006, 262). When buildings become screens, new pitfalls and possibilities emerge that require critical reflection. And when these buildings become exhibition spaces for art and culture, they require curatorial direction that considers the new affordances and limits of the medium.

As mentioned in the preceding chapters, the proliferation of screens and moving images in public space has been met at times with derision: seen as potent distractors, screens can create 'formless fields of attraction' that distort the legibility of the urban environment, diminish sociality, and dehistoricise a place (Crary 1999), particularly if they are used as they most often are: as advertisements. Take, for example, Times Square in New York City, a site that represents the epitome of capitalist spectacle and comprises one of the earliest and densest sites of urban screens. A heavily mediatised environment for the distraction and attraction of peripatetic mobile spectators and passersby, Times Square is a relational space in which spectators can easily become spellbound by the perpetual and frenetic rush of images urging them to identify and consume branded objects and content, themselves emblematic of the commodification of social relations: it is the very definition of spectacle (Debord 1995). Times Square demonstrates the power of its confounding and dazzling heavily-screened public address through the dominant discourses (and dollars) of the corporations it attracts and broadcasts in its very public marketplace for attention and sense impression.

That is not to say that highly commercial screen spaces cannot be allied with other functions, namely critical discourse and artistic exhibition. In fact, since 2012, Times Square has been the site of an ongoing Midnight Moment instituted by the Times Square Advertising Coalition (TSAC) and Times Square Arts. During a Midnight Moment program 15 of the largest screens in Times Square are coordinated to display a single artwork for three minutes. In the past, the program has featured works by artists such as Tracey Emin (see Figure 4-1), Yoko Ono, and Alfredo Jaar (Times Square Arts 2014).

In addition to the display of art on public advertising screens, there are a growing number of digital, outdoor, large-scale public displays that are dedicated to year-round non-commercial content, using the attractive power

Figure 4-1: Tracey Emin, *I Promise to Love You* (2013), Times Square Arts Midnight Moment, New York. Photo: Ka-Man Tse @TSqArts, courtesy Times Square Arts.

of scale and screen (the logic of the monument and the logic of media) to capture audiences and compel them to view or even interact with artworks. As noted in Chapter 2, Montreal's *Quartier des spectacles* is a network of permanent projection sites and lighting features in the city's core designed to showcase original content and integrated programming with various cultural festivals (McKim 2012). In the past, artists such as Rafael Lozano-Hemmer have animated the space with video- and light-based installations. And while spaces like *Quartier des spectacles* do open seemingly greater possibilities for artistic innovation and audience development in the field of massive media than the sparse space and time for art afforded by commercialised sites like Times Square, Joel McKim argues that we should not just assume that *Quartier des spectacles*, and other sites like it, guarantee artistic innovation by virtue of displaying art. McKim notes that they can just as easily contribute instead to the 'general aestheticisation' (2012, 135) and branding of the city for touristic and economic purposes. *Quartier des spectacles*, while presenting artworks designed for its many display sites, and never displaying ads, can still be seen as an advertisement for the 'creative city' (Landry 2008) or an element of competitive differentiation. This may be the central challenge for public art and its curation in general, particularly public art that requires high levels of capital investment and government oversight to exist. How can the programing and curation of

these sites deliver audiences to critical and creative encounters with art, the city, and each other within the challenges and constraints that come with producing complex and costly large-scale public works? How can they avoid becoming mere advertisements for cities and for art in general?

A Short History of Public Screen Practice

Like well-trained judo wrestlers, artists and curators that have presented works on large-scale public displays have not necessarily confronted the power of monumental corporate adversaries directly so much as used their inertia to destabilise them, creating temporary spaces of appearance for critique and contestation. Two interventions that established the genre of architectural screen practice include Jenny Holzer's *Truisms* (1981) in which the artist displayed phrases such as 'PROTECT ME FROM WHAT I WANT' and 'ABUSE OF POWER COMES AS NO SURPRISE' on Times Square's Spectacolor screen, and Krzysztof Wodiczko's *Astor Building* (1984), a projection of a padlock on luxury condos in lower Manhattan. Public art critic Grant Kester notes that these works reclaim 'the urban public sphere as a space in which differences of privilege and political power could be revealed and questioned rather than suppressed' (2006, 264). Works such as Holzer's and Wodiczko's use the large-scale projected image to draw attention to the misdeeds of the past and present latent within urban space and architecture. They create temporary publics that harness the power of visibility in the city and engage a 'representative publicness' (Habermas 1989, 5) that is not always present in relatively stoic, silent, and unchanging architectural surfaces.

More coordinated and sustained efforts into the critique of the role that large urban displays play in the quality and construction of public life have come from the landmark curatorial organisations Artangel Trust and the Public Art Fund. Both organisations have targeted electronic billboards as particularly potent sites in the struggle for representation in the city. Like Negt and Kluge, they can be said to view 'the media of industrial commercial publicity, in their most negative implications, as an inescapable horizon, and as the most advanced site of struggle over the organisation of everyday experience which contextualises all other sites' (Hansen 1993, 211). Specifically, London-based Artangel Trust (1985-91) focused on the use of advertising media such as billboards and outdoor screens (Connoly 2013), while Public Art Fund, Inc., founded in New York City in 1972, focused on the placement of public art in a variety of urban neighbourhoods and contexts, including *Messages to the Public*, initiated in 1982, which made use of the

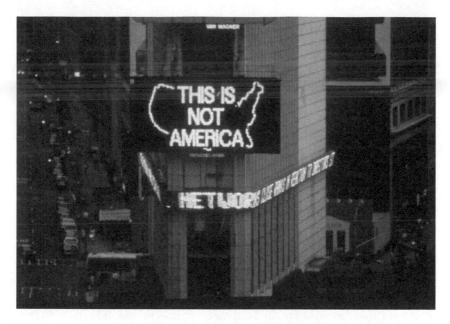

Figure 4-2: Alfredo Jaar, *A Logo for America* (1987), commissioned by the Public Art Fund for the Spectacolor Sign, Times Square, New York, April 1987. Photo: courtesy Daros Latinamerica Collection, Zurich, Times Square Alliance, New York, Solo © Alfredo Jaar.

Spectacolor board at One Times Square (see Figure 4-2) to display artist shorts of about twenty seconds in length, twenty minutes apart, inserted between advertisements (Phillips 1989). As Patricia Phillips argues, inserting art into the temporary contexts of large, luminous public displays can be subversive, introducing a productive ambiguity between the art moment and the advertisement. Phillips argues that situating art within the spectacle of advertisements can show how 'public life has become emblematic not of what is shared by a constituency but of the restless, shifting differences that compose and enrich it' (ibid., 331). Spectacle is part of life, so why avoid it? Why not confront it head on and allow difference to play out from within? The work of Artangel Trust, Public Art Fund, and artists such as Jenny Holzer inquire into the medium of large-scale urban screens scenarios as they are most commonly seen: as advertisements that are out of our reach, questioning their effects and exploring the limits of dissent and dissensus by disrupting the habitual flow of corporate address.

Of course, the exploration of such limits can be highly limited itself. In the case of *Messages to the Public* less than 2 per cent of the total screen time was given to art. As such, the work might be seen at best as urban acupuncture, contributing to the health of the contemporary public sphere by stimulating

the otherwise stifled 'openness, inclusiveness, multiplicity, heterogeneity, unpredictability, conflict, contradiction, and difference' (Hansen 1993, 189) of the public sphere in a highly commercialised zone of address.

Toronto's artistic and curatorial collective Public Access provides a similar example. Their project *Some Uncertain Signs* (1986), sought 'a new aesthetics of interruption' (Sloan 2006, 224) by negotiating access to an electronic signboard on the city's main commercial thoroughfare in order to present the work of 22 artists, a group that included Wodiczko and Holzer. Public Access hoped to reach an expanded audience and to scramble the semiotic chains of meaning within the city. Theirs was a tactic of disruption and confusion in order to shake citizens out of their spectacular slumber. Whether or not they achieved this is difficult to gauge, and this is true of public artwork in general, due to the varying levels of awareness of the project or of public art in general of the public that passed by the sign and the difficulty of identifying and following up with them to gather feedback. What is clear is that the work of Public Access did not go unnoticed: one of the works, a piece entitled *Lesbians Fly Air Canada* by Lynne Fernie, had to be altered to avoid litigation from the airline. Air Canada clearly believed that Public Access would confuse audiences as intended.

The work of Public Access and of the Artangel Trust and Public Art Fund can be seen as part of an important 'process of contradiction' (ibid., 226), a polemical and proactive gesture, that seeks to be replicated in other cities that share similarities in the standardised technologies of public display. As Connolly argues in her article on the changing 'mediascape' of public art, public spaces have been altered significantly by the imbrication of media such that they require artistic interventions to once again be 'temporarily imagined as public' (2013, 215), that is open to a de- and rehistoricisation, something that Public Access was able to do for a limited time.

The practices of curatorial groups like Public Access also highlight the need for art to reach beyond the primacy of museums and commercial galleries. Similarly, as McQuire argues, 'A crucial role for new media art in public space is the potential to avoid the filter of sites such as the art gallery, and thereby engage audiences who might never cross that threshold' (2008, 149). Public art must meet a wider audience in unexpected public places and do so in ways that best suit this public stage — to raise the stakes of art by making it more central to 'the production of social relations and forms of life' (Hardt 2009, 26), or to expose the relational role the public plays in this. The work of Lozano-Hemmer is particularly instructive of how art in public space can construct and reveal relationships between participants, viewers, buildings, images, and architecture in the way it

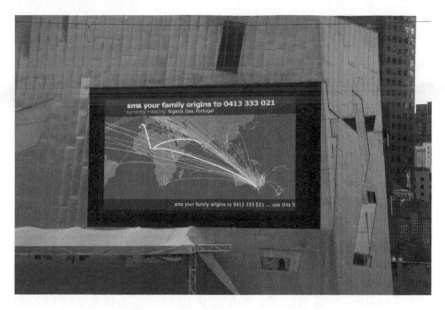

Figure 4-3: starrs & cmielewski, *sms_origins* (2009-2010), Federation Square, Melbourne.
Photo: Josephine Starrs and Leon Cmielewski, courtesy of the artists.

turns buildings into interfaces and public spaces into interaction fields. His
work, *Body Movies* (2001), a computerised projection-based shadow play and
image-matching installation that has been presented at various times on
architectural façades in public squares around the world, fosters boisterous
behaviour amongst participants and interactions between diverse groups
ranging from polite cooperation to playful interference. Josephine Starrs and
Leon Cmielewski's *sms_origins* (2009–10) (see Figure 4-3) provides another
example of an artwork naturally suited for a public building rather than the
gallery. In Melbourne's Federation Square, public screens visualised real-time
site-specific statistics of migration patterns sourced from the text messages
of participants. The installation mapped these crowd-sourced trajectories
live on the screen, reorganising electronic telecommunication and elements
of personal narrative through a tangibly collective and civic experience.

Massive Media and Public Art

Advancements in technology have opened new sets of possibilities for artistic
expression and experimentation on buildings in the public realm. This
has created an expanded field of expression that includes on- and offline
forums for participation, feedback, and control. The public art of massive

media — that is, emerging practices and places of exhibition that combine expressive architectural-scale elements (in the form of urban screens, public projections, or media façades) and telecommunication elements unique in their physical scale and geographical reach — requires new curatorial strategies and theoretical frameworks to help us understand and support its potential for creativity and criticality in the city.

Two concepts emerge that are particularly useful for understanding the relationship between the combination of media fragments and the observer in contemporary massive media scenarios: Murphie's (2004) concept of 'transversal' subjectivity and Verhoeff's (2012) concept of the 'composite dispositif'. As demonstrated in the preceding chapters, instead of a single dispositif, massive media create overlapping dispositives, given that their technical assemblage of urban media environments must be construed as a relational and contingent composite. Such a techno-social situation produces what Murphie (2004) designates as 'transversal' subjectivities existing in many localities, or trans-locally. To understand identity as transversal within a composite dispositif is to understand it not as transcendent or fragmented, but as deeply enmeshed with other identities, media situations, and locations. This usage of the term 'transversal' builds upon the term as defined in Guattari's *The Three Ecologies*, in which he argues for the need to learn and think 'transversally' in a globalised world enmeshed with technology, that is, in a way that considers the 'interactions between ecosystems, the mechanosphere [technology], and the social and individual universes of reference' (2000, 43). The enacting of different profiles on multiple websites for various purposes is one phenomenon that demonstrates the way identity, for example, is expressed and performed transversally today: it is a social and individual universe of reference supported by a substantiation of a 'mechanosphere'. Trans-local, transversal identity is produced in a unique way through urban screens that are similarly networked or participatory yet more strongly related to physical space, and thus more clearly to social, ecological, and technological systems. Because data and communication now inscribe urban spaces and link disparate real-world locations, interactive screen-works on and of buildings have the potential to utilise as well as enhance transversal thinking and pathways for creative and critical projects.

What People Have in (The) Common

The question that must continue to be asked by artists and curators amidst the proliferation of massive media in cities is this: to what end? Will the

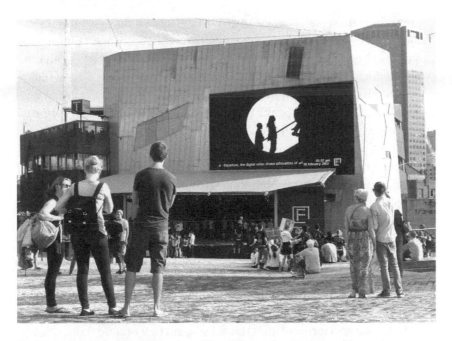

Figure 4-4: Tom Carr, *Arrival – Departure* (2013), Federation Square and Streaming Museum, Melbourne. Photo: Greta Jaeger, courtesy of Art Plural Gallery.

building as screen simply deliver audiences more efficiently to the messages of advertisers, or can it endow city spaces with a greater potential for diversity in thought, aesthetics, and participation? Can these screens be used to generate important discussion about common issues or disrupt the status quo?

For philosopher Chantal Mouffe, public art should create spaces where shared concerns emerge, where dissent is promoted, and where the implementation of a radical, plural democracy is encouraged. In her view, instead of seeking horizons of intersubjective agreement, public art and monuments should establish spaces of common action rather than consensus. Her ideal public sphere, then, would be one embodied in artworks that further *dissensus*, that is, artworks that refuse to simply commemorate or celebrate and instead foster grounds for equitable debate (2007, 4). As Mouffe notes, 'What is needed is widening the field of artistic intervention, by intervening directly in a multiplicity of social spaces in order to oppose the program of total social mobilisation of capitalism' (ibid., 1). Examples of public art interventions by groups like Public Access aimed and succeeded, to a degree, in doing precisely what Mouffe describes — challenging the dominant consensus of urban spaces as places of uninterrupted commercials that leave little room for negotiation or heterogeneity.

What the transversal, composite dispotif of large-scale telecommunica-
tion networks ventilated through expressive architecture and public space
can offer is both a potential site of contestation and a site where shared
concerns might emerge from a new conception of the public. Can we com-
municate with and through public space? How? With what? What can and
cannot be said? Who can speak? These questions evoke a new conception of
what we might call 'the common', or a material and social grounds for the
necessity of politics. 'The common', in this sense, as Michael Hardt (2009)
argues, emerges as a dominant economic and social mode of public space.
These questions also evoke what Rancière (2000) calls 'the distribution of
the sensible', or the way that our surroundings disclose themselves and our
positions within them to us. Digital, networked, urban screens and public
projections certainly change the parameters and the stakes for public space
and public personhood in these ways.

Massive media as public art might be seen to harbour a responsibility to
coordinate a relationship between contemporary technology, politics, and
economics, constituting a commons 'oriented towards the production of
social relations and forms of life' (Hardt 2009, 26) that oppose those already
given by corporate, commercial, technical, and civic agglomerations and
that harness the specific advancements of coordinated technologies that
we find in public space. The responsibility for 'giving form and meaning to
degrees of freedom opened by the progress of technology', as Paola Antonelli
(2008, 9) notes, following closely from McLuhan, can be seen to fall to
artists, designers, theorists, and curators of new media in the context of
the public sphere. An important element of this technology for Antonelli
is 'elasticity' — seamless movements between scales and contexts of space
and information (ibid., 4). The digitally networked screen, linked to a mobile
phone for example, as in the aforementioned *sms_origins*, mixes the public
scale and context of the city and its messages with the private scale and
context of the mobile phone as well as the private world of information that is
ported through and stored within it. The attention switching that must occur
to oscillate between these contexts is designed to be as seamless as possible,
or coordinated such that an effective composite dispotif is created where
multiple contexts of information (the city, the public screen, and the mobile
screen) work together to recentre an audience, delivering them individually
to a collective experience that identifies with no specific place or time yet,
in a way, inhabits them all. As such, the dynamic characteristics of plurality,
transversality, relationality, and networked connections engendered by the
interfaces of massive media hold within them the potential for enacting
new forms of the commons and being public.

An important function of supporting a practice of public art for massive media lies in curation, and particularly in an extension of the debates and methods developed in the curation of new media art. In Beryl Graham and Sarah Cook's analysis (2010), the curator of new media art must be a translator or interface between established structures and art forms and new, emerging forms and technologies in order to initiate important dialogues about space and materiality, ephemerality and permanence, and cybernetics and participation. One example that Graham and Cook provide regarding new media art curation is *Learning to Love You More* (2002-2009), a project that existed both as a website and a series of non-web presentations of work made by the general public in response to assignments posted by artists Miranda July and Harrell Fletcher on the project's website. Participants accepted assignments such as '#30 Take a Picture of Strangers Holding Hands' and '#67 Repair Something', sending in documentation and reports as required (Fletcher and July 2002-2009). This work was then posted online under names the participants chose for themselves. Here, the artists used digital networks to coordinate and encourage participation, sharing, amateur art making, and temporary performances and interventions.

Along the same lines as Graham and Cook's work, Joasia Krysa (2006) adds that the digital tools and techniques that are now incorporated into arts practices are also available and transformative to the curatorial process itself. *Learning to Love You More* is exemplary, once again, of this as it taps into the Internet's ability to communicate to a transversal audience as well as its public archival function, essentially transforming the curatorial process through technology into the creation of digital interfaces and instructions that facilitate collection, contextualisation, and presentation. As such, curatorial work after new media can also be understood to be composite and transversal, shaped by technological networks, elements of software, and their protocols. Together, what these theorists and curators point to is a changing field of curatorial and artistic practice by way of networked, digital media that affects all fields of artistic production and presentation.

Large-scale public networked urban experiences centred upon expressive architectural surfaces directly address and shape the urban experience in a cosmopolitan, globalised, post-digital world, opening up new ontological and epistemological possibilities for citizens, the city, and curatorial practice. The Berlin-based Connecting Cities Network and New York-based Streaming Museum are two examples of curatorial organisations primarily concerned with the challenges of massive media: curating within networks of media, urban sites, and trans-local audiences, and developing an emerging commons through massive media forms. In the following section I describe the history,

mandate, technical tools, administrative structures, and recent projects of each organisation, interspersed with perspectives gleaned from personal conversations and collected interviews of key figures, initiator and artistic director of Connecting Cities, Susa Pop, and founder and creative director of Streaming Museum, Nina Colosi. These organisations were chosen as they both aim to operate on a global scale, have an established track-record of work in the field that spans at least a decade, and have strong visions for what the future of large-scale, networked, public interactivity through urban media environments and public art could be.

Connecting Cities

Berlin-based Connecting Cities seeks to coordinate the commissioning and circulation of artistic and social content across a primarily European (but increasingly worldwide) network of media façades, urban screens, and projection sites. They can be seen to be developing a networked, public art 'commons' (Hardt 2009) that incorporates transversal publics and habituates audiences to new engagements with and across connected public spaces. They also help to develop infrastructure and expertise to foster experimentation and artistic freedom in these emerging techno-social scenarios (Connecting Cities 2014a) that increasingly depend on the creative use of the complex composite dispositif of public space, various sensors and screens, and networked participation.

Supported by the Culture Programme 2007-2013 of the European Union, Connecting Cities organises and coordinates a network of curators that include partners from various arts and cultural organisations on five continents. It has grown out of a number of curatorial initiatives that began with the formation of Public Art Lab (PAL) in 2003 by curators and cultural producers Susa Pop and Mirjam Struppek. Since 2007, PAL has focused on media-based art in the urban context that explores the potential for urban screens and media façades to act as communicative beacons and transfer points between citizens and cities (Connecting Cities 2014a).

Initial forays into this field by PAL were met with difficulties associated with working with existing corporately owned infrastructure. Two screens that PAL experimented with were the Nightscreen-Gasometer and O2 World arena façade in Berlin. With both screens, one located in an area of accelerating gentrification, the other functioning primarily as a sign for a new science and research centre, initiator and artistic director Susa Pop found that it was difficult to communicate with the corporate entities that controlled the

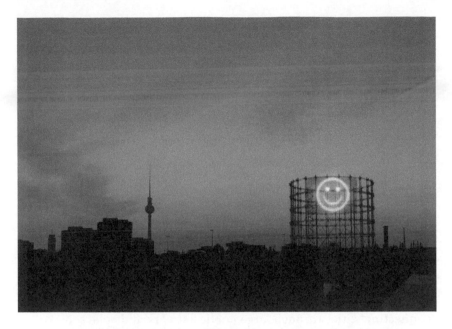

Figure 4-5: Richard Wilhelmer, Julius von Bismarck, Benjamin Maus, *Mood Gasometer* (2008), Media Façades Festival 2008, Berlin Gasometer, Berlin. Photo: courtesy of the artists.

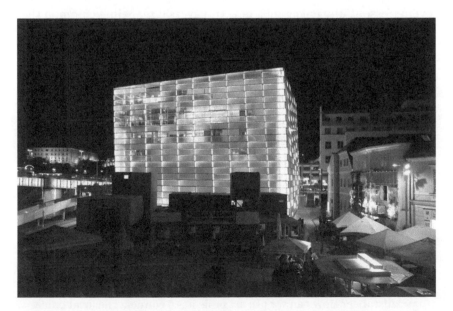

Figure 4-6: h.o, *Connecting Monsters* (2013), Connecting Cities, Ars Electronica Center, Linz, Austria. Photo: Pascal Maresch, courtesy Ars Electronica.

screens and that artistic messages were often lost amidst regularly scheduled, non-artistic programming that was geared towards short impressions for passersby on foot or in vehicles (May 22, 2014, phone call with author). Instead of grappling with the productive tensions inherent in presenting art between commercials, Pop and Connecting Cities' focus was to 'reclaim the screens' in order to explore their 'socio-cultural potential' and 'open them as community platforms and digital stages to connect cities and citizens with artistic scenarios' (Pop quoted in Toft 2013b). This was something that was not seen to be possible when only a mere sliver of the total screen time was available to engage audiences. Unlike earlier public art organisations interested in public screen infrastructure such as Toronto's Public Access, they were not seeking to create an 'aesthetic of interruption' (Sloan 2006). Instead, their focus shifted to continual experimentation in creating a new public sphere supported by a more sustainable commons centred upon urban screens and multiple, focused encounters with a developing audience.

According to Pop, it was in 2010 that attention shifted to the idea of 'connecting' cities through large public networked displays to explore artistic scenarios that were inclusive of local culture but also engaged in a 'trans-local' dialogue (Pop quoted in Toft 2013b). This was further explored through the Media Façades Festival Europe 2010, which connected seven European cities via urban screens and media façades and joint broadcasting events, essentially engaging a new transversal real-time common that was just then becoming a technological possibility. By 2010, it had become apparent that urban screens and media façades were operating through internet technologies and thus offering new possibilities for connections with buildings that were both networked and physical.

The mandate of Connecting Cities covers several basic tenets that emerge from these early debates and technological shifts. For example, Connecting Cities opposes the commercial use of urban media. Instead of advertising and branding, Connecting Cities is concerned with linking citizens within and across cities. Their networked displays 'provide space for intercultural encounters and exchange' (Connecting Cities 2013a) and ask questions pertaining to the nature and possibility of transversality in contemporary cosmopolitan culture:

> Can urban media façades become a catalyst for shared encounters in an identity-creating temporary field of interaction across the border of time and distance? How can we use art projects to connect the local public virtually with other places? and; What are the expectations and visions of our neighbours? (Connecting Cities 2013a)

Connecting Cities is currently focused on imagining and creating new democratic forms from the elements of technologised urban space, supporting temporary trans-local public spheres that seek to furnish conversations about potentially divergent 'expectations', following somewhat from Mouffe's understanding of the public sphere as a site for contestation.

Furthermore, Pop has stated that the goals of Connecting Cities are to 'create in people's mind not only awareness but an understanding of the current evolution of our urban environment' that sees public space as 'a space for creativity, visibility, and exchange of culture where a connected public sphere is created' (quoted in Toft 2013b). This goal follows from a contemporary understanding of a public sphere that must address a 'distribution of the sensible' Rancière (2000) through the lens of hybridity and relationality, reminding and educating various groups about where and how they might be able to engage in public discussions related to common concerns. Such theories and goals find a place in their latest round of programming (2013-2015) in which Connecting Cities explored the themes of the Networked City, focusing on city-to-city interventions, the Participatory City, focusing on engaging the spaces around the media façade both locally and trans-locally, and the Visible City, focusing on creating real-time windows into environmental and contextually relevant data. The mandate of the Connecting Cities Network has grown out of a perceived disconnection and distraction caused by conventional uses of urban media and is now directed towards the fostering of local and trans-local connections and understandings, particularly through experimental networked scenarios.

Connecting Cities' focus on the trans-local and the network extends to the tactics of their curatorial approach that seeks to connect curatorial expertise and infrastructure, essentially creating a temporary curatorial commons and trans-local exhibition space for each project. This is vital for effectively addressing a newly envisioned hybrid and relational public sphere. Connecting Cities taps into local knowledge and avoids the constraints associated with commercial screen environments by building relationships with and between curators at various arts and cultural institutions that have their own media façades, such as *Quartier des spectacles* in Montreal, Medialab-Prado, Federation Square in Melbourne, and Bauhaus Dessau. Often these institutions have their own local mandates that must be coordinated with those of Connecting Cities. For example, Federation Square's 'big screen' must share its screen time for commissioned artworks with live sporting events and promotional content for the site, whereas Medialab-Prado is concerned solely with the production, research, and dissemination of digital culture.

Figure 4-7: Connecting Cities Network (2014), screenshot. Photo: courtesy of Susa Pop.

CONNECTING CITIES NETWORK

The CONNECTING CITIES NETWORK
(CCN) was initiated in 2012 and is a rapidly
growing network of media facades and
urban screens worldwide.
www.connectingcities.net

CONNECTING CITIES

Funded by the
Culture Programme
2007-2013 of the
European Union

Culture

m-cult,
Helsinki

RIGA 2014

Lab.

Media Architecture
Institute, Vienna

Sapporo

BIS, Istanbul

Jerusalem

Bankok

Hong Kong

Sydney

Federation Square
Melbourne

A recent project that reflects the coordinated efforts of the curatorial network of Connecting Cities and their mandate is *Binoculars to... Binoculars from...* (2013) by Varvara Guljajeva and Mar Canet Sola (see Figure 4-8). Part of the 'Networked City 2013' program, *Binoculars* involved the installation of 'binocular-like' kiosks in public squares around Europe that would provide a view of similarly equipped but otherwise unidentified remote locations. With coordination and support from Connecting Cities, the project was produced by FACT (Foundation for Art and Creative Technology) in Liverpool, and adapted by Ars Electronica in Linz, Medialab-Prado in Madrid; Public Art Lab and Foundation Bauhaus Dessau in Dessau, Public Art Lab and ikono in Berlin; iMAL (Centre for Digital Cultures and Technologies) in Brussels; m-cult in Helsinki; Federation Square in Melbourne; and Foundation Riga 2014 in Riga. After its completion, information about the project was included on the Connecting Cities 'Technical Framework' website describing the hardware required for the façade, computers, lights, interfaces (a detailed technical diagram is available on the site), networks, and a list of technology required both at the production city and the presentation city.

Binoculars was inspired by the panorama binoculars one might find at lookout points in various cities. While observing other locations from the binoculars, viewers eyes are captured and displayed on the urban screen of the observed place in real-time. The experimental proposition, facilitated by a combination of technologies centred upon large urban screens, is one of trans-cultural and trans-local connection that constitutes a new 'gaze' oscillating between surveillance, tracking, play, and telecommunication: all elements that are increasingly part of a trans-local commons that constitutes economic and social transactions such as social networks and energy consumption. *Binoculars* shows how such a nexus of concerns can be made into a more public matter by engaging a composite dispostif of networks, screens, and public space. Via *Binoculars*, Connecting Cities demonstrates an emerging commons and the media and spaces we can use to engage and contest it, thus spawning questions and potential debates about the possibilities and perils of networked technologies, vision systems, global consciousness, and public displays.

As noted earlier, the coordination of display contexts necessary for this is achieved through a network model that harmonises the curatorial goals of Connecting Cities with the local mandates of partner organisations. While Connecting Cities does observe and incorporate feedback from their ongoing presentations, missing from their curatorial process is the direct participation of the public. Although this does enter into the curatorial process to varying degrees depending on the outreach efforts of partner organisations, it remains conspicuously absent from their mandate.

Figure 4-8: Varvara Guljajeva and Mar Canet Sola, *Binoculars to… Binoculars from…* (2013), Connecting Cities, Bauhaus Dessau. Photo: Ruthe Zuntz, courtesy of Public Art Lab.

Officially, the curatorial process of Connecting Cities involves meetings, workshops and the maintenance of a centralised database of projects and protocols. Typically, a call for artists is sent out outlining general guidelines and themes. Then, artists are pre-selected through a collaborative process involving the host organisations. A final list of artists is provided to curators in each participating city and they select at least one artist to be produced locally for the event as well as deciding on suitable sites for the work. Selected artists are invited to a workshop where, together with curators, they develop projects, concepts, and technological setup and circulation plans with the other participating cities, ensuring that they are in line with the different local circumstances and production conditions. The result of such a collaborative and networked process has been the establishment of an infrastructure of diverse urban screens and media façades in regard to resolution, size, daylight compatibility, content management systems, internet connectivity and site-specificity. This system also facilitates the leveraging of local and national governments for funding, creating the conditions for the sharing of curatorial expertise, and nurturing audiences for large-scale, networked public works. Such coordination and leveraging serves to highlight the difficulty of any kind of bottom-up, grassroots approach to controlling and directing the uses of large urban screens, something

that has not changed significantly since early public screen experiments. This is a distinct weakness or limitation to constructing a commons from public screens.

While Connecting Cities could improve the way that citizens might be incorporated into the curatorial process through co-design, for example, they excel at using network tools to shape and support the curatorial process amongst fellow curators, infrastructure owners, and participating artists. A separate website entitled Connecting Cities 'Technical Framework' (Connecting Cities 2013b) helps to provide continuity, ease, and cohesion between the disparate technologies and contexts of the curatorial network. The 'Technical Framework' site is both a repository and archive of previous works, as well as a site that collects information about the specific technical capabilities and constraints of each façade in the curatorial network. Links to key technologies commonly required in media façade installations such as Processing, Raspberry PI, and Open Sound Control (OSC) are complemented by a link to the Connecting Cities GitHub community that serves as a forum for troubleshooting problems specific to these sites and technologies.

In this way, the work of Connecting Cities certainly reflects an ongoing shift in curatorial attention from objects to processes and dynamic network systems. Media theorist Sean Cubitt suggests that a measure of success for any work in a digital milieu depends on a work's 'breadth and depth and complexity of networks engaged and engendered' (2007, 313) — essentially its 'elasticity' (Antonelli 2008, 4). Connecting Cities provides the means for breadth and depth of connection across networks of telecommunication and of global urbanity, and an elasticity of scales and contexts, something that is demonstrated in a project like *Binoculars*. Such a metric of success applies just as much to curating, particularly in scenarios as geographically dispersed and technically complex as Connecting Cities. Specifically, the Connecting Cities 'Technical Framework' represents precisely what Krysa and Graham and Cook envision as part of the expanded field of curation for new media and networked systems; in short, it is a tangible instantiation of new possibilities for the organisation of the curatorial process that includes software, protocols, and networks. At the same time, it refers back to very real, very material sites and social processes where the curatorial meets the concrete experience of exhibition. The Connecting Cities Network extends our idea of what curation is and reminds us that curating today cannot be separated from social and technological developments (Krysa 2006, 7).

Furthermore, Connecting Cities harnesses the potential of transverse publics and networked scenarios by situating themselves, and the works they select, as 'interface actors' (Susa Pop, May 22, 2014, phone call with

author) — following on from Graham and Cook's (2010) definition of curating after new media — orchestrating the performance and practice of public sociality across diverse contexts. This often involves finding ways to include the audience and habituate them to new rituals of public art practice and reception through the design of participatory protocols and cues. Medialab-Prado's work *#ProgramaLaPlaza* is a prime example of this (see Figure 4-9 and Figure 4-10). The project allows participants in any location (with an internet connection) to write code for Madrid's public media façade which can then be viewed on the façade immediately thereafter. Medialab-Prado then selects the best of the contributions to be shown as part of a one-week exhibition. The aforementioned *Binoculars* also works to propose a new mode of engagement, one that acknowledges a mutual desire to look and be looked upon between and amongst urban populations. Both projects seek to develop communities, audiences, and publics that leverage media façades through the local and trans-local interactions. The networked frameworks within which projects like *Binoculars* and *#ProgrammaLaPlaza* emerge reflect an emphasis on greater circulation of these works and an open research component which helps the Connecting Cities Network develop as a form of DIT (do it together) activism (McKim 2014, 6) for public space and massive media, and solidifies their role as 'interface actors' in community building.

Connecting Cities also demonstrates a refocusing of work for large urban screens that seeks to create and foster a commons and a foundation of a public sphere that address contemporary ontological and epistemological issues: what or where exactly is the space of encounter and contestation that we share as urban, networked beings? Under what terms do we encounter and address one another? And to what degree can we see ourselves reflected back to ourselves in our trans-local spaces? As noted earlier, we can often only see ourselves reflected back to ourselves and address one another in meaningful ways in public space through the affordances opened up by artists concerned with these questions and the curatorial network that supports them. In this sense, both the artist and curator harbour a responsibility to create rich spaces of interaction and contestation that blend networked and trans-local participation. They also harbour a responsibility for understanding that the commons exists in a hybrid, contingent space that combines code with bricks and mortar, the screen with the street and the building. While the symbolic spaces of large public display are important focal points in these works, it is the amorphous spaces of interaction and social contexts and forums in the case of Connecting Cities, such as the 'Technical Framework' enabled through various works, that support enriching, participatory hybrid environments.

Figure 4-9: Frederic Granon, *BigBro* (2013), #ProgramaLaPlaza, Medialab-Prado, Madrid.
Photo: courtesy of Medialab-Prado.

That said, the spaces created and engaged by these projects cannot be seen
as going as far as becoming sites of dissent or radical, plural democracy, as
is hoped of critical public art by Mouffe. Particularly in *Binoculars*, there
is a reduction of participation and expression to the eye that is captured,
transmitted, and recombined across public spaces. In many ways, the sup-
pression of speech or text is a necessity of trans-local dialogue, namely that
it must sidestep the complexities and specificities afforded by language in
order to engage audiences that do not necessarily share a common language.
The connection, then, is an emotional and symbolic one. While this may lay
the groundwork for future dialogue, and certainly was a catalyst for local
dialogue amongst participants and viewers at the various locations of the
installation, the result is a minimal quality of debate with respect to the
formation of a democratic trans-local public sphere. Despite this, *Binoculars*
is not merely a spectacular aestheticisation of the city or a facile entertain-
ment, as McKim warns (2014). Rather, it presents new possibilities for the

Figure 4-10: Medialab-Prado, *#ProgramaLaPlaza* (2013–), screenshot. Photo: courtesy of Medialab-Prado.

building as screen. It engages an embodied transversality amongst diverse locations that can help to build temporary but powerful international connections amongst city dwellers, especially as audiences and their attendant interfaces for communication become more sophisticated. This addresses the ever-present challenge of developing an audience that is willing to be patient enough and skilled enough to participate with remote contexts across public spaces. For example, the elasticity in space and time created by the composite dispositif and transversal identities of *Binoculars* might be read in relation to the recent rise in popularity of Meerkat and Periscope (Tweedie 2015), two applications that allow individual users to broadcast live feeds from their smartphones. This phenomenon has even been taken up by news organisations such as The Guardian (Lewis et al. 2015) that have used it to report on breaking news stories and events such as the civil

unrest in Baltimore in the spring of 2015 — it may be something that in conjunction with massive media could be directed to confront international issues such as environmental degradation and human rights through the ongoing habituation of seeing through another's eyes.

At this point, it is important to consider the relationship that massive media works have to the concept of the spectacle. While large-scale media works on buildings may be enticing and distracting due to their size and visibility, a condition of Guy Debord's (1995) definition of the spectacle, they are also activated by participation through which criticality and variation can be enacted. Massive media spectacles thus contain a critical element through their openness to participation. That said, participation and the novelty of trans-local experiences are a double-edged sword: while they can disrupt the spectacle of commodified public spaces, they can also function to more completely deliver audiences to corporate and commercial goals of promoting telecom companies, creative cities, and entertainment districts. This is something that curatorial groups must be cognizant of in the growing field of massive media.

As noted earlier, due to the constraints associated with commercial screens, Connecting Cities moved away from occupying the gaps between advertisements. While previous art organisations using public advertising boards, such as the Public Art Fund and Artangel, targeted commercial spaces in order to critique them on their own ground, and to insert art into a larger cultural economy (Connolly 2013, 206), Pop observes that there are limitations to what can be done within the commercial frame. Typically, no segments longer than a few minutes are available, as was the case with the Times Square Spectacolor sign, thus the critique of spectacle in this form was particularly limited. As Pop (2014) notes, 'All that can be shown in that timeframe are videos or a trailer; you cannot really experiment with them'. By partnering and developing relationships with sites that consistently host art and experimental programming such as Medialab-Prado, Melbourne's Federation Square, or Montreal's *Quartier des spectacles*, funded exclusively through government grants, civic partnerships, and funds from commercial tenants (in the case of Federation Square), Connecting Cities can instead pursue an agenda of co-creation/curation and 'urban prototyping' where new public interfaces can be tested through prolonged iteration and observation (Susa Pop, May 22, 2014, phone call with author). It is also important to note that most of these sites in the Connecting Cities Network are designed with substantial embedded infrastructure including sensors, lighting, wiring and other permanent elements such as touch-screen kiosks that allow these spaces to function as user interfaces — an expanded relational

commons. Infrastructure control, then, becomes one of the pre-requisites for Connecting Cities and the curation of massive media in general, and one of the key distinctions between curatorial aims that critique spectacle directly versus those that envision deeper encounters through large-scale public displays.

With an emphasis on experimentation, Connecting Cities has moved away from their original intent to 'give these platforms back to people' (Susa Pop, May 22, 2014. Phone call with author), sensing that the highly provisional and restricted access to commercial screens and limited screen time did not lead to any lasting development of the medium and at worst furthered the detrimental impact of corporate interests in public space: interstitial art had become an ad for the ads and did little to foster new ways of being public. As mentioned earlier, Connolly argues that interventions are necessary when public space has become overrun by media messages. As the ecology of media changes, so do the interventions that keep public space public, albeit temporarily (2013, 215). Instead of grappling with commercial sites that bury the art within the noise of a competing composite dispositif and persuasive programming, Connecting Cities has opted to intensify the already-built platforms that have existed explicitly for art audiences and community development from the start so that new publics can be imagined and tested with greater consistency and regularity.

Streaming Museum

Streaming Museum forms temporary partnerships with cultural and commercial centres to produce contemporary-themed art exhibitions on screens (including its website) and public spaces on seven continents (Streaming Museum 2013). Although based primarily in New York City (though they would contend that they are not necessarily located in any specific place), the organisation works with digital and physical infrastructure and curatorial networks around the world that suit a specific curatorial theme which governs a year-long cycle of programming. Some of their partners have included bitforms (United States), Nam June Paik Art Center (Korea), and Zayed University (Dubai).

Streaming Museum officially opened on January 29, 2008, exhibiting *Good Morning Mr. Orwell* (1984), a work by Nam June Paik that was broadcast around the world in 1984. By coordinating public screens on every continent; Johannesburg, South Africa; Antarctica, Jubany Scientific Base of Argentina; Seoul, Korea; Melbourne, Australia; London, UK; Dallas, Texas; Montevideo, Uruguay; as well as Second Life, Streaming Museum was able to show Paik's

Figure 4-11: Pfadfinderei + The Constitute, *Dancing in the Rain* (2013), Connected Cultures Programme, Galeria de Arte Digital SESI-SP, Avenida Paulista, Sao Paulo, Brazil. Photo: verve cultural, courtesy of Public Art Lab.

work internationally once again. Just as Paik's work emerged at a time in which satellite television was seen as a viable site for the contestation of the tele-visual broadcast hierarchy that had been established in the twentieth century (Hansen 1993) — an exploration of the 'positive and interactive uses of electronic media' (Paik 1984) — its appearance in the launch of Streaming Museum signified an equally optimistic view of the possibilities for art and cultural dialogue within the largely commodified confluence of large digital displays, digital mobile devices, and the Internet. *Good Morning Mr. Orwell* also represented a mixture of art and popular culture, appropriating a variety show structure but injecting it with performances by avant-garde artists such as Merce Cunningham, John Cage, and Joseph Beuys that probed the nature of the human condition in this new era of technology. As Nina Colosi (quoted in Toft 2013a), founder and creative director of Streaming Museum, notes, Streaming Museum 'was launched at the cusp of the global expansion of the Internet and screen culture, including mobile, computer and urban screens'. It sought to represent and explore the new ontological and epistemological possibilities of urban, digital networks established by the composite dispositif of interoperable media devices, transversal identities, and hybrid spaces.

Figure 4-12: Björk, *Mutual Core* (2012), Times Square Midnight Moment, Streaming Museum & MOCAtv, New York City. Photo: Ka-Man Tse, courtesy of Streaming Museum.

Streaming Museum takes its name from the idea that the future of the museum is one that they believe should mimic the 'streaming' forms of data that comprise cultural production today. A 'streaming' museum eschews the solidity of built forms, opting instead for temporary instantiations on networked screens, while reaching its public either online or in hybrid public spaces supported by massive media. As Colosi (April 7, 2014, e-mail to the author) notes, it 'goes where the people are'. In this case, 'the people' are assumed to be always in, on, or around screens. Exhibitions have travelled to over 65 locations on seven continents and StreamingMuseum.org since 2008. Streaming Museum adopts a touring exhibition model punctuated by coordinated launch events such as *Good Morning Mr. Orwell*. It thereby aims to cultivate a cosmopolitan pubic sphere that enables a global audience to address issues of media access, representation, and other pressing concerns such as sustainability and renewable energy that extend beyond national borders. Colosi says that the development of streaming media channels and practices on- and offline are the forerunners for an engagement in what she calls 'a system of global governance', a kind of distributed United Nations supported by interconnected media and media spaces:

> It is conceivable that increasing digital interconnection will accelerate the emergence of cosmopolitanism resulting in a league of 'global digital cities'

Figure 4-13: Streaming Museum Network (2014), screenshot. Photo: courtesy of Nina Colosi.

that could share in a system of global governance. This could enable the monitoring and distribution of renewable energies and education, health and other social needs to those areas of the world where it is needed (2012, 52).

Colosi crucially extends the optimism that informed Paik's early experiments with satellite broadcast to the level of the global digital city thus identifying the physical spaces (and challenges such as energy and health) as sites and subjects of concern that are enmeshed with technology and well suited to massive media scenarios that foreground transversality. Concurrent with Streaming Museum's ideals as stated by Colosi is a dedication to contributing to an 'inspiration-and-information-with-social-value economy' (Streaming Museum 2013), that is, a sense that Streaming Museum should work with, not against or in explicit opposition to, the flow of capital and thus within the scenarios and networks of commercially owned urban screens. Thus, Streaming Museum's focus on 'value' is reflected in their willingness to collaborate with corporate entities such as the Times Square Alliance in order to achieve maximum visibility, sustainability (by piggybacking on a profit-driven model where infrastructure is sustained and updated through advertising dollars), and exposure.

The technical and organisational structure of Streaming Museum reflects a shift to networked systems and experiences, as opposed to specified locations or institutions. As Colosi explains: 'Streaming Museum is a new museum concept built with technological elements; it's not fixed in one place' (Colosi 2014). Thus, instead of approximating a curatorial network, Streaming Museum can be seen as curatorial technique that treats networks,

both physical and digital (combined in the form of networked urban screens), as the 'museum'.

Streaming Museum consists of three permanent members, its founder and creative director, Nina Colosi, associate curator, Tanya Toft Ag, and videographer, David Bates, Jr. with a number of curators and directors participating on an ad hoc basis. Essentially, Colosi begins with a curatorial theme, either one that she is interested in or relates to a particular project or festival they are working with. This is followed by a period of intense research and discussion with curators and artists (Colosi 2014). For example, Streaming Museum completed its *Nordic Outbreak* program in 2013, an exhibition of over 30 moving image artworks by Nordic artists curated for public space, which included partnerships with curators and organisations across the Nordic countries (such as a temporary screen at Kiasma in Helsinki), as well as with established partners around the world (such as Times Square Arts in New York City). In this way, Streaming Museum curated the project centrally but distributed it through a network of organisations, sites, and screens (both public and private, permanent and temporary). By cultivating an art audience in the interstices between commercial messages, Streaming Museum does not necessarily critique spectacle; instead it seeks ways in which spectacle can be redirected towards experimental aesthetic experiences in public space.

As part of the *Nordic Outbreak* program, Streaming Museum leveraged its global connections and partnerships to display Icelandic pop signer Björk's *Mutual Core* (2012) on seven continents. Created by MOCAtv for the Los Angeles Museum of Contemporary Art and directed by Andrew Thomas Huang, Björk's video explores the relationship between the human condition and nature on a planetary scale. In the video, after some energetic struggling and explosions, we see Björk emerging from rocks and sand, and then merging with these animated objects and magma flows. While the 'mutual core' she speaks of also alludes to interpersonal connection, the metaphors of 'tectonic plates' and eruptions that disrupt stagnation clearly evoke a sense of intraplanetary connection that is anchored to an ongoing negotiation of humans with geographic and geological space. This theme of the merging of disparate spaces, of 'ridge drifts to counteract distance' (Björk, 2011), found a match in the curatorial program of Streaming Museum that placed *Mutual Core* on display in seven continents through projections and public screenings, including an event at the only cinema in Antarctica. Screenings were also held on the BBC Big Screens, a network of public screens across the UK built originally to present the Olympics and Paralympics but also designed to display some artistic and cultural content thereafter. The

centrepiece of this coordinated event was the Midnight Moment launch at Times Square which spread the video across 15 of the largest screens at the site. Overall, the *Mutual Core* project exemplified Streaming Museum's opportunistic interstitial approach in order to maximise reach and visibility. *Mutual Core* speaks to the notion that we must continue to develop empathy to solve social and globally relevant problems through a communicative process.

Streaming Museum engages the global 'streaming' of data in relational spaces that merge the logic of space and media. This is further developed in their presentation of French media artist Maurice Benayoun, whose works expose the contrast between omnipresence and site-specificity. *Emotion Forecast* (2010), a data visualisation using the graphics of stock market updates to express real-time changes in the 'world emotion global trend', was derived from current events websites in more than 3,200 cities and was shown in New York City's Big Screen Plaza. A second piece, *Occupy Wall Screens* (2011), was also displayed in Big Screen Plaza, and in a mix of indoor, outdoor, commercial, and gallery venues including the ZERO1 San Jose Biennial and Federation Square in Melbourne (see Figure 4-14 and Figure 4-15). This version of Benayoun's emotional forecasting focused on cities involved in the Occupy Wall Street movement and compared their civic mood with the market trends of financial stocks. As the artist notes, *Emotional Forecast* could exist anywhere, as it was created from and for the Internet. It could be widely sourced and distributed for screens on desks and walls alike, and thus fit seamlessly into most display contexts in a globalised world. On the other hand, *Occupy Wall Screens* reflected the importance for some media work to be context specific — in this case, placed in a public square in New York City, allowing the energy surrounding the Occupy movement to stream back into its core. *Occupy Wall Screens* engaged in the spectacle created by the globally recognizable images of New York City and the Occupy Wall Street movement by coopting a public screen typically employed to co-construct and amplify this spectacle.

At the same time, Benayoun and Streaming Museum have used the primacy of New York City to their advantage, noting, as the artist does, that New York City is 'the place to be when you want something to be heard by everybody' (Toft 2012). By involving the mutually inclusive 'mutual cores' of virtual space (embodied by the flows of data and connectivity of the Internet) and a heavily screened, globalised, urban environment (exemplified by New York City in general and Times Square specifically), Streaming Museum presents a model of curation that inserts itself within existing spectacular displays and commercial and artistic streams. Stitching together

Figure 4-14: Maurice Benayoun, *Emotion Forecast* (2012), screenshot. Courtesy of Streaming Museum.

Figure 4-15: Maurice Benayoun, *Occupy Wall Screens* (2012), Big Screen Plaza, New York City. Photo: David Bates, Jr., courtesy of Streaming Museum.

programs of cosmopolitan public address, they adapt commercialised sites as productive venues for global cultural development. Optimistically, as stated earlier, Colosi claims such platforms can support a 'system of global governance' (2012, 52) akin to the United Nations where citizens are connected by streaming channels and interconnected media to collectively make decisions on issues of international import. Yet, Benayoun's work for

Streaming Museum provides an example of what a component of such a 'system of global governance' might look like by proposing a way that data and coordinated public visualisation might be used to identify the causes and effects of trans-local phenomenon in a globalised world.

The takeover of Times Square for Streaming Museum's *Nordic Outbreak* and the coordinated global program that followed addressed the use of a composite dispositif, the semi-coordinated combination of media experience, by uniting the local with a global network of temporary partnerships, screens, and spaces. *Nordic Outbreak* extends one of Anna McCarthy's ideas that aggregated screen environments (such as the multitude of monitors in the Virgin Megastore, once located in the middle of Times Square) physically and affectively mobilise the spectator into the space of address. The outcome of such coordination is a 'public personhood' (2001, 117) in which screen placement and protocols shape subjectivity. By emphasising the oscillation between the personal and communal, local and global, physical and virtual, and commercial and artistic, Streaming Museum expands the parameters of screen cultures to engage viewers in a hybrid mode of address that engages a transversal subjectivity through a composite dispositif.

Streaming Museum believes that a productive balance can be achieved between spectacle and art. In their projects, commercial sites became the places to implement new models for reconceiving the public sphere through art and technology. Colosi argues that corporations should see the inherent value in aligning their image with culture, and vice versa for curatorial organisations. As Colosi (2014) notes, 'I don't think about [corporations and commercialism] as factors we're working against'. Instead, 'the focus is on the realisation of mutual benefits'. Colosi departs somewhat from the oppositional rhetoric of Connecting Cities, as well as Artangel and Public Art Fund before it, by revealing a more cooperative stance toward the sites of massive media that, due to scale and cost, can seldom avoid some form of commercial or touristic justification and may be best tethered and combined through a combination of art and commerce.

Curating RyeLights

In order to observe the conditions associated with curating and programming massive media, and to provide a point of comparison to the previous two examples of Streaming Museum and Connecting Cities, I planned, proposed, and implemented a curatorial initiative called 'RyeLights' for the LED façade of the Ryerson Image Centre and Ryerson School of Image

Arts building (RIC/IMA). The RIC/IMA was the venue of a project discussed in Chapter 3, *In The Air, Tonight,* which visualised Twitter activity related to homelessness and local wind speed and direction on the low-resolution LED façade of the building. After presenting this project for a second time in 2015, university officials warmed to the idea of instituting a year-round curatorial program that would build upon the philosophies and frameworks of Connecting Cities and Streaming Museum described in this chapter. In implementing a year-round schedule of lighting events for the LED façade of the RIC/IMA, allowing students to propose lighting schemes and create and participate in interactive installations, the building has now become open to local interactivity and to trans-local connections as evidenced by projects such as *In The Air, Tonight* and *E-TOWER.* Since the fall of 2016, lighting requests submitted via a website have been evaluated by a panel of staff and student representatives based on the timeliness (how the proposed date of the lighting proposal is relevant), tie-in to community events (whether the lighting request compliments community functions), and inclusivity (whether the lighting request supports the promotion of inclusivity and diversity) (Ryelights, 2018). The focus on time and site specificity, and well as the explicit goal of inclusion, make this an example of, or at least an attempt at, creating a work of media architecture as a critical spatial practice. Examples of lighting requests have included local, school related events such as awards ceremonies and sporting events, but have also included special lightings to support on-campus protests related to issues of national and global significance such as Tibetan Uprising Day and Trans Awareness Month. In November of 2016, RyeLights collaborated with Shades of Our Sisters (2016), an exhibit and online experience created by the families of missing and murdered Indigenous women. The project was aimed at sharing 'the memory of loved ones and what the loss of their life means' to a wider public. For three nights, RyeLights glowed red in honour of Missing and Murdered Indigenous Women, Girls, Transgender, and Two Spirited People in Canada (MMIWGT2S). Light pulses on the building indicated when the hashtags #MMIW #MMIWGT2S and #MMIWG were used on Twitter. With the addition of community input, the RIC/IMA has become more open and available to the community around it and has thus altered the distribution of the sensible in the built environment.

RyeLights has attempted to transform this previously inaccessible and primarily decorative building into a space of social critique. With the integration of social media, the building has become a hybrid interface that, albeit temporarily, writes previously marginalised voices into the fabric of the city and does so not through an unsanctioned, provisional projection, but

through an official and complete transformation of a building's façade. This creates a closer coupling with traditional concepts of monumentality, which see iconic buildings as condensers of memory and ideological meanings, but also with the 'new monumentality' concept which envisions structures and spaces that reflect the collective emotional life groups and individuals.

Like many of the venues that Connecting Cities has migrated towards, the RIC/IMA, an institution with art and design programs, is an ideal site for experimentation and for the development of an audience that can understand and appreciate the work presented on it. This can occur through the long-term habituation and exposure that is possible with a permanent exhibition and interaction site. Over the course of a number of years, students and residents in the area will be exposed to various modes of expression and interactivity on the building, learning where and how to decode and interact with the building, and proposing their own uses.

In order to support such programming and the development of an informed and receptive public for the building, the further development of a technical framework similar to the one created by Connecting Cities is necessary to allow for an ease of programming by artists and students. A permanent interactive public terminal or tangible user interface and dedicated seating should also be considered here to further augment the possibilities for interaction with the building and entrench it within a composite dispositif of on- and offline spaces that position it as an exhibition space for massive media. Furthermore, promotion, integration, and documentation of the works presented on the building through social media and websites (such as YouTube) can expand the reach, influence, and creative possibilities of the works and reinforce the transversality and post-production affordances of the site. In advocating for a permanent exhibition program for this building I see myself first as an activist working towards opening up this building to greater expressivity and engagement, and second, similarly to Nina Colosi and Susa Pop, as an interface actor, facilitating artistic experimentation through the provision of technical protocols, support, and institutional partnerships.

Connecting Sites and Streams

While the building as screen will persist primarily as a highly commercialised phenomenon, it might also be pressed into service, through coordinated curatorial efforts, to critique or co-opt commercialisation, or to re-envision the role of urban media environments in shaping collective

identity, historical consciousness, and public display culture. Connecting Cities and Streaming Museum provide us with two hypotheses for how large-scale public projections and public data visualisations can operate critically, creatively, and cooperatively. Connecting Cities focuses on developing public and curatorial interfaces with existing art organisations that facilitate experimentation and urban prototyping and Streaming Museum provides a curatorial model that seeks to convince both art and non-art venues of the value of connected public displays and cultural programming on a global scale. These works (as well as my efforts in creating a curatorial program for the RIC/IMA) can be seen to embody Maria Lind's recent arguments about what curating is today. She imagines curating 'as a way of thinking in terms of interconnections: linking objects, images, processes, people, locations, histories, and discourses in physical space like an active catalyst, generating twists, turns, and tensions' (2010, 63). Connecting Cities aligns itself with existing arts organisations that have access to display sites, emphasises the importance of the interface between the public and the work in their curatorial selection and direction, and curates as a network which includes providing open-source software repositories for each of their sites. They are primarily concerned with the provision of shared technical information, strengthening partnerships with government funders, networking and sharing information amongst presentation sites, and developing audiences, networks of circulation, and cataloguing works. Streaming Museum prefers a mixed approach, connecting with museums, galleries, and art organisations when possible while also developing economic arguments to convince corporate entities, such as Times Square, of the value of global public programming for social justice and the artistic use of big screens for civic and commercial development. Both are concerned with introducing new aesthetic and conceptual ideas into public spaces, commercially owned or otherwise, for the purposes of developing cosmopolitan trans-local and transversal thinking, and developing audiences for these new combinations of space and media.

For both Connecting Cities and Streaming Museum, sustainability, audience development, and the idea of trans-local and transversal activity, connection, and action lies at the heart of addressing the perceived need to connect places that share culture or are asked to question the integrity of this claim through the embodied telepresence enabled by shared cultural experiences. As such, they begin to renovate ideas of what the commons is and what it means to be public today. It is an idea that is very much rooted in the sense that local contexts must be researched, respected, and developed, while 'local' also has a networked meaning in that familiarity and tradition

can exist also online, and thus anywhere that it can be accessed and engaged. Colosi argues that trans-locality is communicated by computers, mobile phones, and big screens alike (April 7, 2014, e-mail to the author). Similarly, theorist Tobias Ebsen points out that 'Instead of regarding the immaterial content as detached from the material medium, it becomes possible to conceptualise them as interdependent elements' (2013, 166). Perhaps the greatest contribution Connecting Cities and Streaming Museum is the inter-rogation of challenges and possibilities of an increasing interdependency and elasticity of contexts, people, technologies, and places: that is, the impetus to imagine and begin to construct a hybrid commons with massive media.

Support for massive media — large urban screens, reactive architecture and public projection sites — has become more prominent in major cities around the world. The projects of Connecting Cities and Streaming Museum show how curators have redefined the public sphere in the form of networks of public display, distribution, and institutional coordination. Practices at these two organisations demonstrate a broader shift in curatorial attention from autonomous artworks to curatorial networks, hybrid infrastructure, transfer protocols, technical specifications, and software packages. They also demonstrate that large-scale urban digital arts that use public space and architecture as their substrates require particular tactics to either work with or in opposition to pre-existing, commercialised sites of display. Crucial to the curatorial process of massive media are negotiations with corporate and civic entities, each with their own goals that impact what can be presented. Beyond selection and production, curating the building as screen involves a responsibility for harnessing complex dispositives and the complexities of trans-local space for aesthetic critique and empathetic social connection.

An early version of this chapter titled, 'Curating Massive Media' has been published in *Journal of Curatorial Studies* 4(2): 238-262 (2015).

References

Antonelli, Paola. 2008. *Design and the elastic mind*. New York: Museum of Modern Art.
Björk. 2011. *Mutual core*, London: Polydor.
Colosi, Nina. 2012. Imagining digital cities. In *Urban media cultures: (Re)Shaping the public space through urban screens and media architectures*, eds. Susa Pop, Gernot Tscherteu, Ursula Stalder, and Mirjam Struppek, 48-53. Berlin: avedition.
Connecting Cities. 2013a. Networked city 2013. *Connecting Cities*. Accessed August 16, 2015. http://www.connectingcities.net/city-vision/networked-city-2013.

————. 2013b. Technical framework. *Connecting Cities*. Accessed August 16, 2015.
http://www.aec.at/connectingcities/.

————. 2014a. About. *Connecting Cities*. Accessed August 16, 2015. http://www.
connectingcities.net/about-connecting-cities.

————. 2014b. TV. *Connecting Cities*. Accessed August 16, 2015. http://www.con-
nectingcities.net/tv.

Connolly, Maeve. 2013. Artangel and the changing mediascape of public art. *Journal
of Curatorial Studies* 2(2): 196-217.

Crary, Jonathan. 1999. *Suspensions of perception: Attention, spectacle and modern
culture*. Cambridge, MA: MIT Press.

Cubitt, Sean. 2007. Precepts for digital artwork. In *Fluid screens, expanded cinema*,
eds. Janine Marchessault and Susan Lord, 304-320. Toronto: University of Toronto
Press.

Debord, Guy. 2009. *Society of the spectacle*. Trans. D.N. Smith. New York: Zone Books.

De Souza e Silva, Adriana. 2006. From cyber to hybrid. *Space and culture* 9(3):
261-278.

Ebsen, Tobias. 2013. Material screen: Intersections of media, art, and architecture.
PhD thesis. Faculty of Arts, Aarhus University, Denmark. Accessed April 26,
2015. http://tobiasebsen.dk/research/phd-dissertation/.

Fletcher, Harrell, and July, Miranda. 2002-09. *Learning to love you more*. Accessed
January 2, 2013. http://www.learningtoloveyoumore.com/index.php.

Graham, Beryl and Sarah Cook. 2010. *Rethinking curating: Art after new media*.
Cambridge, MA: MIT Press.

Guattari, Felix. 2000. *The three ecologies*. Trans. Ian Pindar and Paul Sutton. London:
The Anthalone Press.

Habermas, Jurgen. 1989. *The structural transformation of the public sphere: An
inquiry into a category of bourgeois society*. Cambridge, MA: MIT Press.

Hansen, Miriam Bratu. 1993. Unstable mixtures dilated spheres: Negt and Kluge's
the public sphere and experience, twenty years later. *Public Culture* 5: 179-212.

Hardt, Michael. 2009. Production and distribution of the common: A few questions
for the artist. *Open* 16. Accessed April 7, 2018. https://onlineopen.org/download.
php?id=46.

Kester, Grant. 2006. Crowds and connoisseurs: Art and the public sphere in America.
In *A companion to contemporary art since 1945*, ed. Amelia Jones, 262-67. Oxford:
Wiley-Blackwell.

Krysa, Joasia. 2006. *Curating immateriality: The work of the curator in the age of
network systems*. Brooklyn, NY: Autonomedia.

Landry, Charles. 2008. *The creative city: A toolkit for urban innovators*. London:
Earthscan.

Lefebvre, Henri. 1991. *The production of space*. Oxford, UK: Blackwell.

Lewis, Paul, Jon Swaine and Ben Jacobs. April 28, 2015. 'This is not the justice we seek': sorrow in Baltimore as grief turns into riots. *The Guardian*. Accessed October 18, 2016. http://www.theguardian.com/us-news/2015/apr/28/baltimore-riots-fires-reaction-looting-protesters-hurt-community-unrest-just-beginning.

Lind, Maria. 2010. *Selected Maria Lind writing*. Ed. B.K. Wood. Berlin: Sternberg Press.

McCarthy, Anna. 2001. *Ambient television*. Durham, NC: Duke University Press.

McKim, Joel. 2014. Distributed design: Media technologies and the architecture of participation. In *DIY citizenship: Critical making and social media*, eds. Megan Boler and Matt Ratto, 283-294. Cambridge, MA: MIT Press.

———. 2012. Spectacular infrastructure: The mediatic space of Montreal's 'Quartier des spectacles'. *PUBLIC* 45: 128-138.

McQuire, Scott. 2008. *The media city: Media, architecture, and urban space*. London: Sage.

Mouffe, Chantal. 2007. Artistic agonism and agonistic spaces. *Art & Research: A Journal of Ideas, Contexts and Method* 1(2): 1-5.

Murphie, Andrew. 2004. The world as clock: The network society and experimental ecologies. *Topia: Canadian Journal of Cultural Studies* 11: 117-138.

Paik, Nam June. 1984. Nam June Paik – Good Morning Mr Orwell (1984). *YouTube*. Accessed December 10, 2015. http://www.youtube.com/watch?v=ooUdI-KFCyU.

Phillips, Patricia C. 1989. Temporality and public art. *Art Journal* 48(4): 331-35.

Rancière, Jacques. 2000. *The politics of aesthetics*. Trans. Gabriel Rockhill. London: Continuum.

RyeLights. 2018. Ryelights. *Ryerson University*. Accessed October 16, 2017. http://www.ryerson.ca/ryelights/.

Shades of Our Sisters. 2016. Shades of our sisters. *Shades of our sisters*. Accessed October 16, 2017. http://www.shadesofoursisters.com/#/.

Sloan, Johanne. 2006. At home on the street: Public art in Montreal and Toronto. In *Urban enigmas*, ed. Johanne Sloan. Montreal and Kingston: McGill-Queen's University Press.

Streaming Museum. 2013. About. *Streaming Museum*. Accessed April 7, 2014. http://streamingmuseum.org/.

Times Square Arts. 2014. Midnight moment archive. *Times Square*. Accessed July 4, 2018. http://www.timessquarenyc.org/times-square-arts/moment/archive/index.aspx#.U-ZHMbsQA_E.

Toft, Tanya. 2012. Interview: Maurice Benayoun. *Streaming Museum*. Accessed July 4, 2018. http://streamingmuseum.org/transcript-benayoun-interview/.

———. 2013a. Interview: Nina Colosi. *Urban Media Aesthetics*. Accessed October 5, 2015. http://urbanmediaaesthetics.org/#?cat=11_interviews?post=1185_nina-colosi-founder-and-creative-director-of-streaming-museum.

————. 2013b. Interview: Susa Pop. *Urban Media Aesthetics*. Accessed October 5, 2015. http://urbanmediaaesthetics.org/#?cat=11_interviews?post=1159_susa-pop-founder-of-public-art-lab-and-director-of-connecting-cities.

Tweedie, Steven. May 6, 2015. Meerkat's CEO describes what it was like the day Twitter decided to crush his app: 'The team went back to the office to get ready to dive in'. *Business Insider*. Accessed October 5, 2015. http://www.businessinsider.com/meerkat-has-nearly-2-million-users-2015-5.

Verhoeff, Nanna. 2012. *Mobile screens: The visual regime of navigation*. Amsterdam: Amsterdam University Press.

5. When Buildings Become Screens

Abstract
This chapter outlines various tactics that artists, filmmakers, curators, architects, city planners, and arts administrators can employ to develop works, sites, and audiences that support a more participatory and representative public culture through massive media. These include: the application of analytical tools from cinema studies, namely superimposition, montage, and apparatus/dispositif, high-level coordination and provision of technical support from curatorial groups that see themselves as public space activists and community facilitators, and sensitivity towards context, both digital and virtual, of large-scale public data visualisations centred upon LED façades. More study and practice is needed as the technologies and contexts of massive media shift and merge with the practices of digital placemaking and smart cities.

Keywords: smart cities, digital placemaking, architecture, curation, cinema

Dancing with Buildings

You put your left foot in, you take your left foot out. And yes, you shake it all about as prompted by the screen in front of you. Soon enough your recorded image is projected for all of the people gathered around the *Place Des Arts* metro station in downtown Montreal who seem to be performing their own dance of spectatorship, watching intently or distractedly, snapping photos to post online, and cueing up for their turn.

If you did any of these things, you would have just participated in *McLarena* (2014), the interactive public artwork by the Montreal design firm Daily tous les jours that I described in Chapter 2, a work that pays homage to Canadian film pioneer Norman McLaren's work *Cannon* (1964) by teaching people to dance like the character in his film and displaying the results on the side of a building for everyone to see. As buildings become

Colangelo, D., *The Building as Screen: A History, Theory, and Practice of Massive Media*. Amsterdam: Amsterdam University Press, 2020
DOI 10.5117/9789462989498_CH05

more like screens with the addition of projection, LEDs, or built-in screen elements, we will increasingly find ourselves amongst public artworks and experiences like this in our cities — works that are large-scale, public, networked, interactive, participatory, and digital. In fact, *McLarena* shows us that what we now expect from public space, and what it can potentially deliver, is rapidly changing.

Inquiring into the past, present, and future of massive media shows us that our urban environments have become progressively more communicative — buildings and infrastructure can now be clicked, swiped, shared, captured, and conversed with. When buildings become screens they can begin to tell us something about the place they are in, about ourselves and others as we engage with them, and connect us to other people and times, both near and far. But that is not to say that some kind of global democracy is automatically extended and enhanced through access to networked, building-scale effects that encourage citizens to act together. In fact, the dangers of aestheticising and obscuring history and making a spectacle of engaged participation through massive media are very real in their mainly commercially driven venues, a number of which have been described in this book. We must humbly understand that the building as screen simply offers a new avenue for the construction of identity and meaning, a new way of making the past resonate with the present, the personal with the political, the individual with the mass. It is, in part, this newness that has drawn me to investigate and untangle the construction of these sites and experiences in order to uncover insights that can be used to critique and reconfigure power relations as they become increasingly mystified and obscured by technology.

Tactics and Strategies

With careful planning and design and critical conceptual rigour, massive media can help to recuperate and revive urban space while also fostering hybrid public spheres (on and offline) of cooperation, conviviality, conversation, and contestation. When buildings become screens, and when they are made to speak and listen through various interfaces, we can create perceptual laboratories that present novel proposals for how we might conceive of and create place in the twenty-first century.

One such tactic is the application of analytical tools from cinema studies, namely superimposition, montage, and apparatus/dispositif, to the study of massive media. These techniques and analytical lenses serve to demonstrate

the ways in which massive media both follows from, incorporates, and departs from cinema and other standardised forms of technical expression and spectatorship. When we understand the affordances and risks associated with other media forms, from empowerment to mystification, we can better critique the form in question, as well as better design for more democratic outcomes. It is also important for the ongoing study of media in all of its forms to understand how media are never distinct from one another, but always implicated in one another in increasingly complex ways. The application of other media-related theory, in particular more recent theories associated with the study of augmented reality, could prove germane to a deeper understanding and critique of hybrid publics in the media city and better outcomes for massive media installations.

More tactics have emerged from the exploration and application of principles of new media art curation to the building as screen. Due to their hybrid nature, connected as they are to various sensors, data streams, and remediated through the post-production of personal photography and associated social media networks, massive media require high-level coordination and the provision of technical support from curatorial groups that must see their role as activists, fighting for sustained access to these highly charged spaces, and as facilitators and organisers, habituating audiences to these new forms of contestation and connection and developing more nuanced forms of communication with and through them. Having studied a number of sites and situations of massive media in this book, it is clear that cultural visibility in general is highly controlled and contested through technological, economic, and political means, and sustained action and persistence on the part of artists, curators, and citizens is required to make incremental but important shifts in how we will be able to read and write our cities in the future through public space and architecture.

This book has also explored ongoing interdisciplinary study of digital culture in its tests of the theoretical claims made about the transformative properties of digital technology in cities and for architecture and monuments. The combination of programmable LED façades or digital projection mapping, coordinated sound, and other digitally coordinated media elements such as radio signals and social media, were shown to contribute to theories of relational and hybrid space made by McQuire and De Souza e Silva, while also proving productive for the engagement of a new approach to architecture and monumentality that we might describe as 'supermodern' (Ibelings 2002) which sees structures as imbricated and expressive of the participatory, contingent, and ambivalent nature of

expressions and connections that we experience in a data society. The connections made between people, images, information, and space do not displace tradition, connection, and meaning so much as give it a different velocity and topography. Armed with this knowledge, we might reliably predict and guide future outcomes, directions, and critical practice in the growing field of massive media and the ever-evolving fields of architecture, social media, public space, and monumentality. One such practice that this study has exposed and outlined is that of public data visualisation which is particularly prevalent in large-scale low-resolution media façades. Public data visualisations, in their massive embodiment of data of shared consequence, and the subsequent intensity of embodiment experienced by spectators and participants against the scale and significance of urban space, are poised to grow in number and importance, and thus must continue to be analysed and developed critically. This can be done, as seen here, through social media analysis which exposes the uses of public data visualisations at a micro and macro level, dissecting individual social media posts and discourses that demonstrate levels of contestation and conversation centred upon the building as screen, but also by observing their overall representative usage over time. It can also be done by carefully analysing and considering the context (carrier, content, and environment) (Vande Moere and Wouters 2012) of massive public displays, and evaluating how they are situated, informative and functional (Vande Moere and Hill 2012). Public data visualisation also implies that the way we can come to know ourselves, others, and our environment will increasingly be dependent on a complex combination of times, spaces, and dispositives that will rely on active participation and passive capture in myriad forms, algorithmic processing, and context sensitivity. More work is required here, namely in the way that cities will make themselves legible and malleable through public displays and tangible user interfaces.

Finally, an engaged practice with the building as screen is necessary to better consider the ever-changing qualities and characteristics of agglomerations of space and media, and to disseminate theories and shape public culture more directly and publicly. By working with the materials and theories of space, media, and monumentality, I have explored and exposed some of the complexities and stakes involved in developing a composite dispositif through various on- and offline means to capture and deliver an audience to experiences with space, history, and one another. While the goal of my projects, and other artistic and critical approaches to massive media, was to create playful, participatory, heterogeneous, inclusive, unpredictable, and contradictory spaces of encounter, it is clear

that these same tactics and goals are being applied to similar projects, namely commercial ventures and promotions such as Verizon's #WhosGonnaWin installation with the Empire State Building, with results that serve to narrowly constrain public discourse while spectacularising democratic access. In the face of this, sustained experimentation and artistic critique in the form of the development of curatorial programs for these spaces as well as purpose-built, well-supported, dedicated sites for experimentation with trans-local encounters through massive media are necessary in order to develop the complexities of a new public sphere that will be crucial in addressing the complex trans-local issues of identity, environment, and economy that we will continue to face.

More Massive, More Media

More study and action is needed by artists, curators, and academics in the field of massive media. For one, technologies, tools, and practices in the field are changing every day, with bigger, brighter, and lighter lighting elements and projectors being produced, mounted, and directed at wider swathes of the urban environment. In addition to this, improvements and developments in the composite media forms of massive media such as social media and embedded, networked sensors are undergoing similarly rapid changes and evolutions as evidenced by the growing importance of the Internet of Things (IoT) which seeks to create networks of sensitive, communicative objects through embedded, connected electronics. As massive media grows in its applications and complexities, we must continue to probe it for its critical potential and its ability to build empathy, connection, and context across on- and offline spaces, developing publics to serve trans-local identity formation, political representation, and cultural expression. Arts organisations, schools, curatorial agencies, and governments at all levels must appreciate and understand the growing importance of these sites for this purpose.

Another area of intersection and interest for massive media is with the increasingly popular concept of smart cities. Updating his concept of the media city, McQuire uses the term 'geomedia' to describe 'the convergence of media sectors, the ubiquity of digital devices and platforms, the everyday use of place-specific data and location-aware services, and the routinisation of distributed, real-time feedback' (2016, 19). These principles also characterise what has been called the 'smart city', which has been defined as 'constellations of instruments across many scales that are connected

through multiple networks which provide continuous data regarding the movement of people and materials' (Batty et al. 2012, 482). When buildings become screens, they become important communicative infrastructural elements of smart cities that reveal and potentially enhance or even critique this 'constellation' of embedded instruments. Examples of such elements include wifi and infrared sensor equipped light posts that gather information about people and devices that pass by, aiding in urban wayfinding, traffic management (particularly with the advent of driverless vehicle technology), and 'smart' trash bins that optimise sanitation services. The overall goals of smart cities and their attendant technological constellations of sensors, monitors, relays, and screens (including those embedded in buildings), is to create efficiencies, thus reducing costs and decreasing urban frictions and challenges such as traffic congestion, pollution, and disorientation. With this in mind, McQuire warns that while smart cities may be beneficial in some ways, advancing a rhetoric of informational transparency and citizen empowerment, they have yet to demonstrate how largely inaccessible and proprietary infrastructure can achieve either of these goals. He is also skeptical of what he calls a 'technological rationality' which smart cities, and capitalism in general, are built on, and perhaps even dependent on, in which innovation arises not from human-centred invention but from the instabilities and needs that technology articulates for itself (2016, 159). Furthermore, Adam Greenfield (2013) notes that in privileging flow through hidden infrastructures and decisions, smart cities remove the necessary friction of urban life which is central to advancing radically democratic principles of dissensus and agonism (Mouffe, 2007), that is, of holding many identities, goals, values, and opinions together instead of seeking consensus and conformity. Knowing that a future with fewer sensors and screens is not an option, Greenfield asks, 'How might we leverage the potential of data-gathering, analysis and visualisation tools to improve a community's sense of the challenges, risks, and opportunities facing it, and support it in the aim of autonomous self-governance?' (2013, 23) As dense transfer points for data, analysis, and visualisation, similar questions might be posed of media architecture, the building as screen, and practices of massive media.

Also of particular importance for further work in this area is the role that documentation plays in producing an image of the city through massive media. While the Empire State Building populates its social media feeds nightly with high-quality images taken from an ideal viewpoint, these extra-large-scale displays are captured in their entirety from vantage points that are shared by few in the city, but widely disseminated and potentially

internalised by larger, networked populations to produce a collective image of the city primarily through remediation. Research on massive media could be extended to other countries and regions, comparing the role that regional politics and culture play in shaping massive media and the practices associated with them. McQuire and his colleagues (Barikin et al. 2014) have already pioneered some of this research by studying the translation of gestures between large public displays in Seoul and Melbourne, but much more research is needed as these scenarios and practices continue to proliferate.

Another area in which this analysis might be extended using the tools and methods presented in this book is in taking a closer look at the specific differences between the use of live and pre-recorded images in large-scale public artworks. Although I have covered a number of massive media scenarios in this book, I have not specifically focussed on the qualities of liveness in the creation of powerful emotional and collective experiences. Yet another area to explore is the prevalence of the use of the face in massive media to communicate, connect, and develop empathy. More study into the history of the face in monuments and in architecture may produce interesting insights into the contemporary use of portraiture and selfies in massive media. More research could also be done into the ways public art has addressed specific societal issues and how it can now be addressed differently or more effectively through massive media. To focus this analysis, a single issue could be selected, such as climate change or poverty, and case studies could be presented and analysed along with a number of artistic projects.

Finally, more study is needed on existing organisations, their protocols, practices, tactics, and results with respect to massive media. The innovative work of organisations such as Medialab Prado and Galeria de Arte Digital SESI-SP in Sao Paulo have yet to be studied in greater detail and would make excellent case studies to address ongoing questions about the provision and programming of massive media: How are publics continuing to engage with the building as screen? How can their feedback be solicited and integrated into the planning and production of massive media? Do citizens have the opportunity or right to decide if their cities will be the sites of such agglomerations of media and architecture? And if so, what level of control do they have over their programming? I have started to explore these questions in this book, but more work is needed as more buildings become more screen-like, screen-reliant, and more massive in their size, reach, and consequence for the future of cities and citizenry.

References

Batty, M., Axhausen, K. W., Giannotti, F., Pozdnoukhov, A., Bazzani, A., Wachowicz, M., Ouzounis, G. and Portugali, Y. 2012. Smart cities of the future. *European Physical Journal Special Topics* 214: 481-518.

Barikin, Amelia, Nikos Papastergiadis, Audrey Yue, Scott McQuire, Ross Gibson, and Xin Gu. 2014. Translating gesture in a transnational public sphere. *Journal of Intercultural Studies* 35(4): 349-365.

Greenfield, Adam. 2013. *Against the smart city (The city is here for you to use book 1)*. New York: Do Projects. Accessed April 6, 2018. http://www.amazon.com/ Against-smart-city-here-Book-ebook/dp/B00FHQ5DBS.

Ibelings, Hans. 2002. *Supermodernism: Architecture in the age of globalization*. London: NAi Publishers.

McQuire, Scott. 2016. *Geomedia: Networked cities and the future of public space*. Cambridge: Polity.

Mouffe, Chantal. 2007. Artistic agonism and agonistic spaces. *Art & Research: A Journal of Ideas, Contexts and Method* 1(2): 1-5.

Vande Moere, Andrew, and Hill, Dan. 2012. Designing for the situated and public visualization of urban data. *Journal of Urban Technology* 19(2): 25-46.

Vande Moere, Andrew, and Wouters, Niels. 2012. The role of context in media architecture. *ACM Symposium on Pervasive Displays* (PerDis'12), ACM. Article 12.

About the Author

Dave Colangelo is Professor of Digital Experience Design in the School of Design at George Brown College, Director, North America, of the Media Architecture Institute, and Co-Founder of Public Visualization Studio.

List of Exhibitions, Films, Songs, Videos, and Installations

#ProgramaLaPlaza (MedialabPrado, 2013-)

30 moons many hands (Public Visualization Studio, 2013)

Astor Building (Krzysztof Wodiczko, 1984)

Binoculars to... Binoculars from... (Varvara Guljajeva and Mar Canet Sola, 2013)

Body Movies (Rafael Lozano-Hemmer, 2001)

Canon (Norman McLaren, 1964)

E-TOWER (Public Visualization Studio, 2010)

Emotion Forecast (Maurice Benayoun, 2010)

Empire State of Mind (Jay-Z feat. Alicia Keys, 2009)

Family of Man (Edward Steichen, 1955)

Girl on Fire (Alicia Keys, 2012)

Glimpses of the USA (Charles and Ray Eames, 1959)

Good Morning Mr. Orwell (Nam June Paik, 1984)

In The Air, Tonight (Public Visualization Studio, 2014)

Le Moulin à Images (*The Image Mill*) (Robert Lepage / Ex Machina, 2008)

Learning to Love You More (Miranda July and Harrell Fletcher, 2002-09)

Lesbians Fly Air Canada (Lynne Fernie, 1986)

Man with a Movie Camera (Dziga Vertov, 1929)

McLarena (Daily tous les jours, 2014)

Messages to the Public (Public Art Fund, Inc., 1982)

Mutual Core (Björk, 2012)

Nordic Outbreak (Streaming Museum, 2013)

NOX (Onur Sönmez and Tamer Aslan, 2013)

Occupy Wall Screens (Maurice Benayoun, 2011)

Pollstream-Nuage Vert (HeHe, 2008)

Psycho (Alfred Hitchcock, 1960)

Shades of Our Sisters (2016)

sms_origins (Starrs and Cmielewski, 2009-10)

Some Uncertain Signs (Public Access, 1986)

The Line (Public Visualization Studio, 2013)

The Tijuana Projection (Krzysztof Wodiczko, 2001)

Truisims (Jenny Holzer, 1981)

Vectorial Elevation (Rafael Lozano-Hemmer, 1999)

Index of Names

Index of Subjects